FUCK OFF, I'M COLORING!

The COMPLETE COLLECTION

De-Stress With Over 150
Lively Coloring Pages

DARE YOU

STAMP CO.

A belligerent subset of
Cider Mill Press Book Publishers

DEYST.

13-Digit ISBN: 978-1-64643-149-6
10-Digit ISBN: 1-64643-149-9

This book may be ordered by mail from the publisher. Please include $5.99 for postage and handling. Please support your local bookseller first!

Books published by Cider Mill Press Book Publishers are available at special discounts for bulk purchases in the United States by corporations, institutions, and other organizations. For more information, please contact the publisher.

Cider Mill Press Book Publishers
"Where Good Books Are Ready for Press"
501 Nelson Place
Nashville, Tennessee 37214

Visit us online!
cidermillpress.com

Typography: Adobe Garamond Pro, Archive Tilt, Festivo Letters, Satisfy

Printed in Malaysia

23 24 25 26 27 DSC 8 7 6 5 4

IF you're reading this, you're our kind of motherfucker. Or you just might be a fan of Dare You Stamp Co. already. And why wouldn't you be? We're awesome. Our line of completely irreverent products is perfect for sticking it to the man and flipping off your haters with style.

Whether you signed your vacation request with our *F This Shit Stamp Kit*, told Santa where he can shove his coal with our *Tis the Season to Be Naughty Postcards*, or became the antihero of your dreams with our *POW! Stamp Kit*, you know we're done being polite. So why not tell the world to fuck off? Break out that pack of crayons you abandoned in middle school and color the fuck out of any number of these swear-filled pages. Frame them, hang them, or leave them all over your boss's desk with your resignation letter stapled to the back. What you do with these are up to you, dumbass. If you feel like showing off, you can tag @cidermillpress on social media and share your fucking awesome creations with the hashtag #fuckoffimcoloring.

Now go forth and be the complete asshole you were meant to be, we dare you.

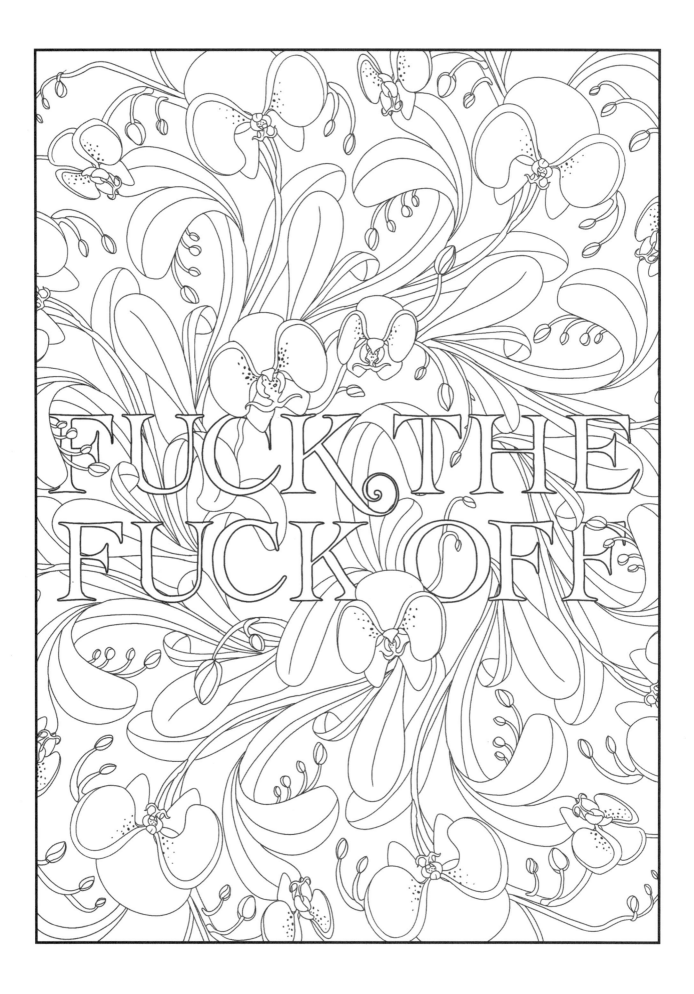

TABLE *of* CONTENTS

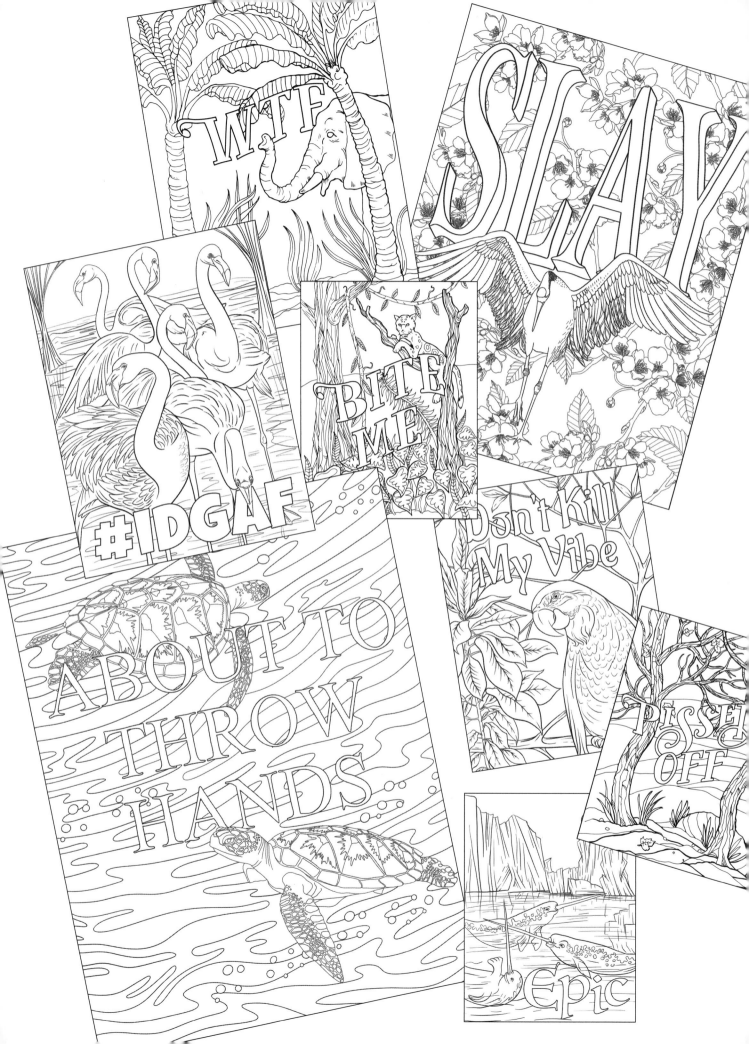

INTRODUCTION

Work, paying bills, screaming kids, needy friends and family—being an adult sucks! The stress and hassles come from all directions, and they can be relentless. But this big-ass book is here to help!

Tune out the noise by practicing some profane self-care with these pages of edgy one-liners and immature, yet wonderfully satisfying quips. Color the bullshit away and let off some steam.

Channel your stress into these curse-filled pages and let the fantastic glory of irreverence be your guide to tranquility and laughter.

Go on now, get fucking to it! Color the hell out of this book!

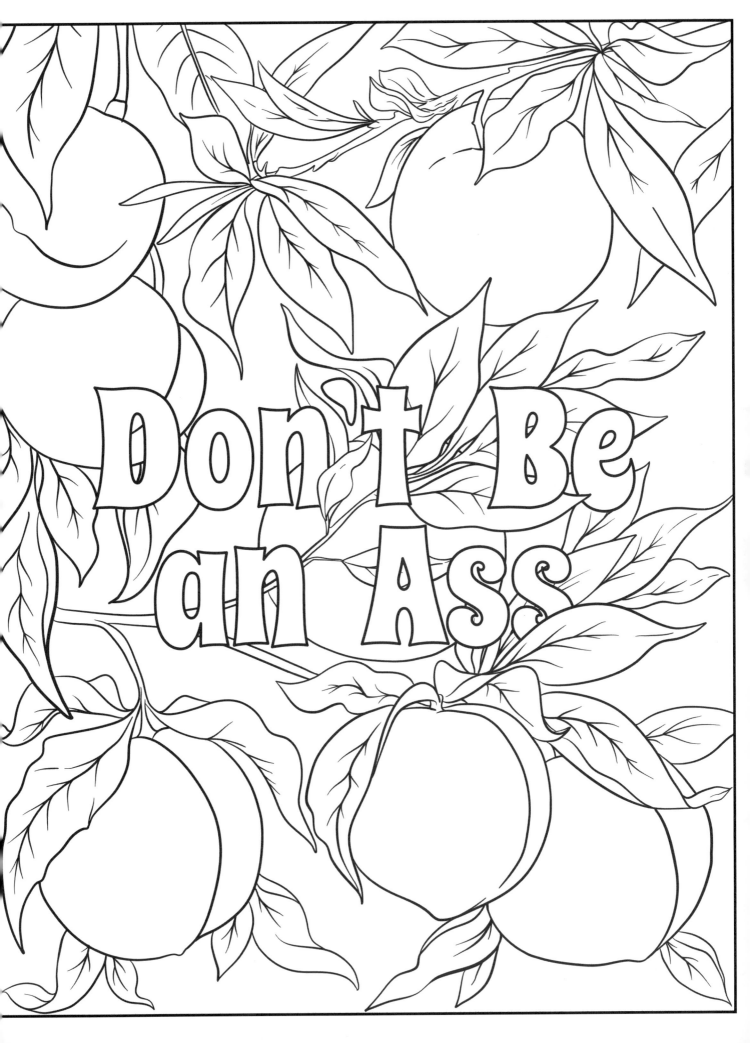

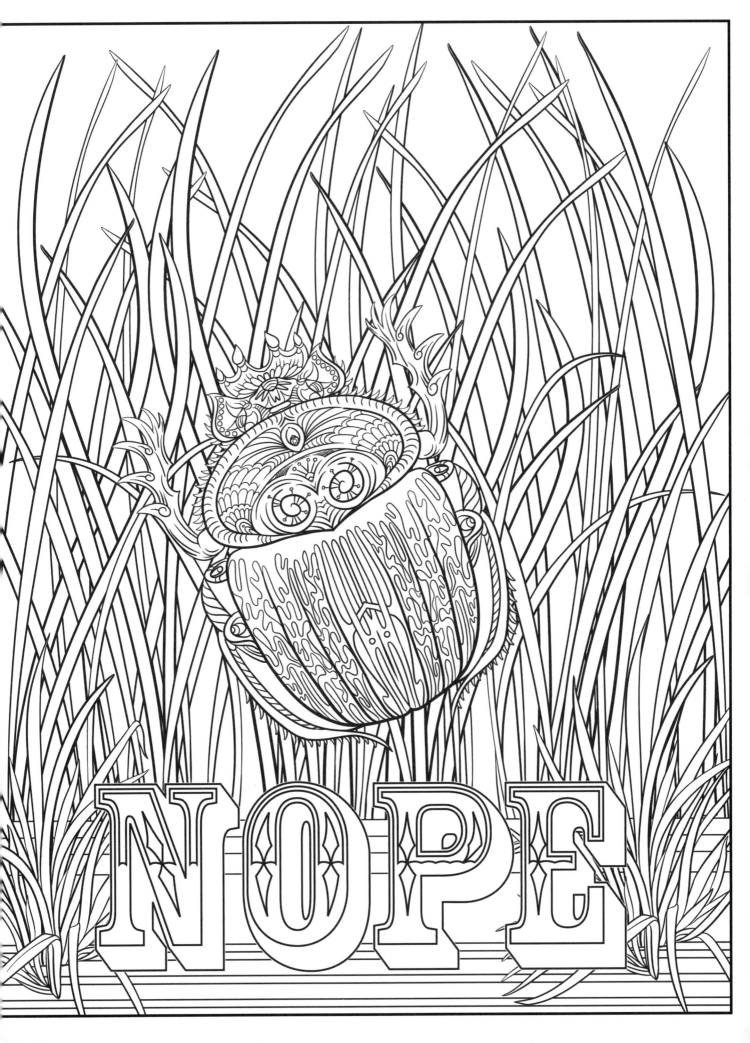

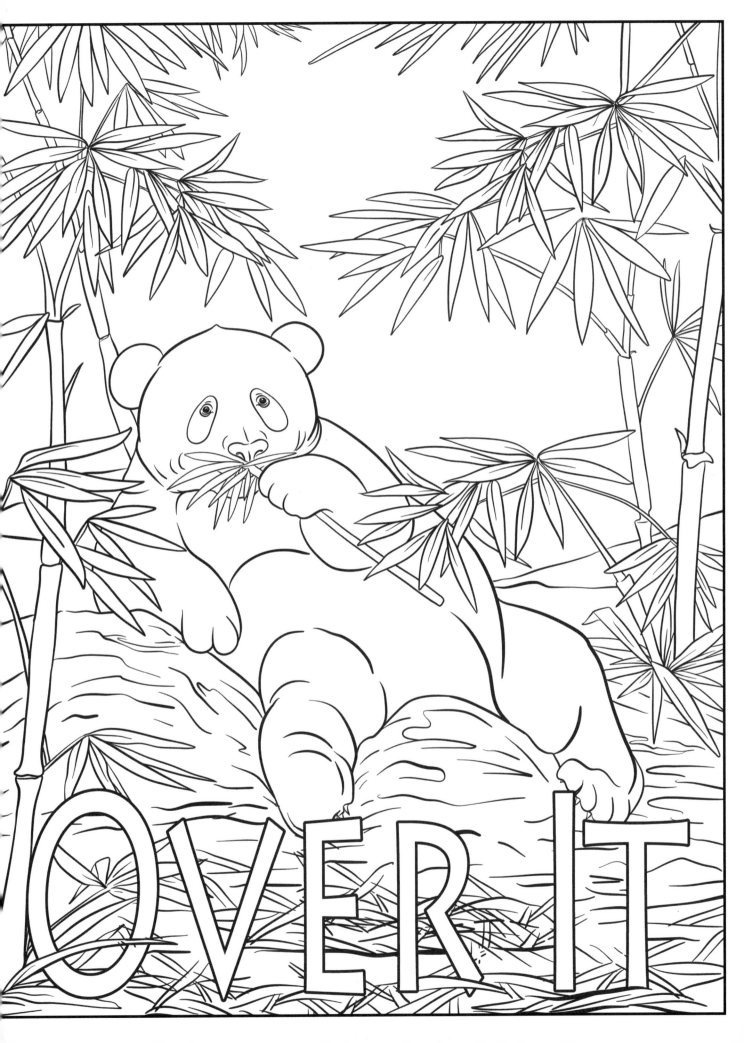

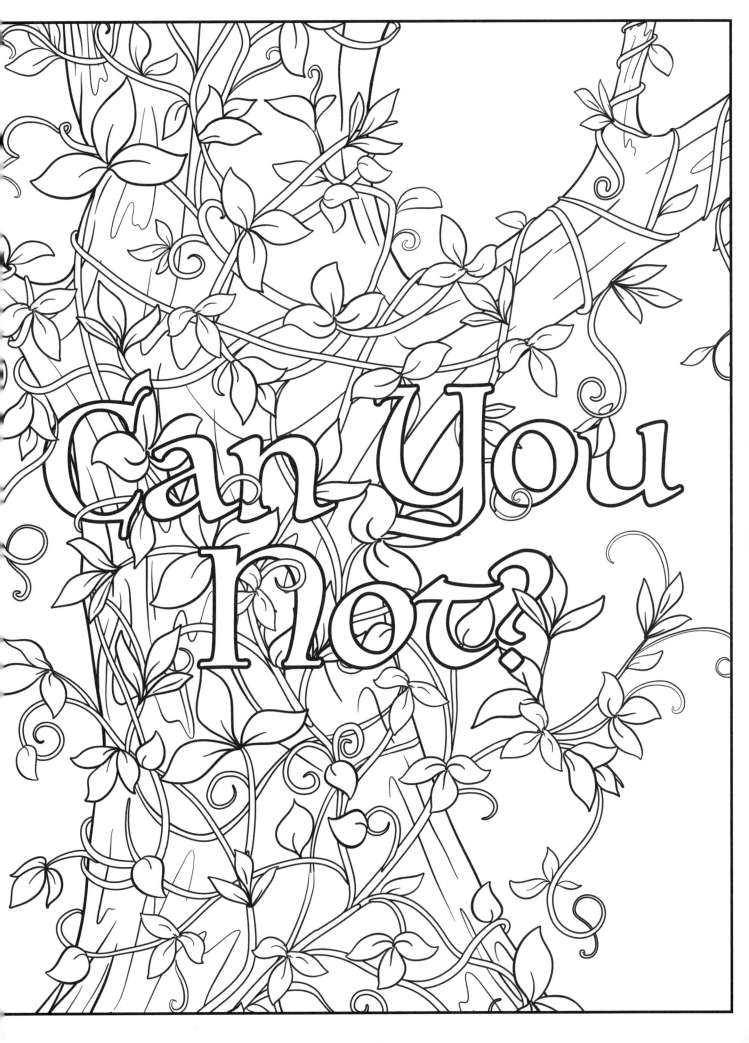

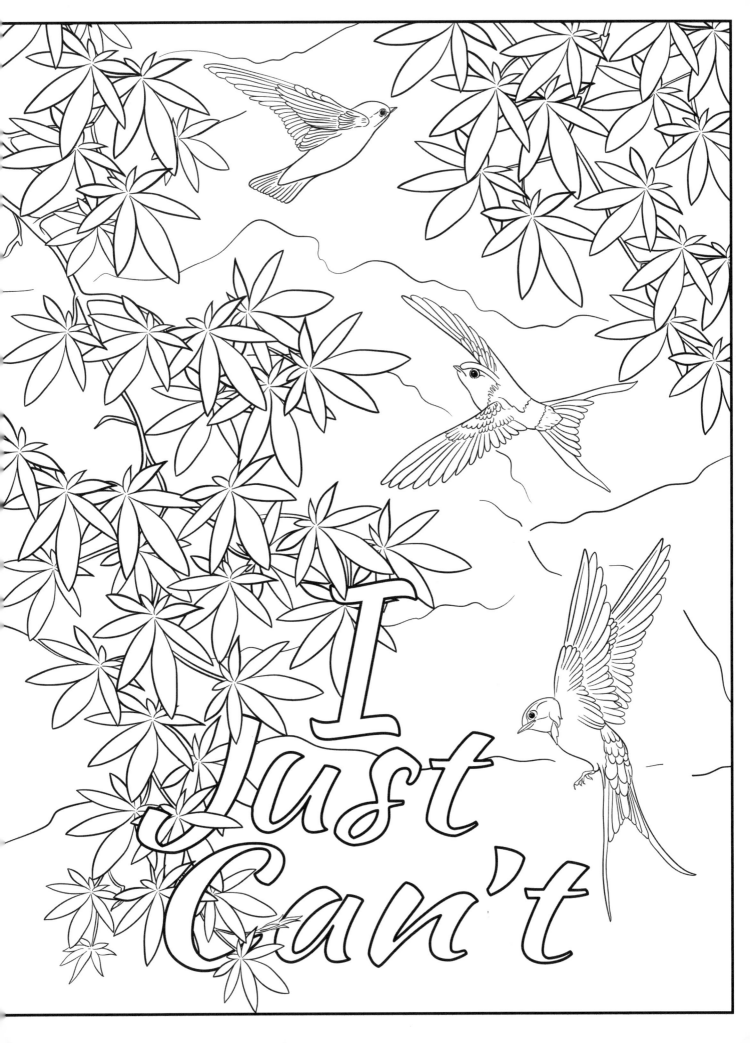

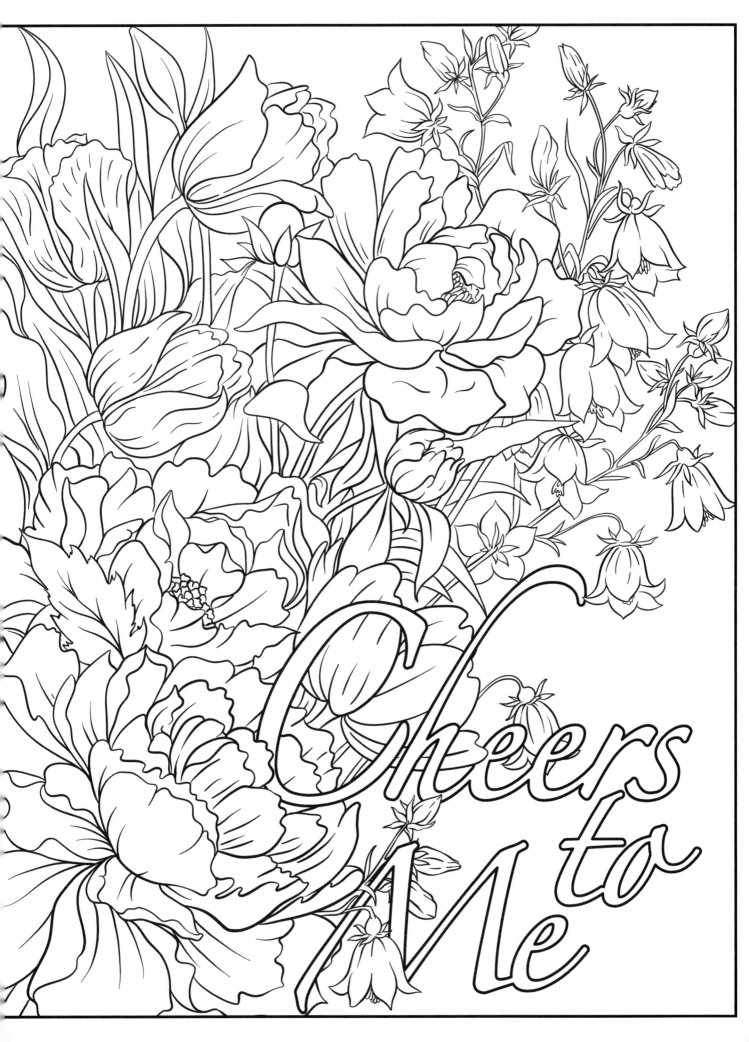

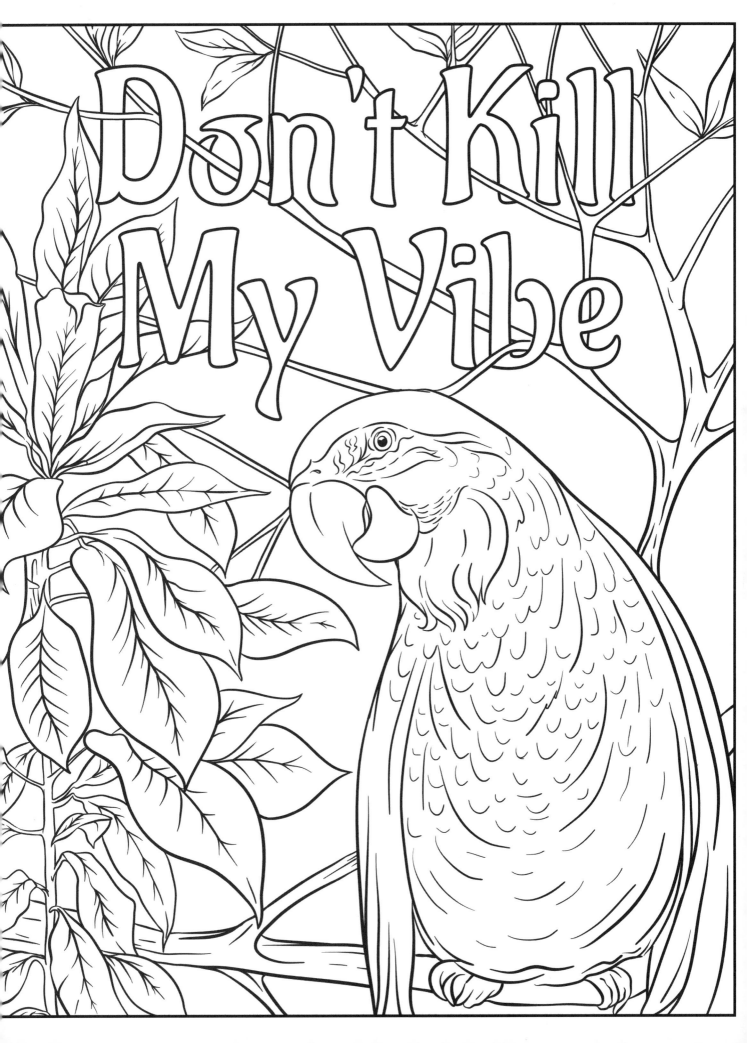

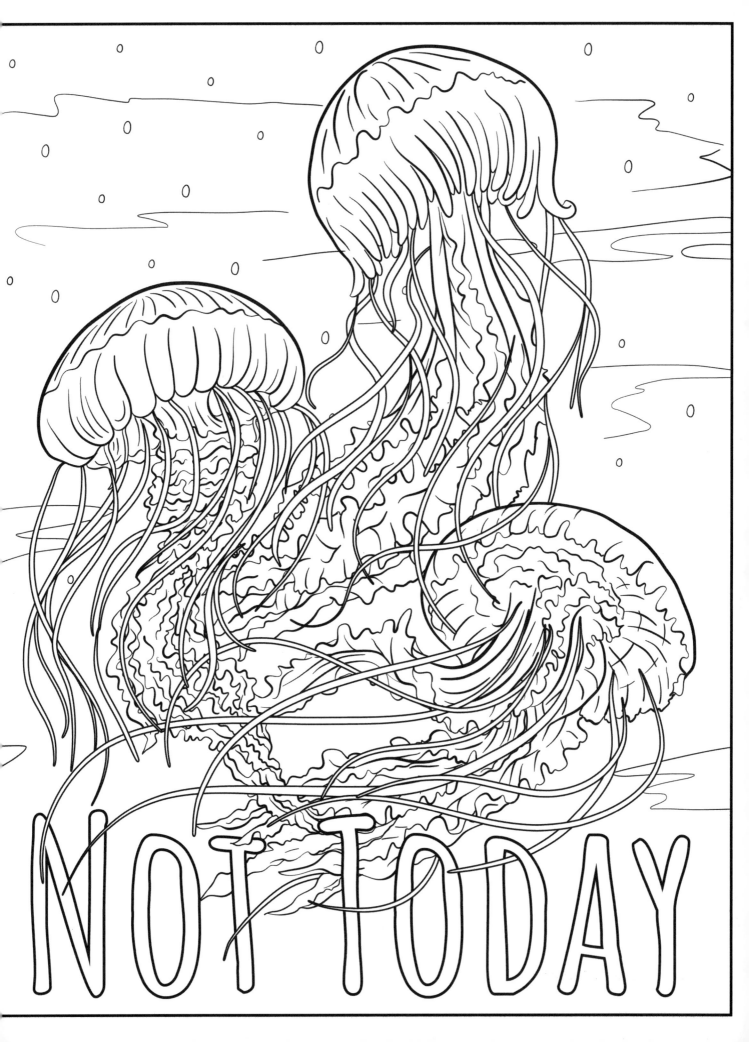

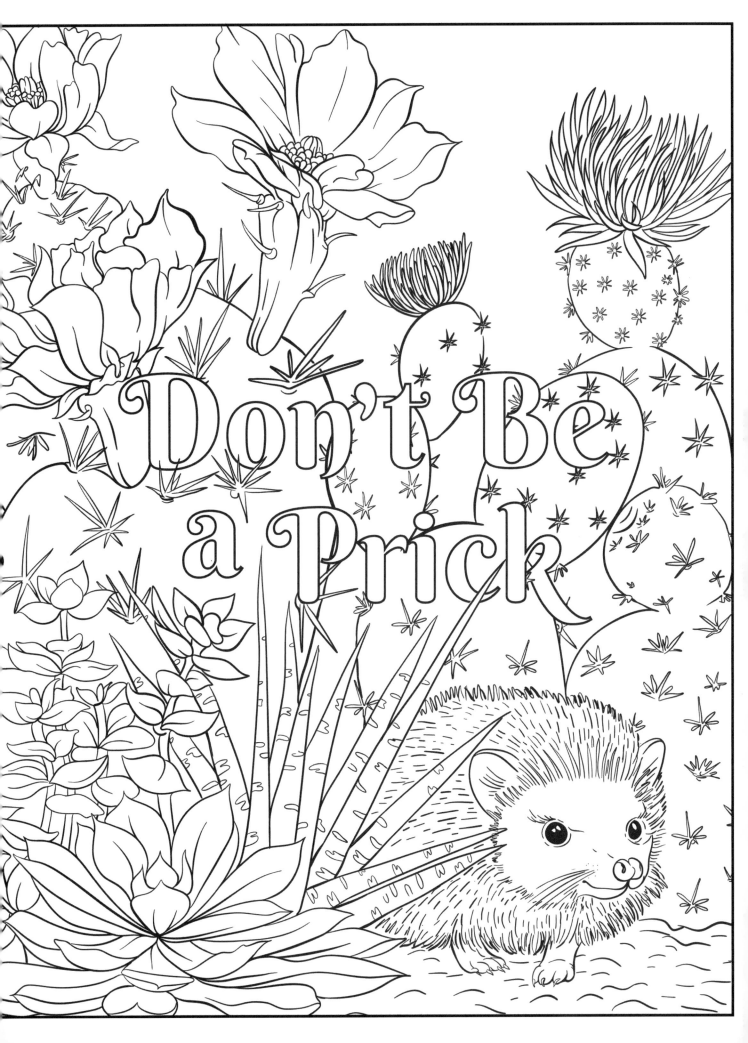

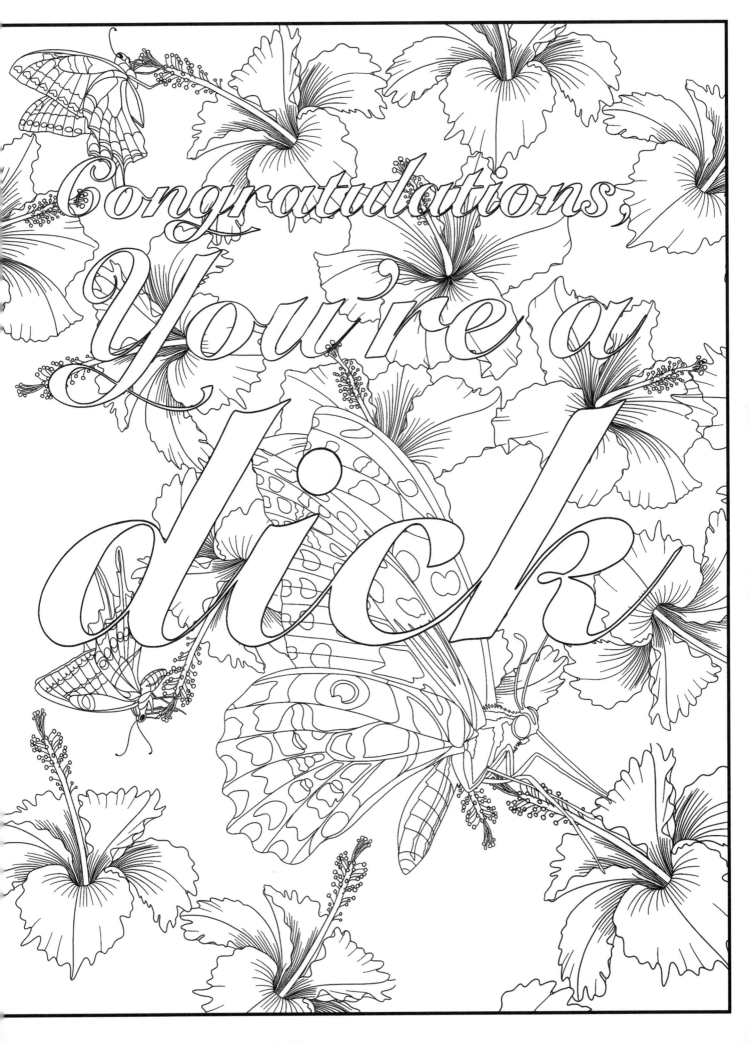

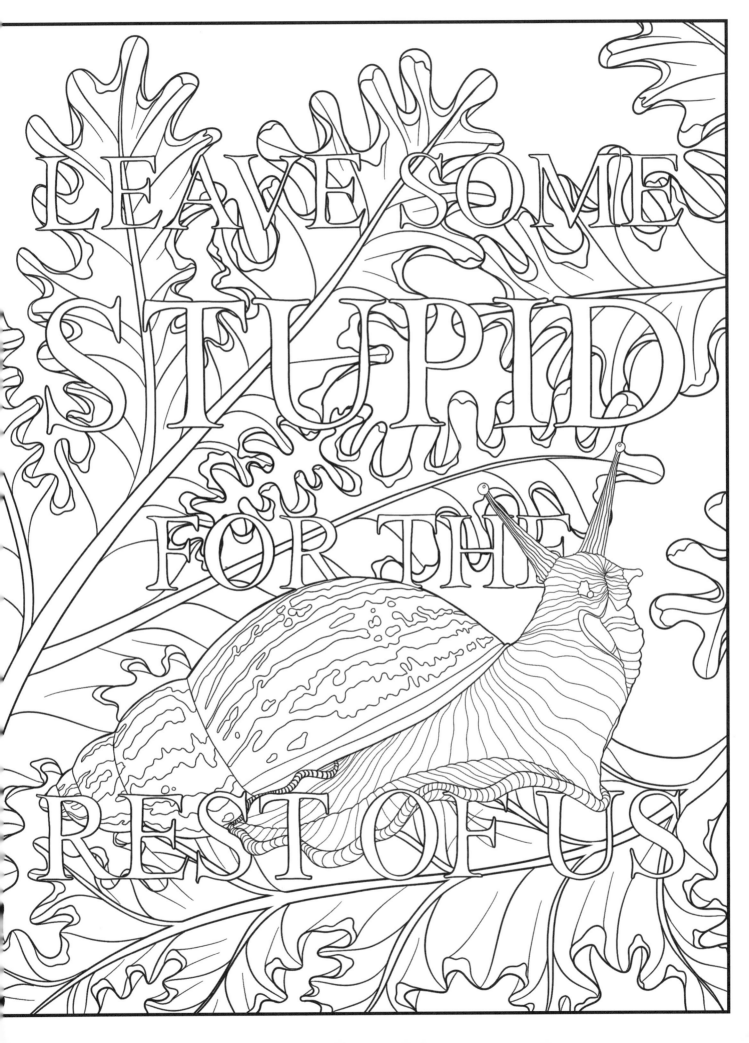

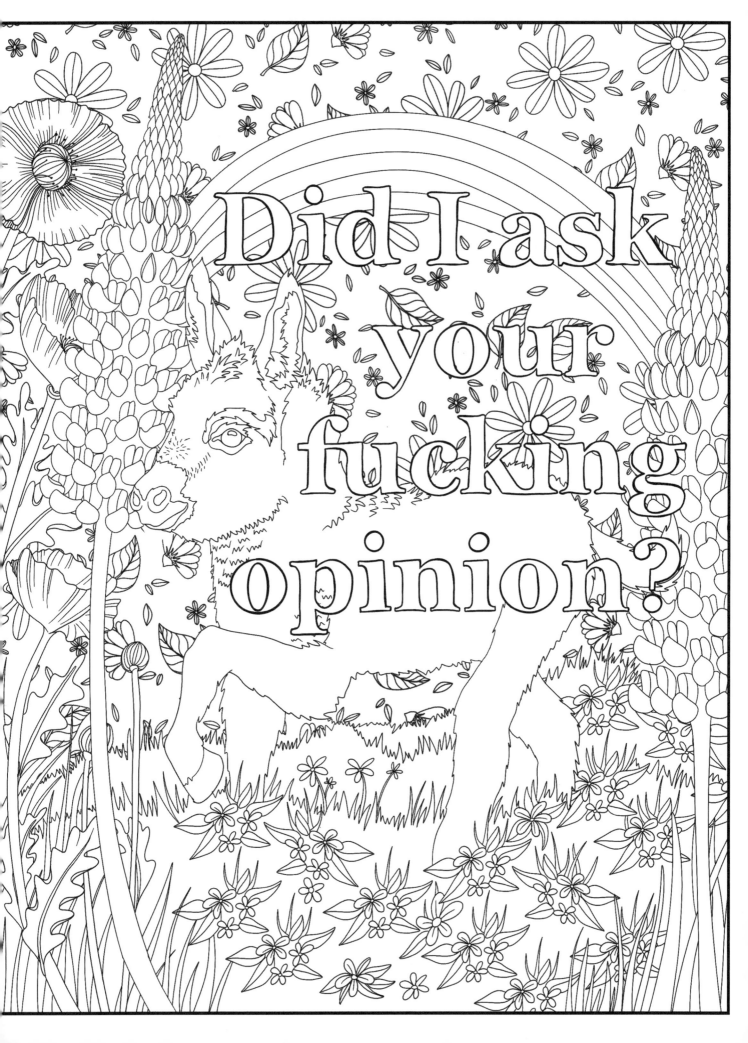

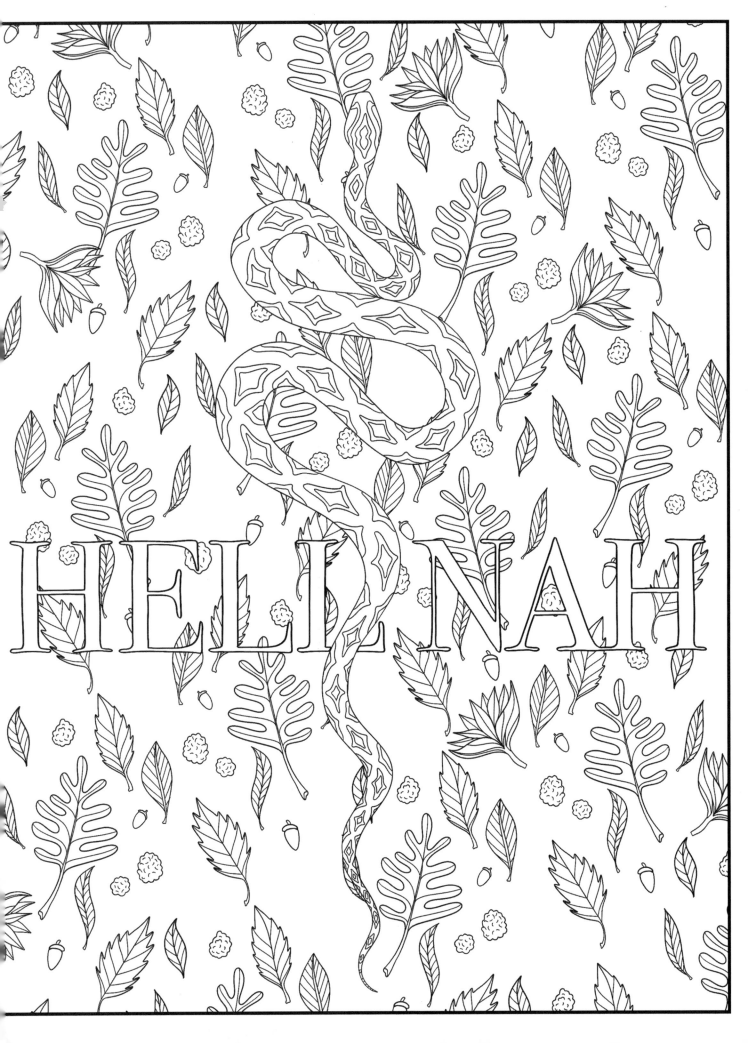

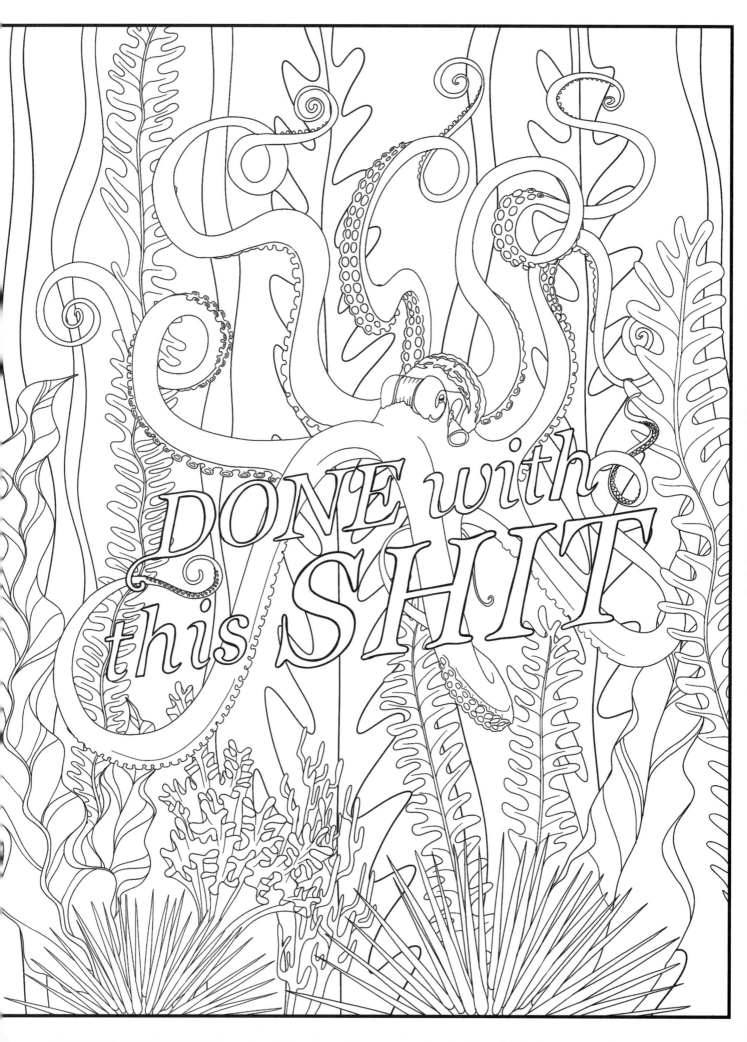

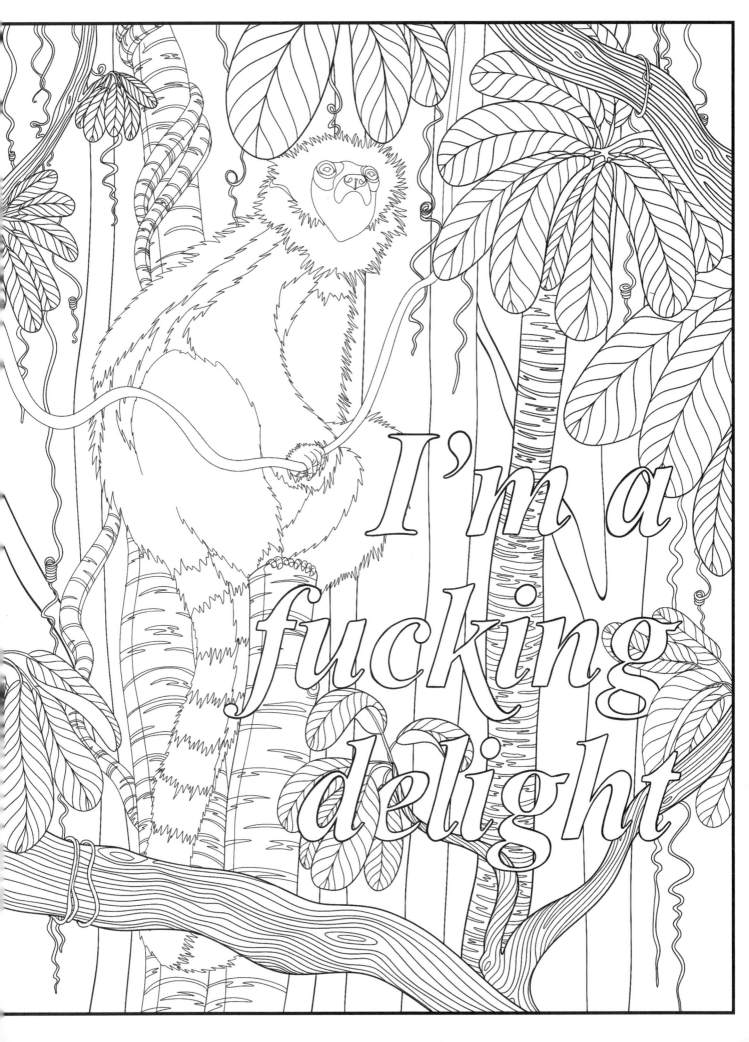

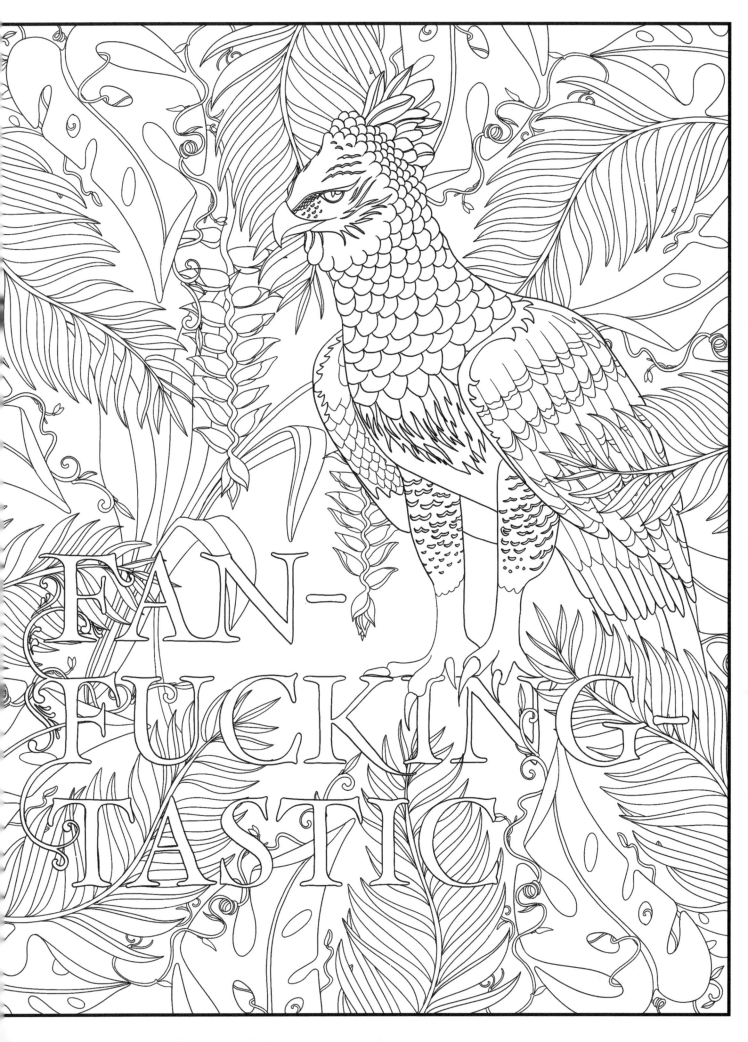

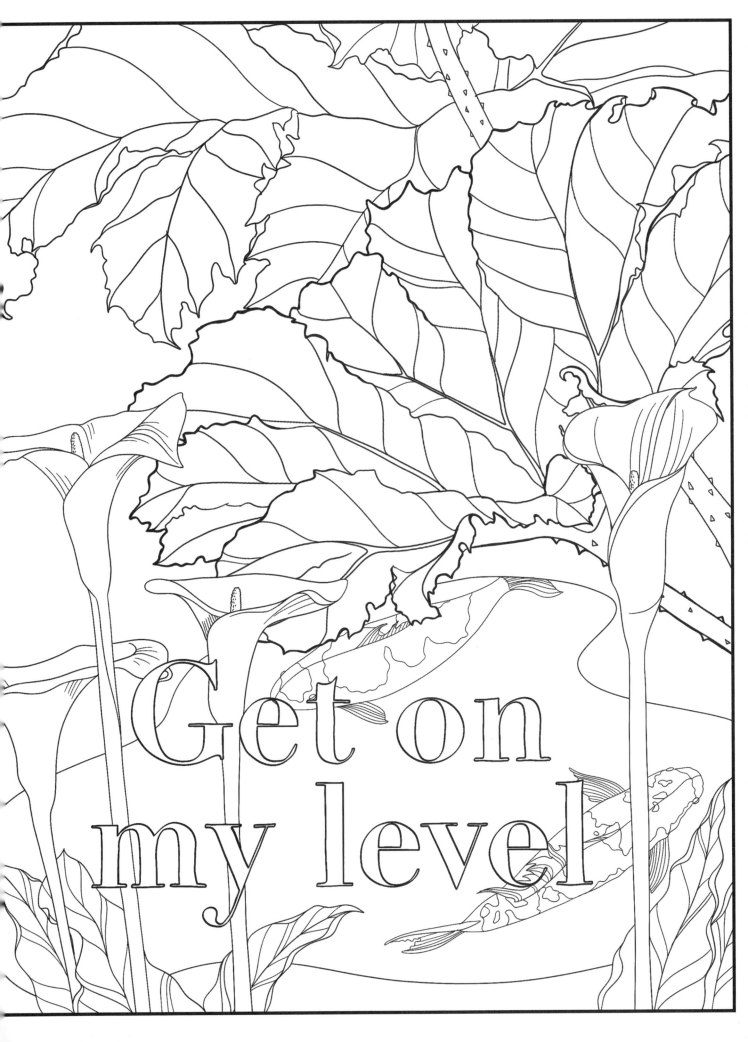

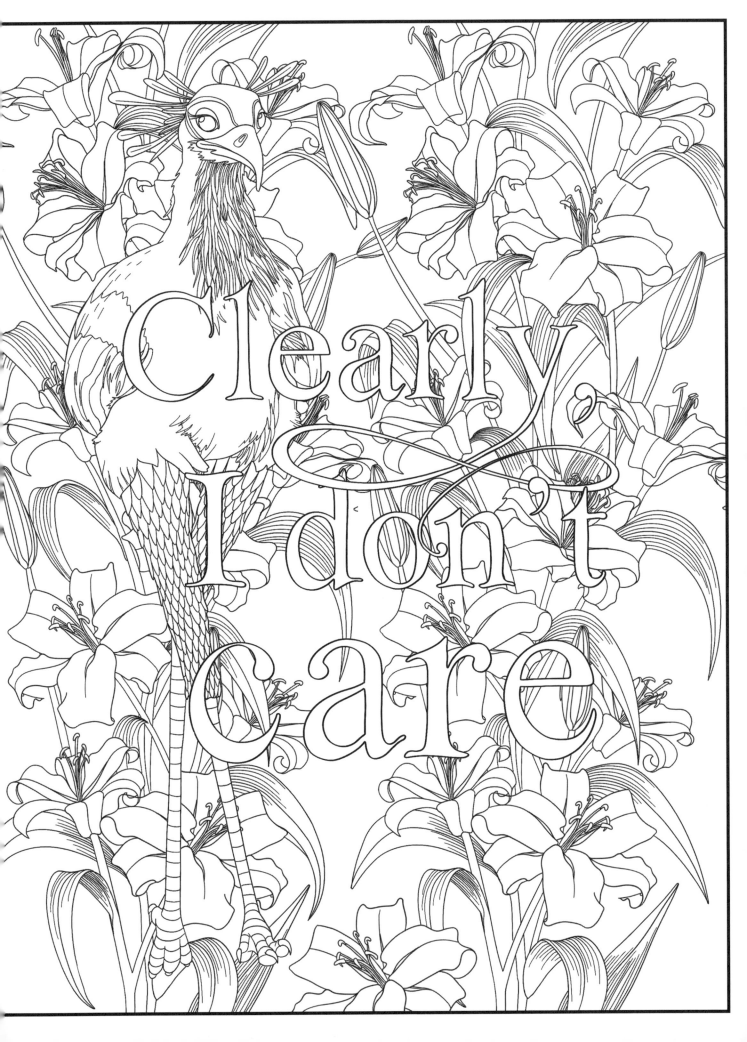

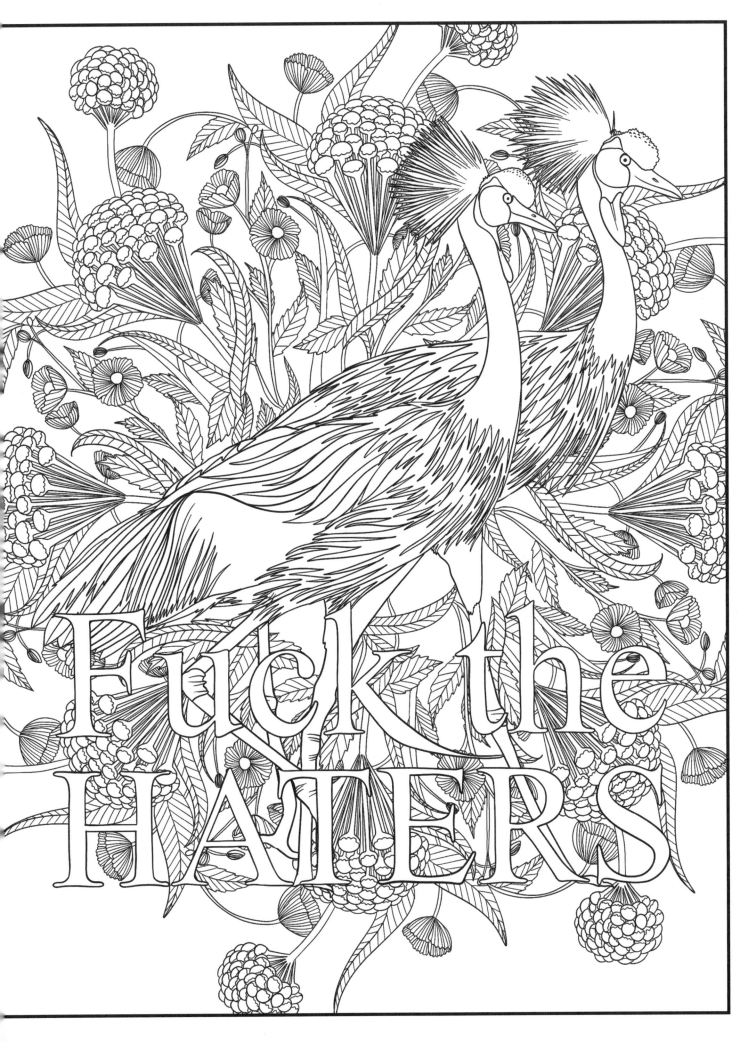

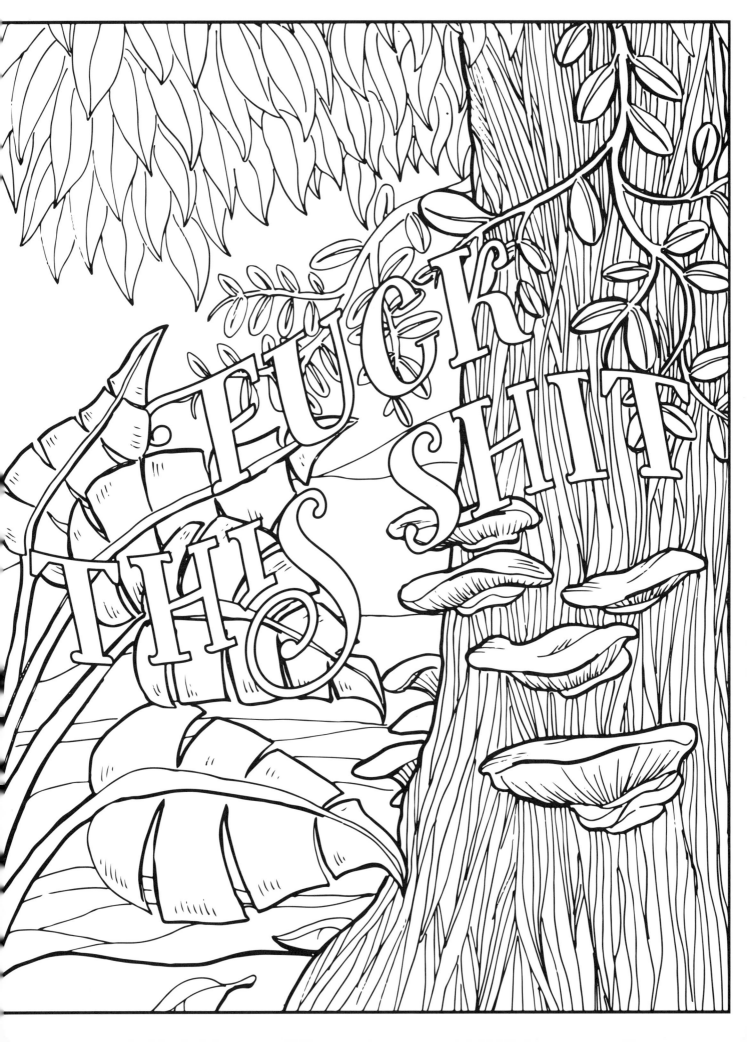

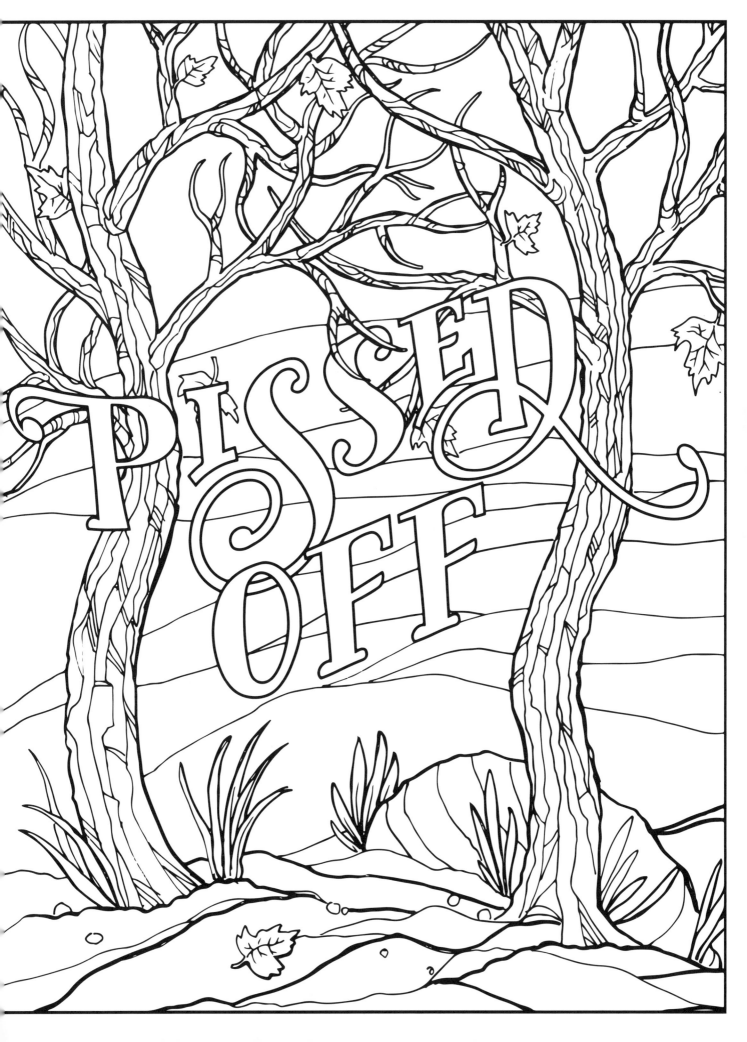

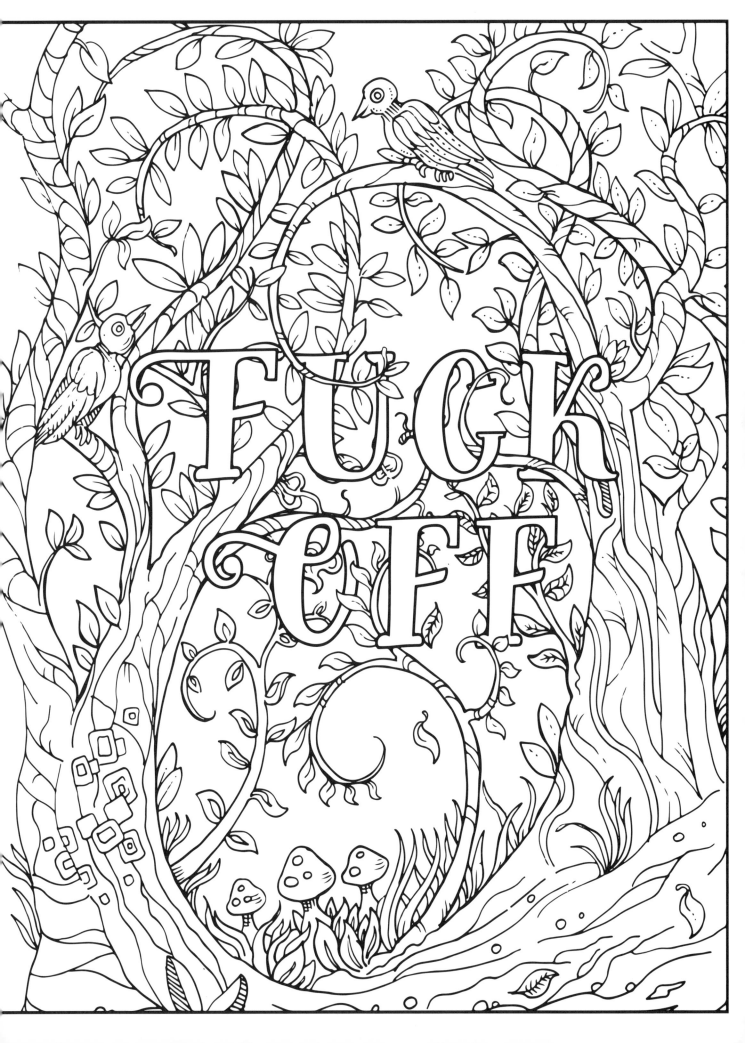

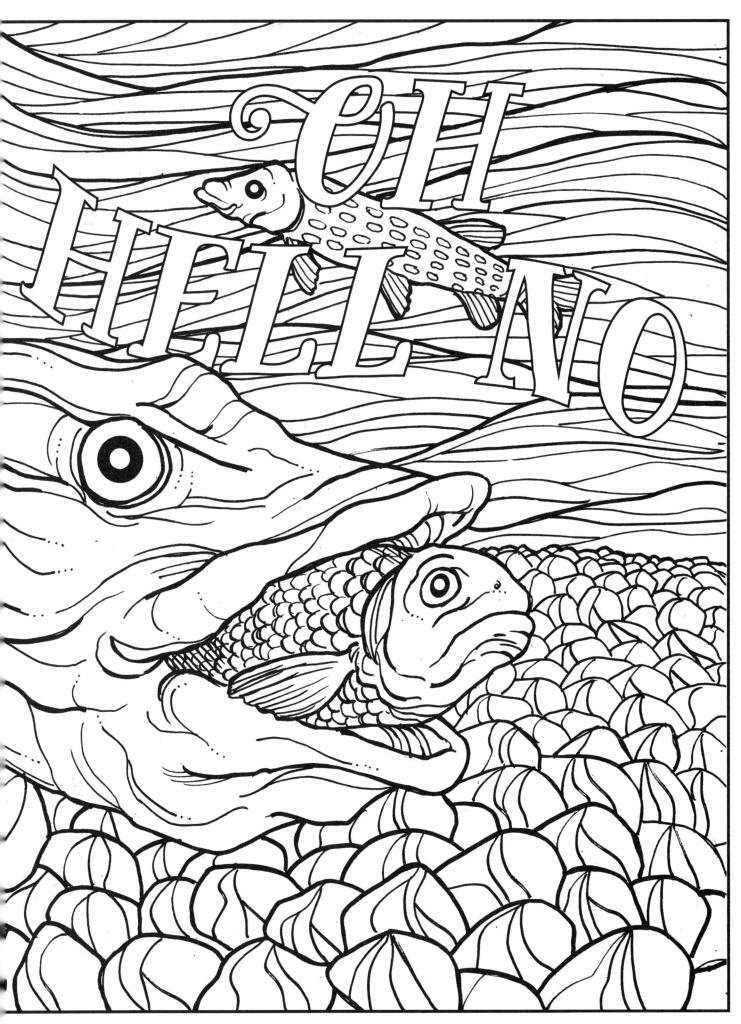

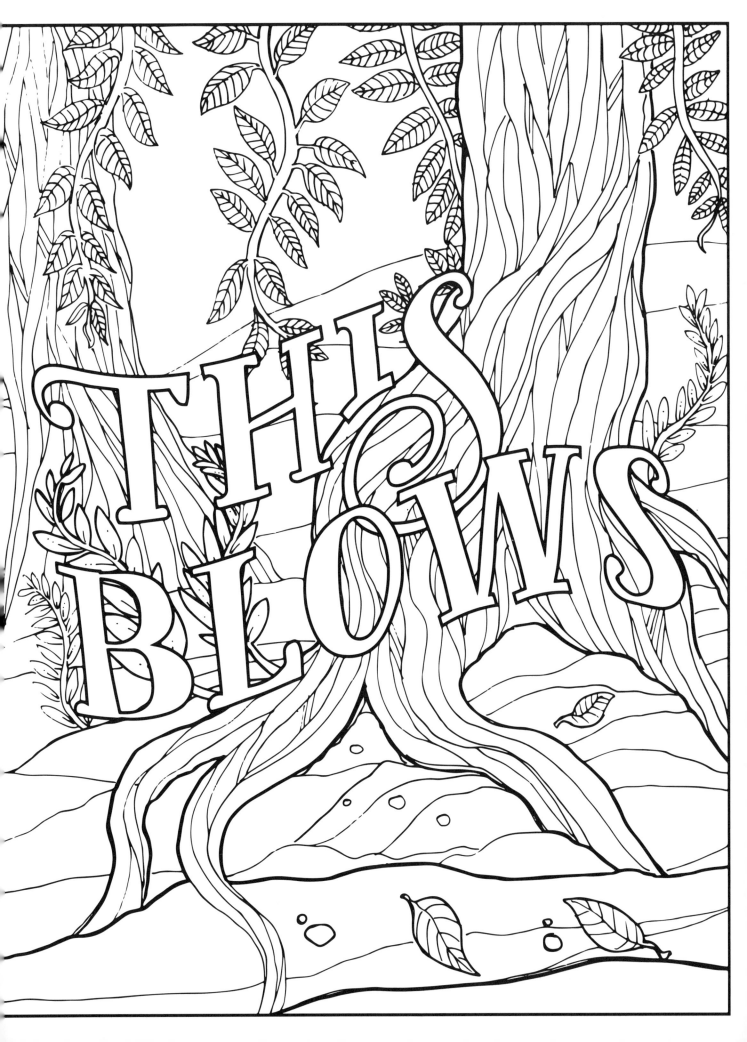

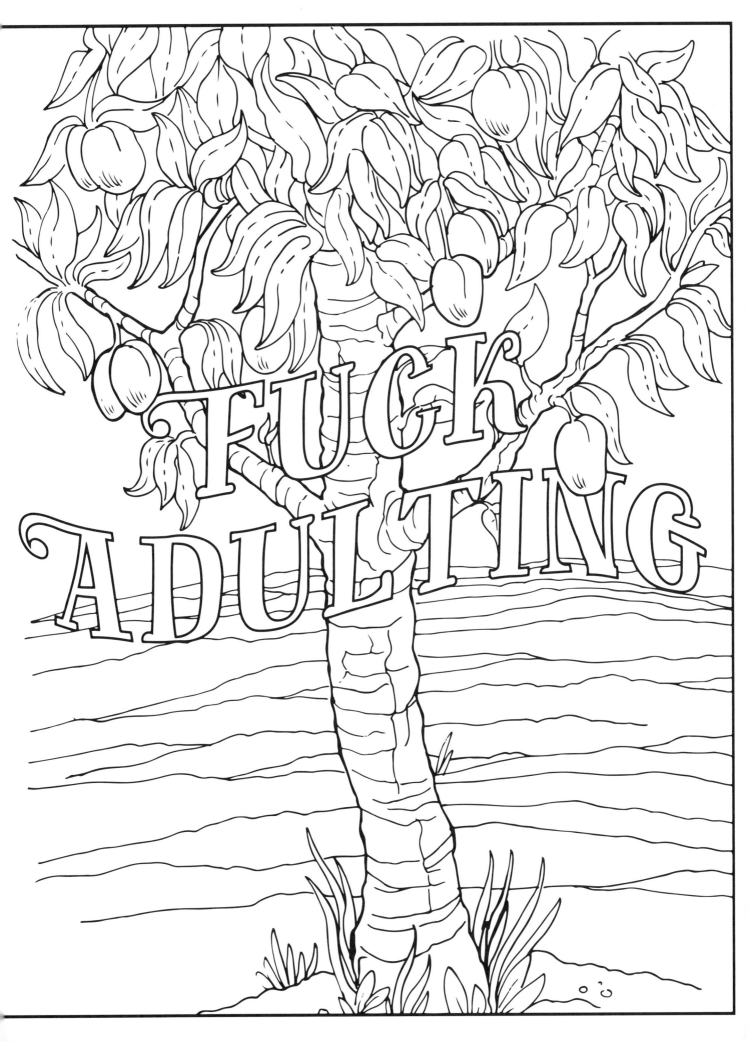

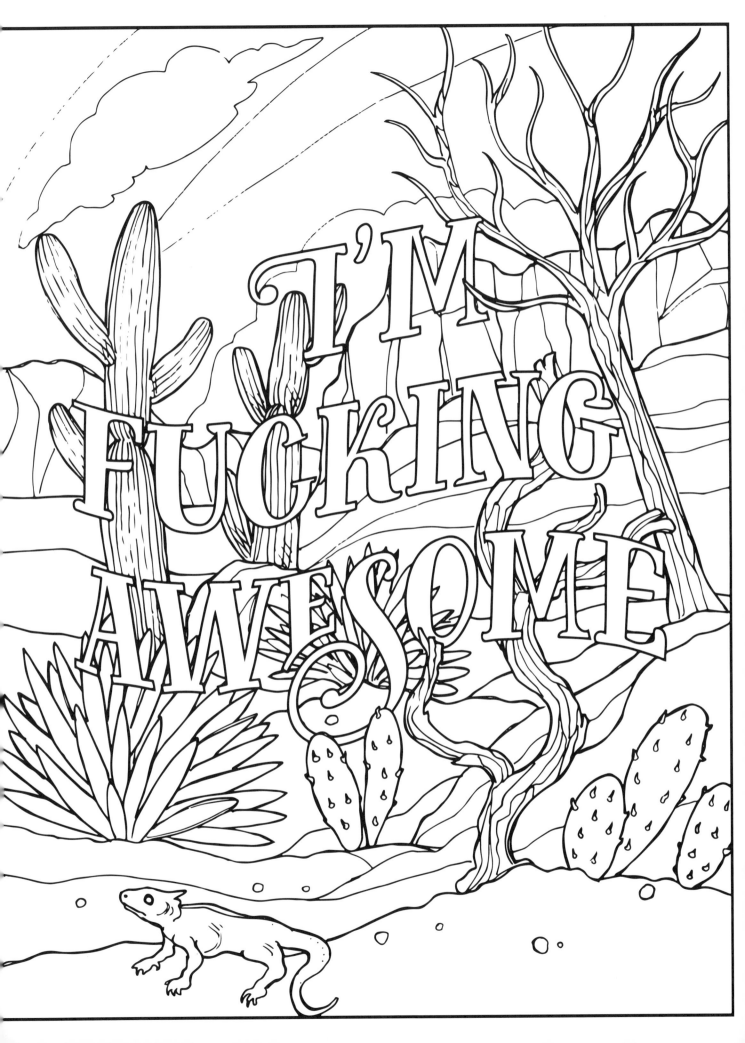

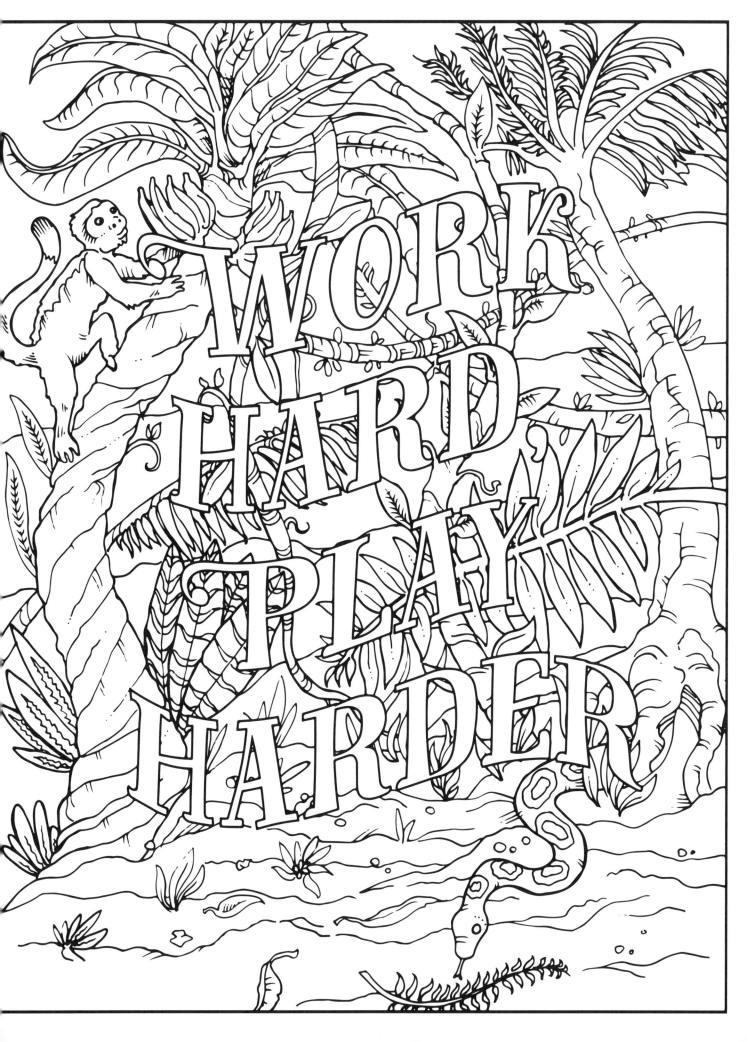

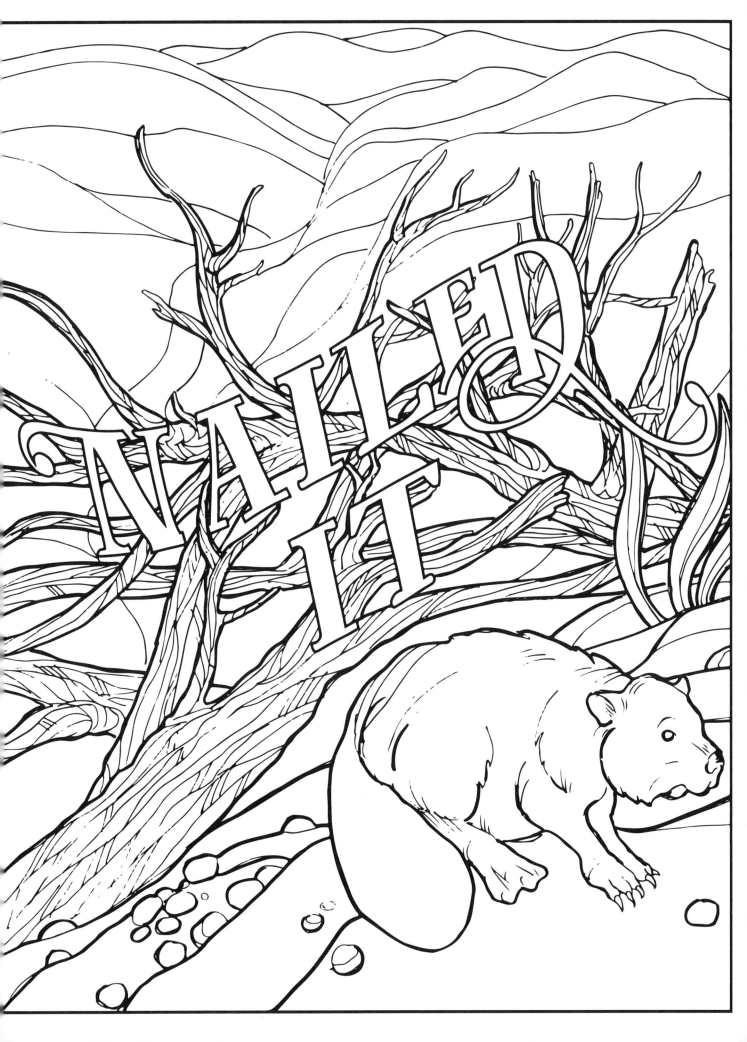

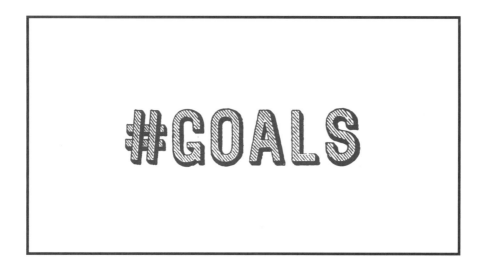

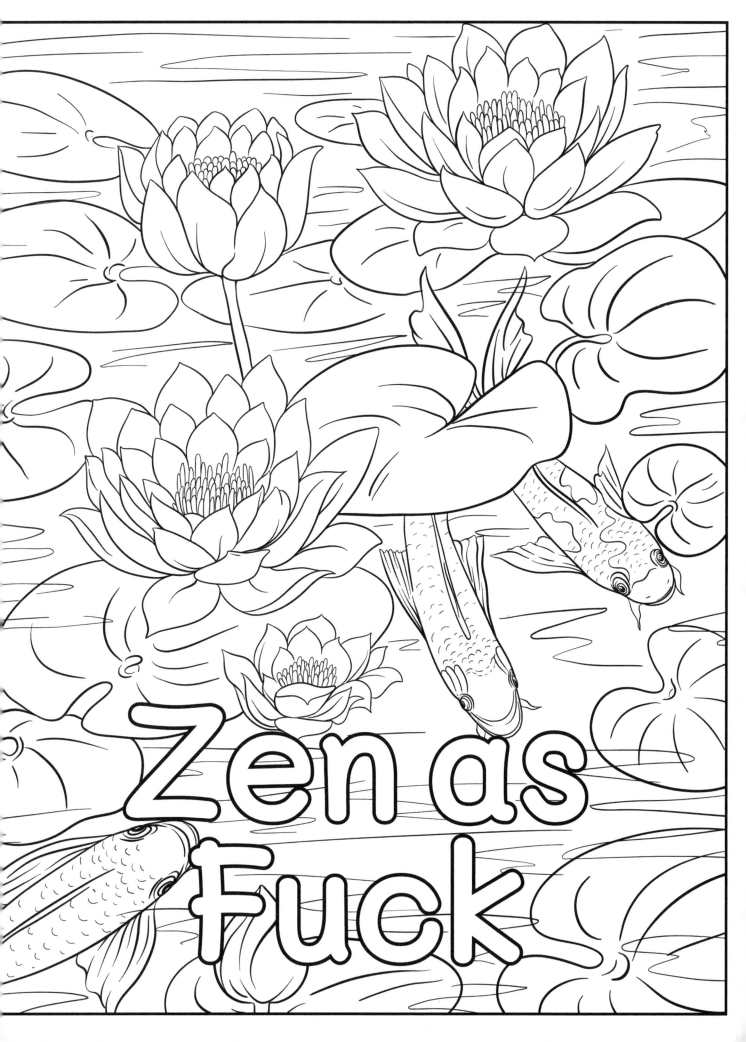

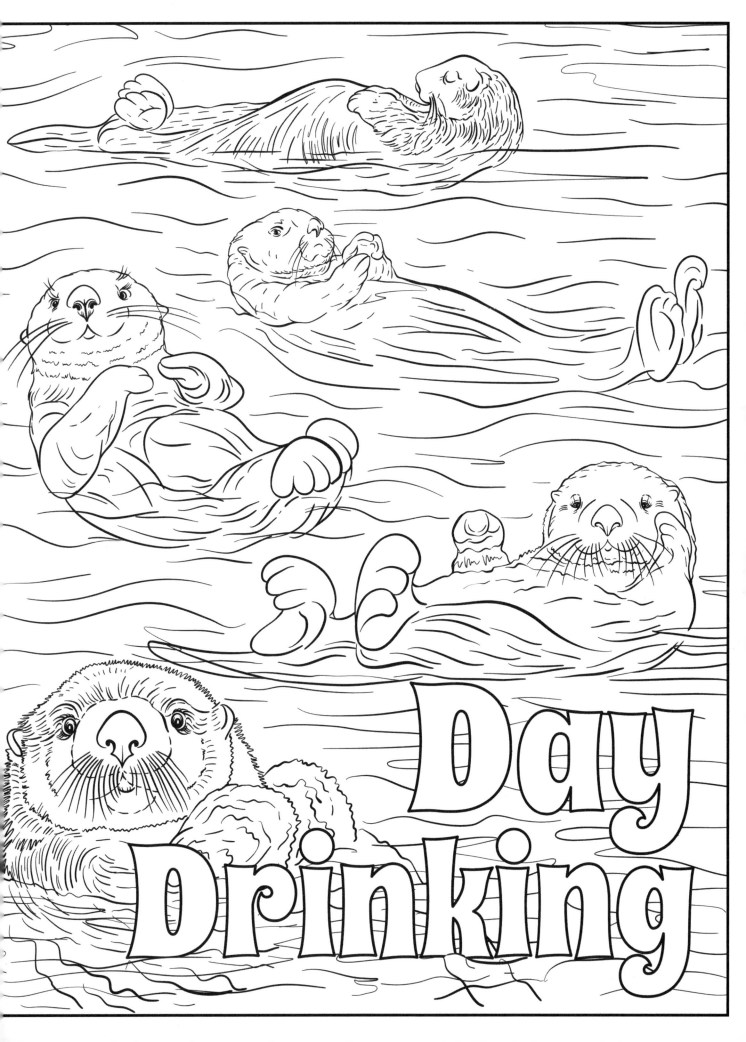

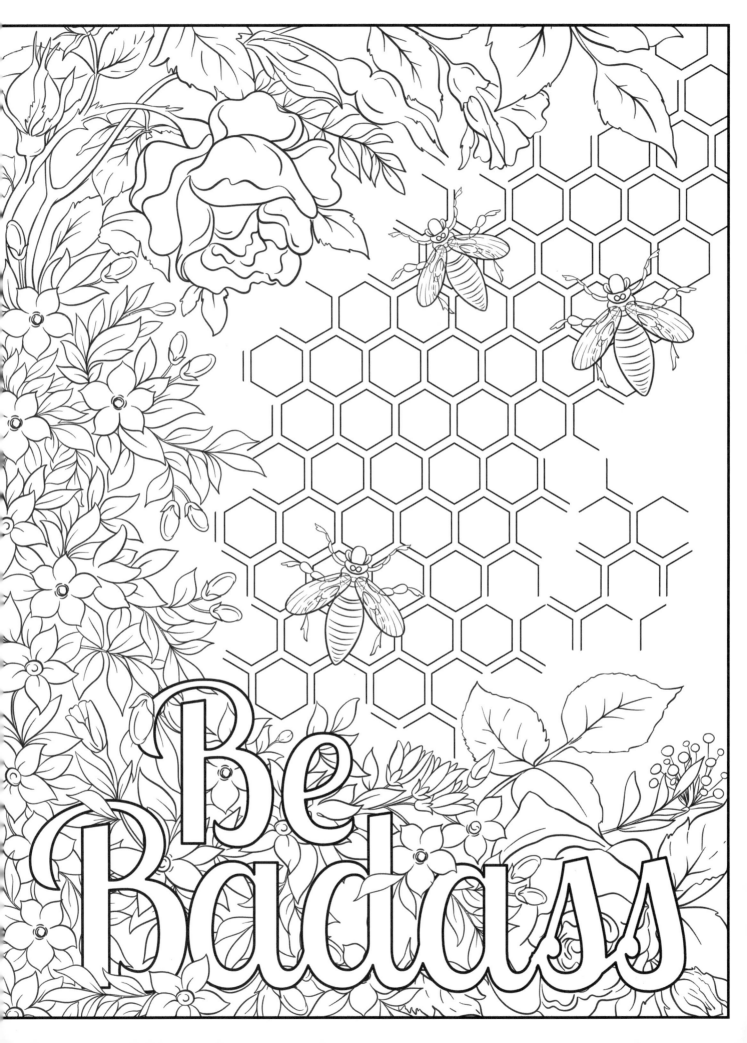

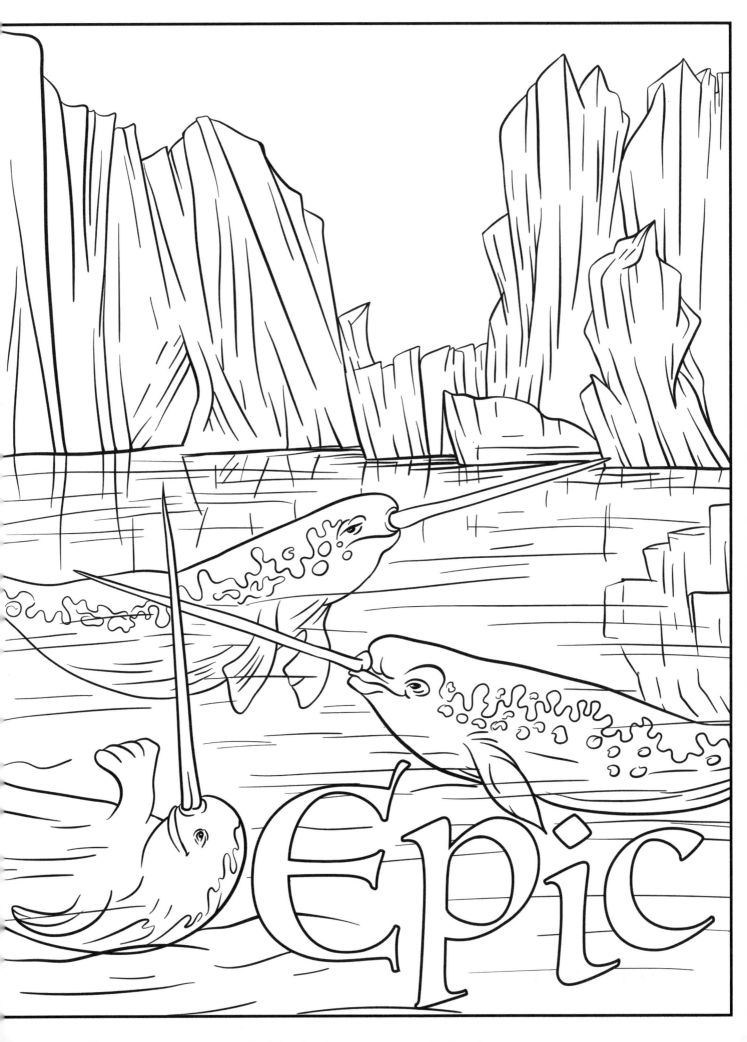

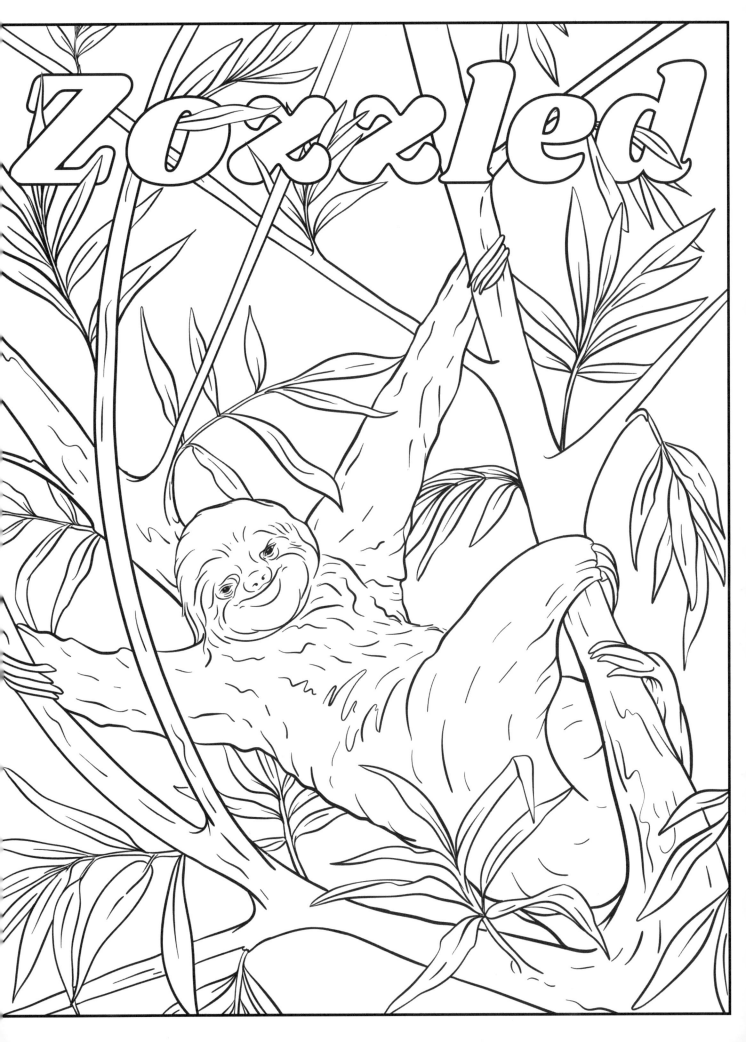

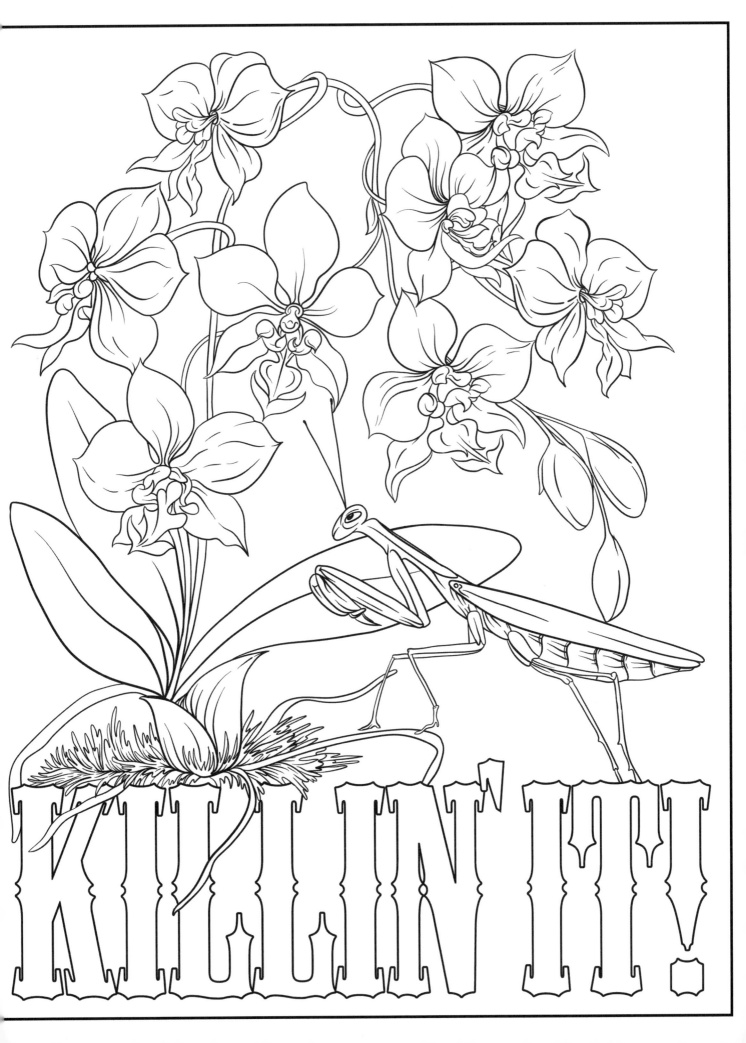

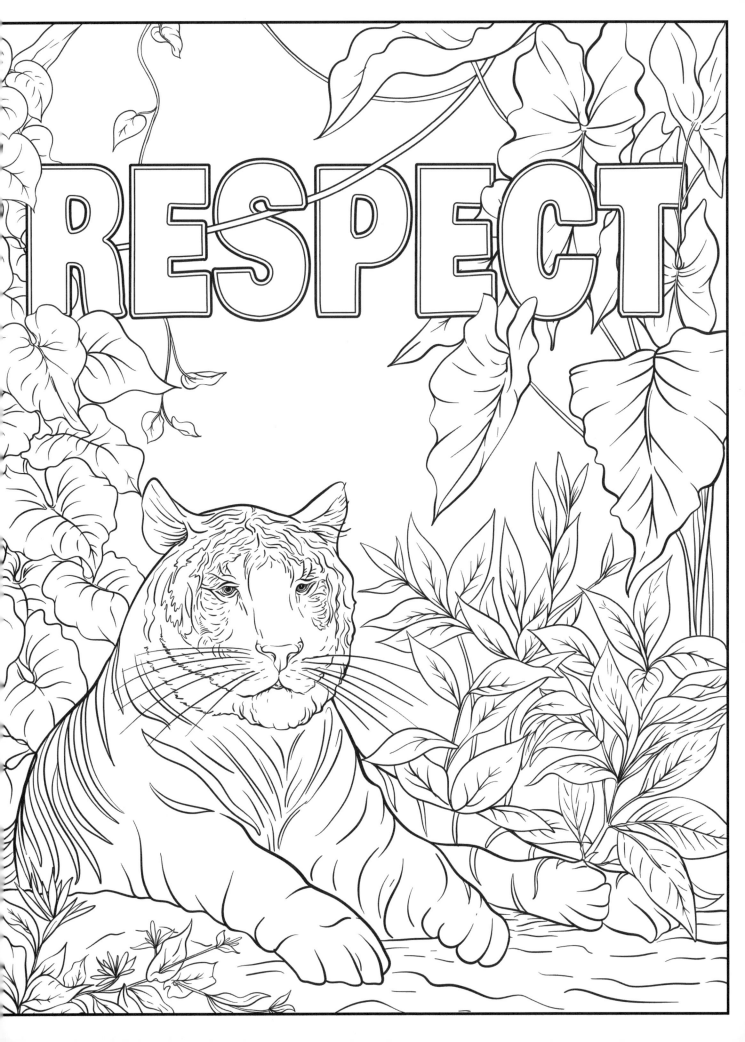

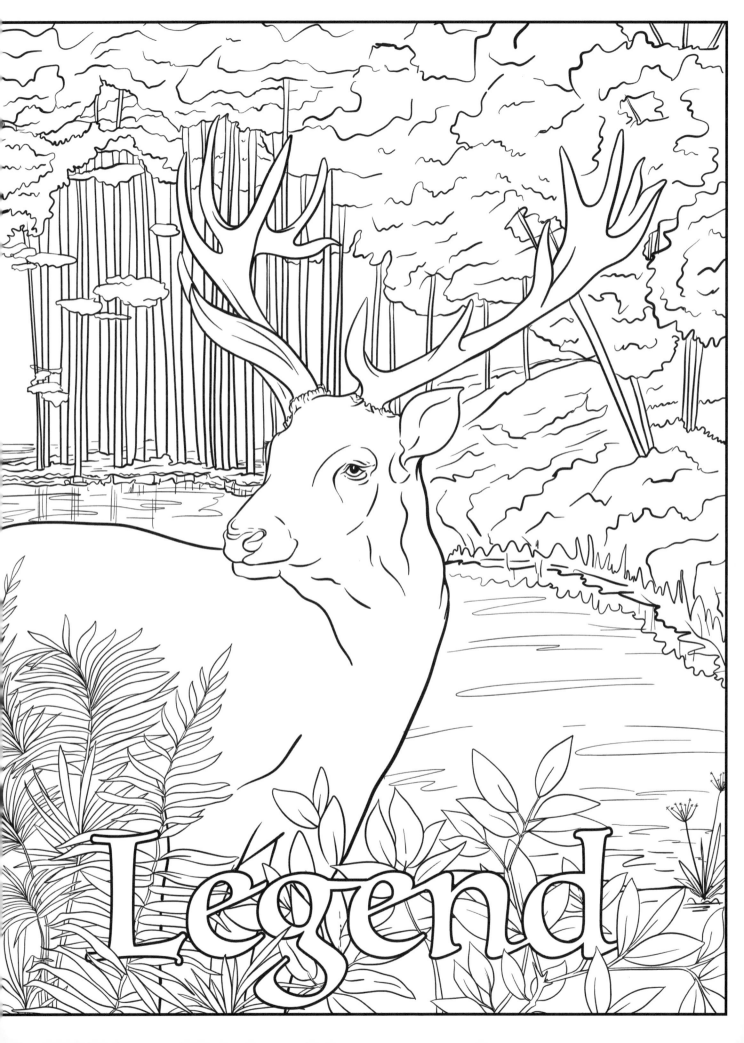

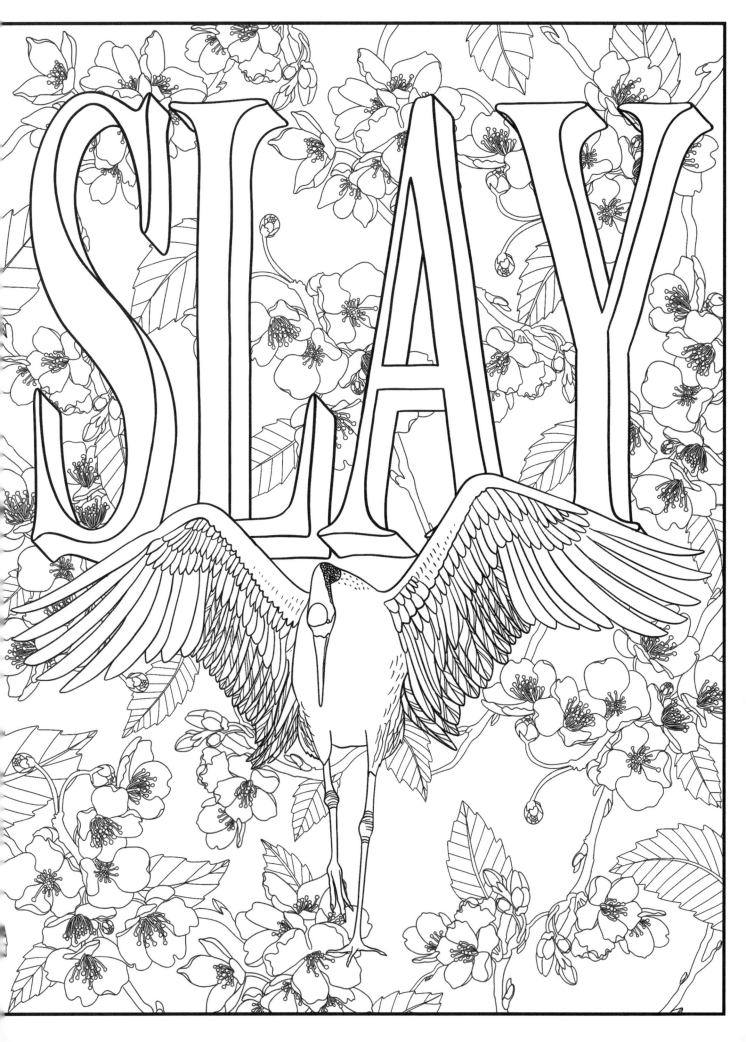

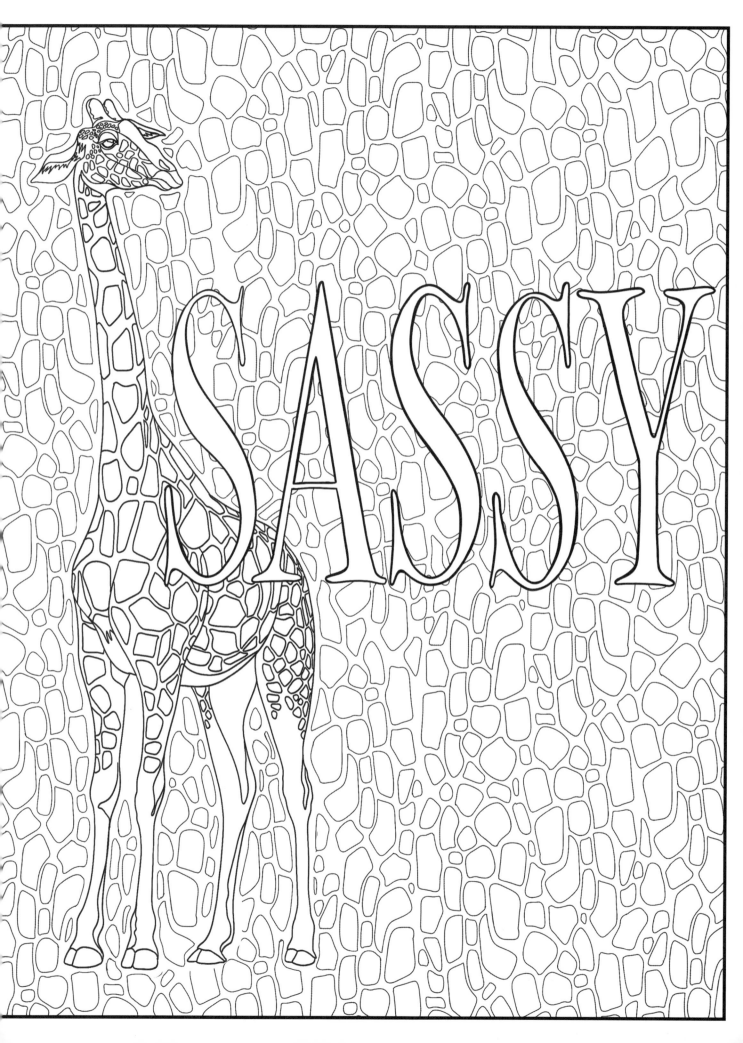

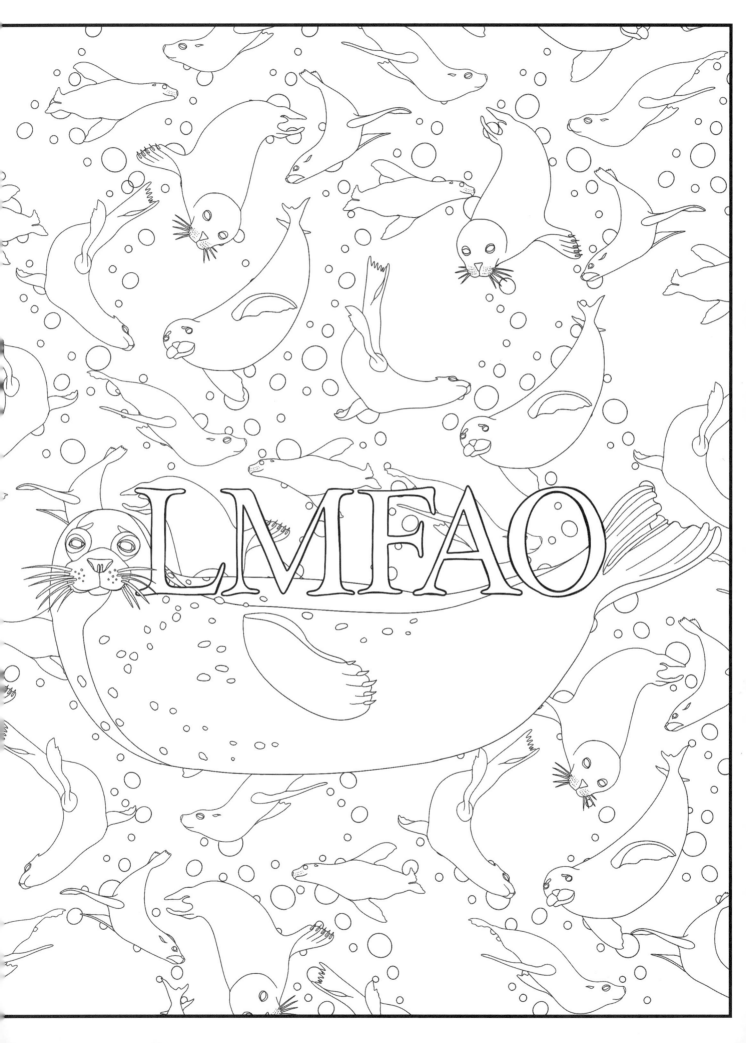

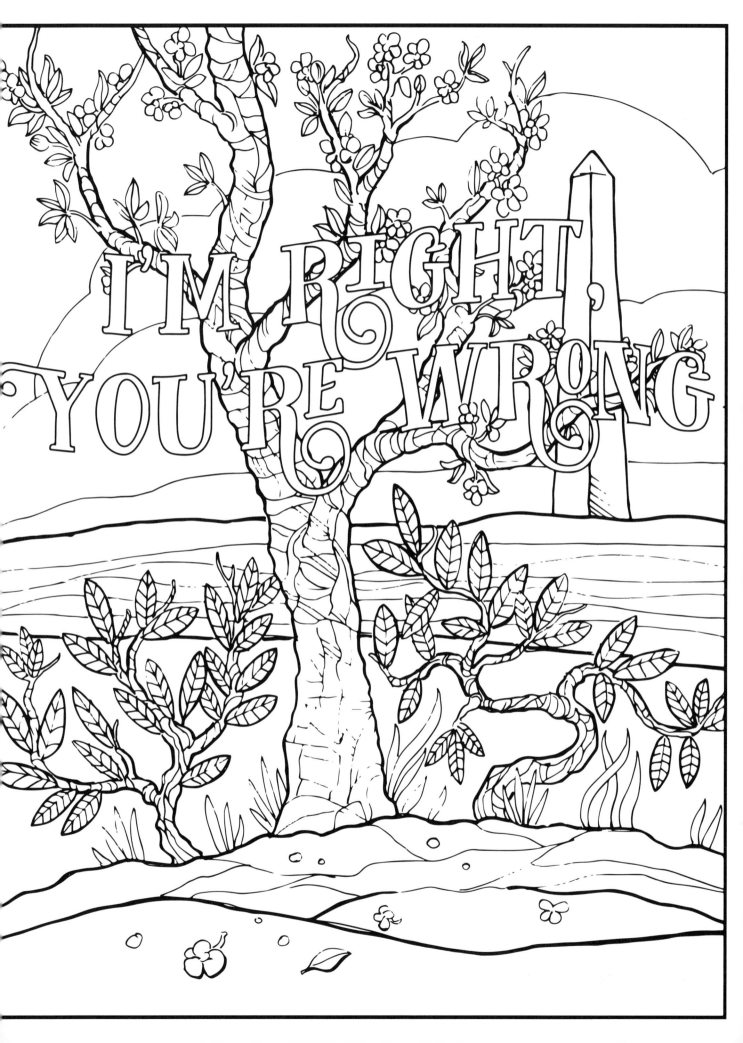

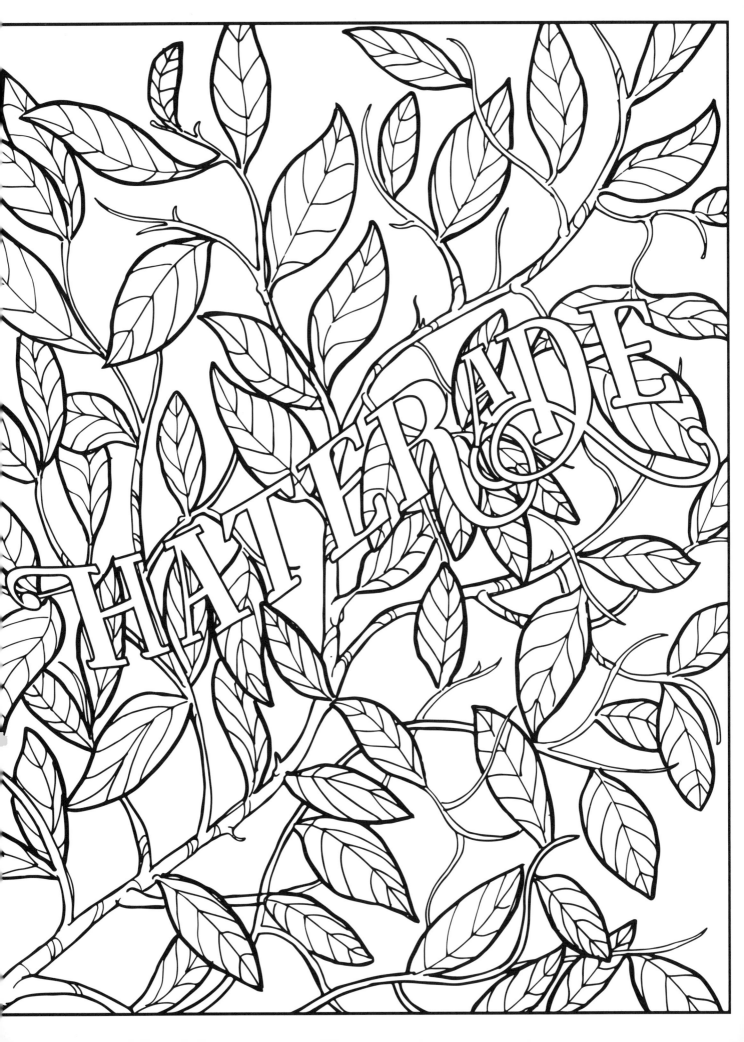

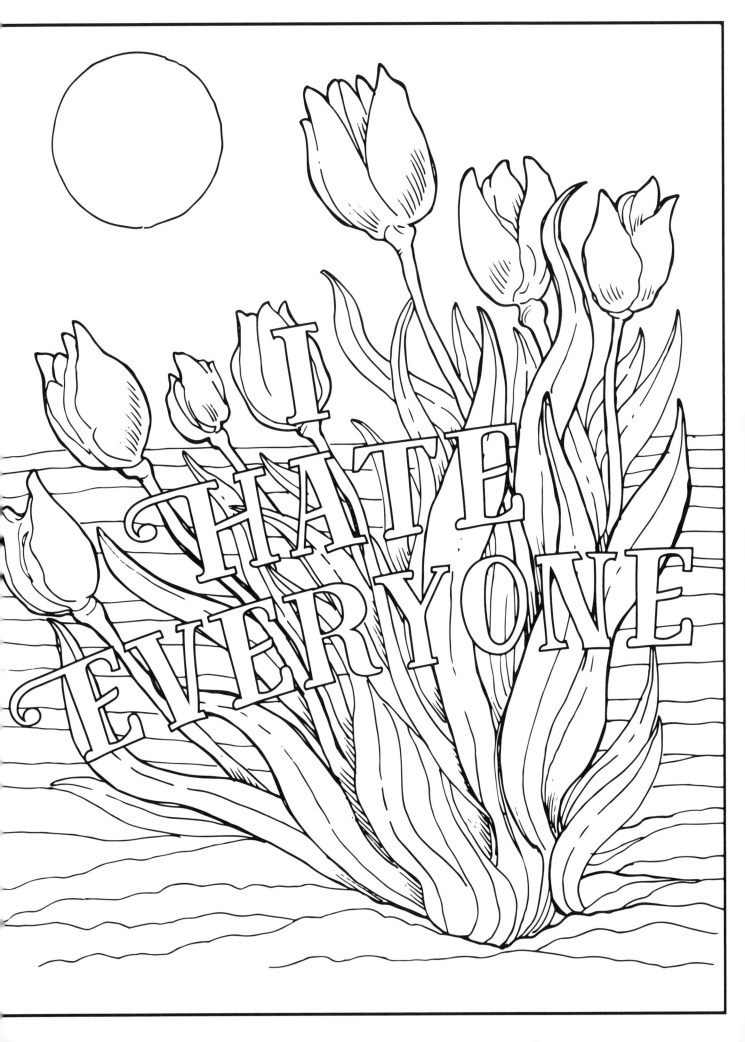

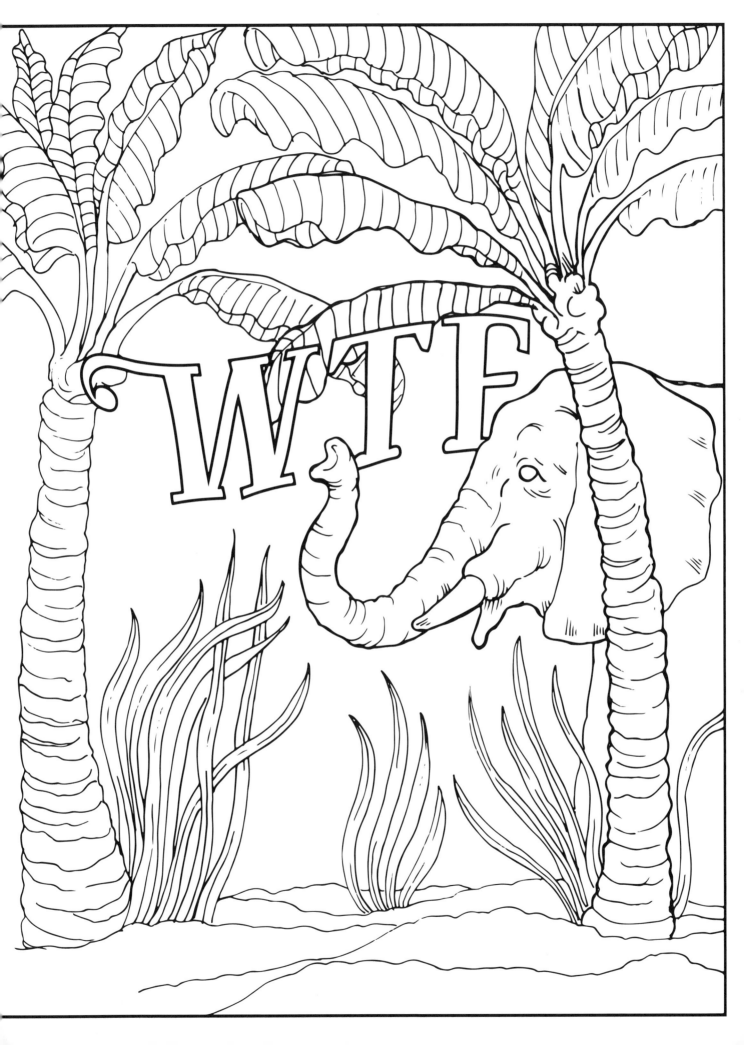

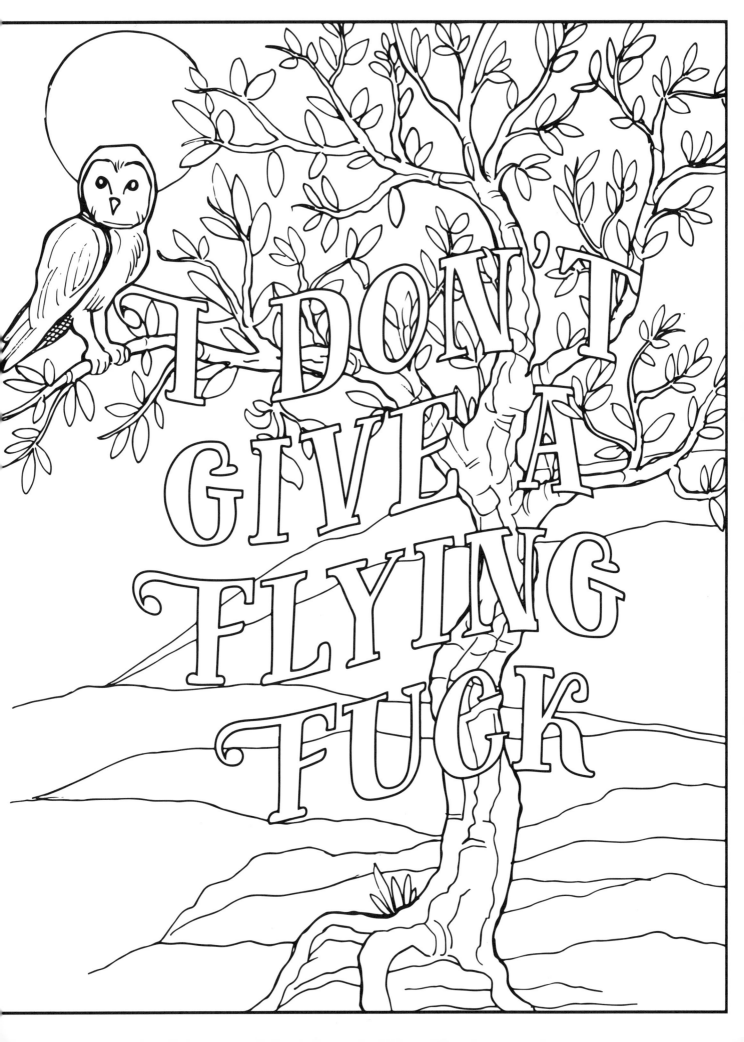

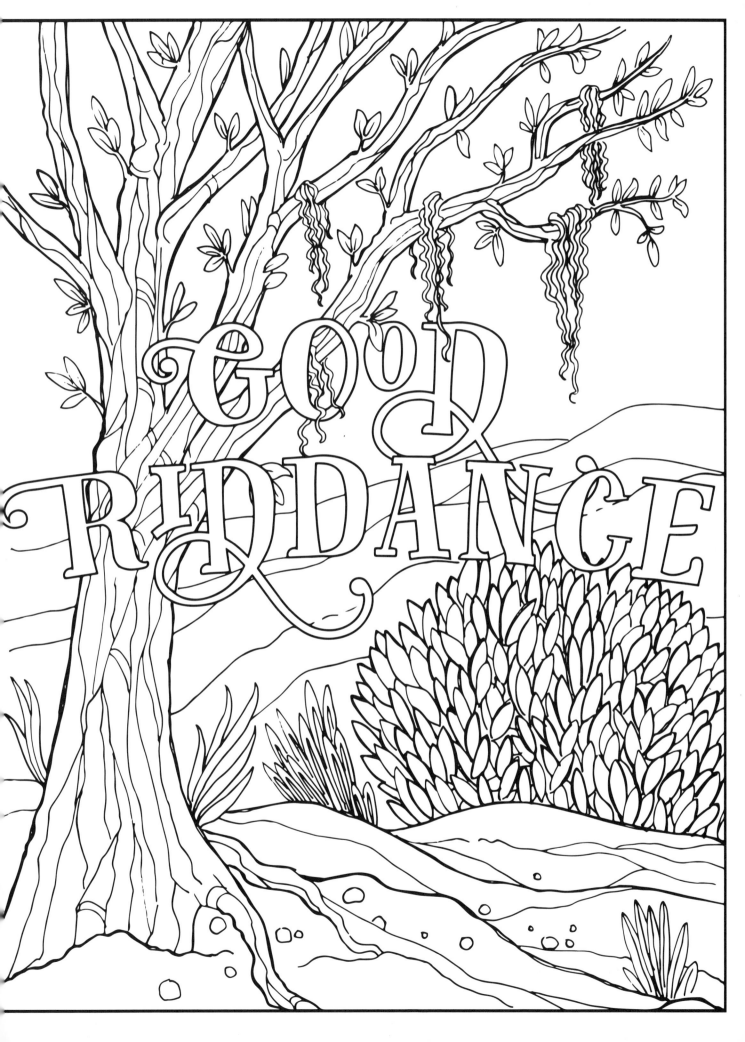

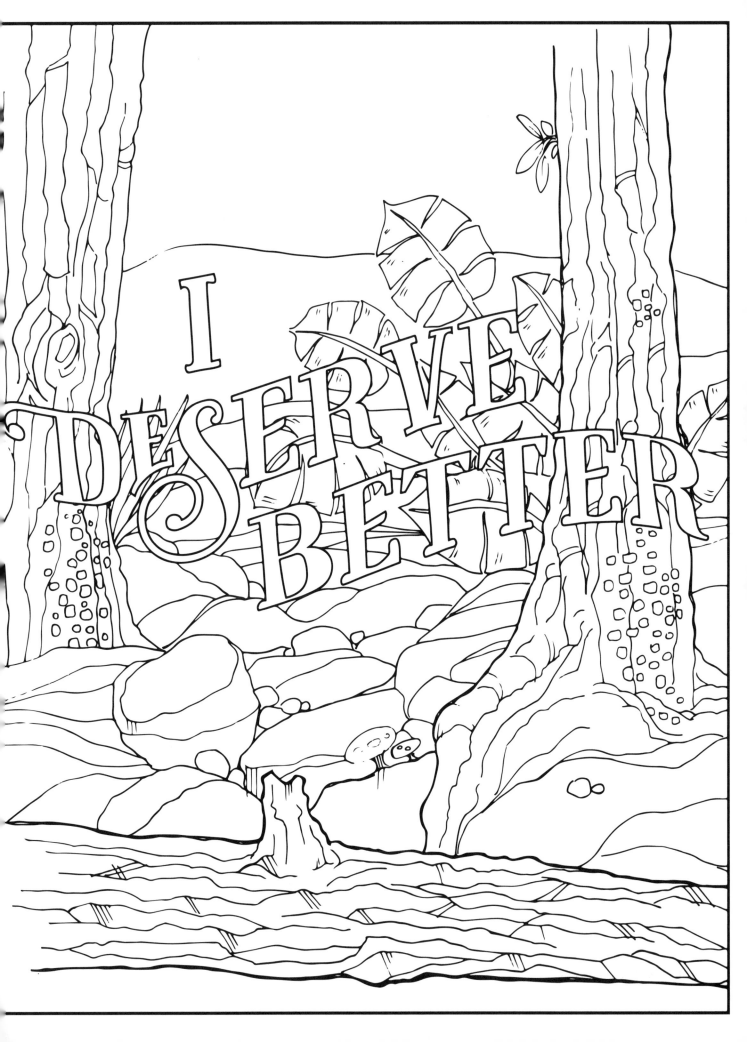

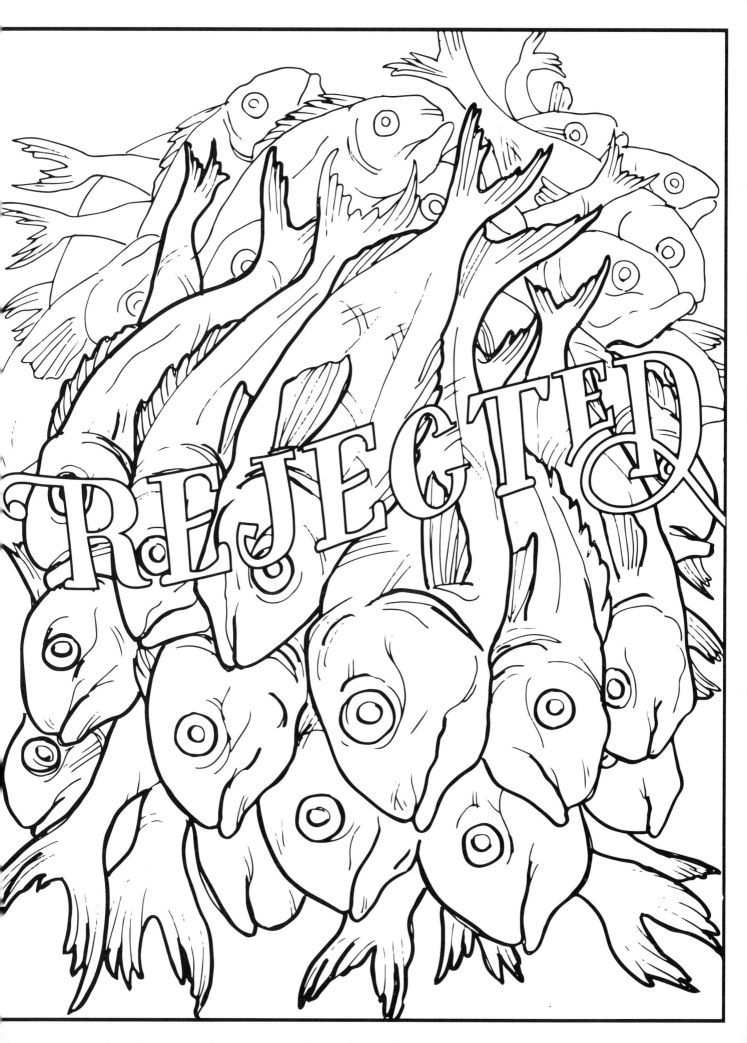

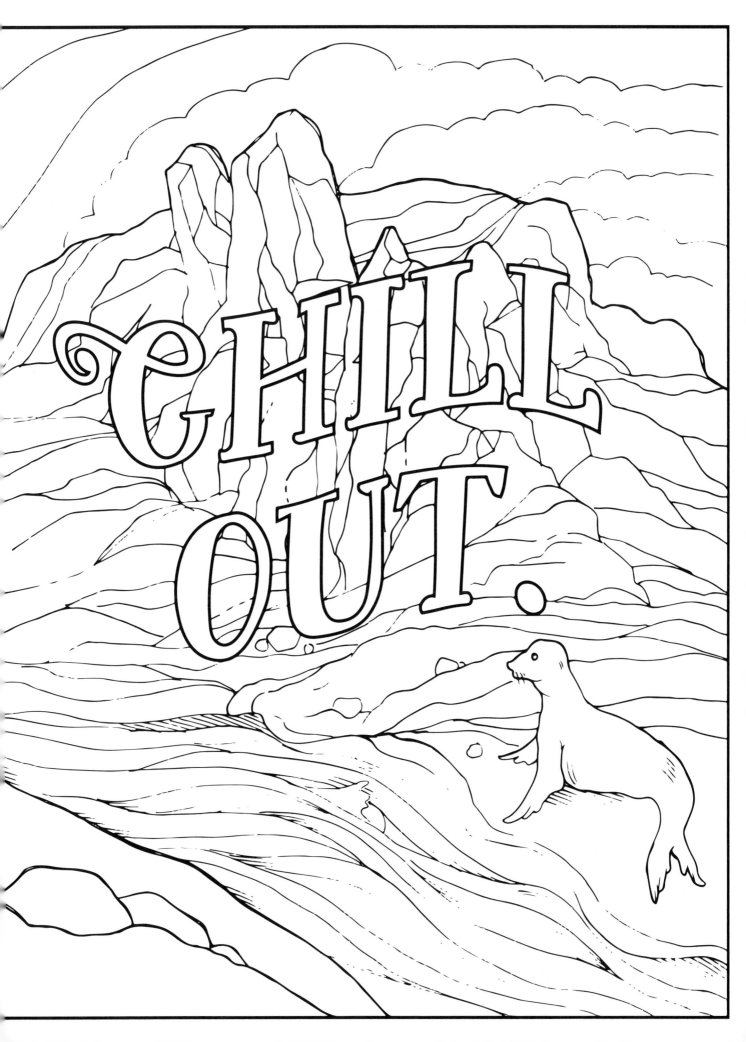

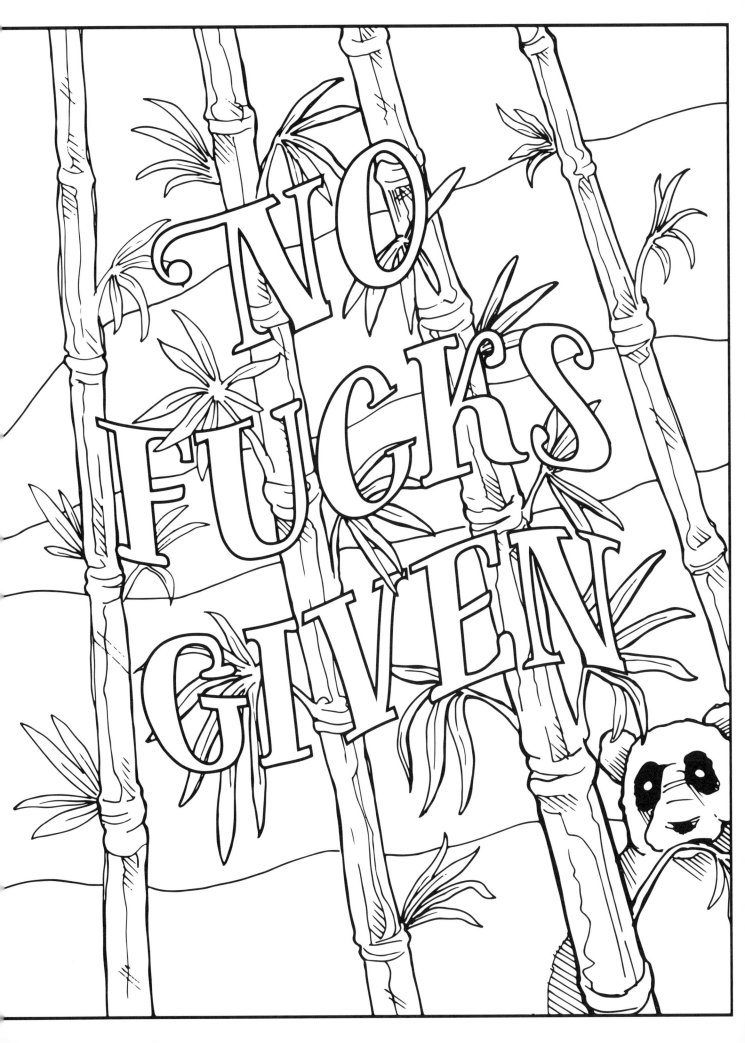

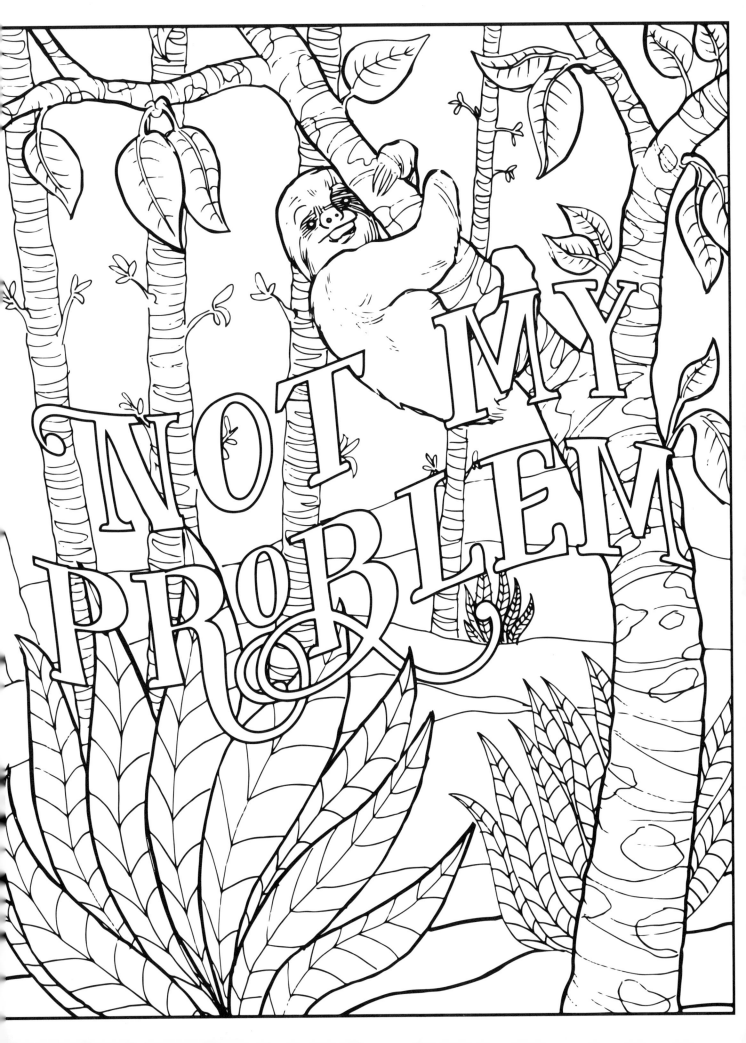

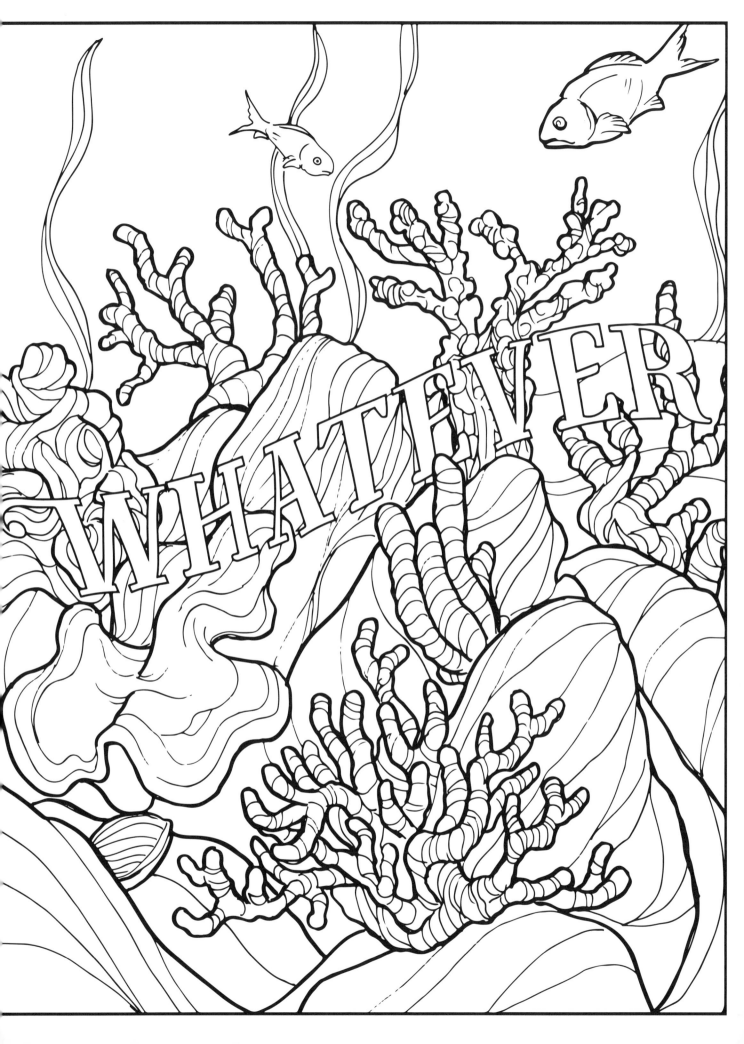

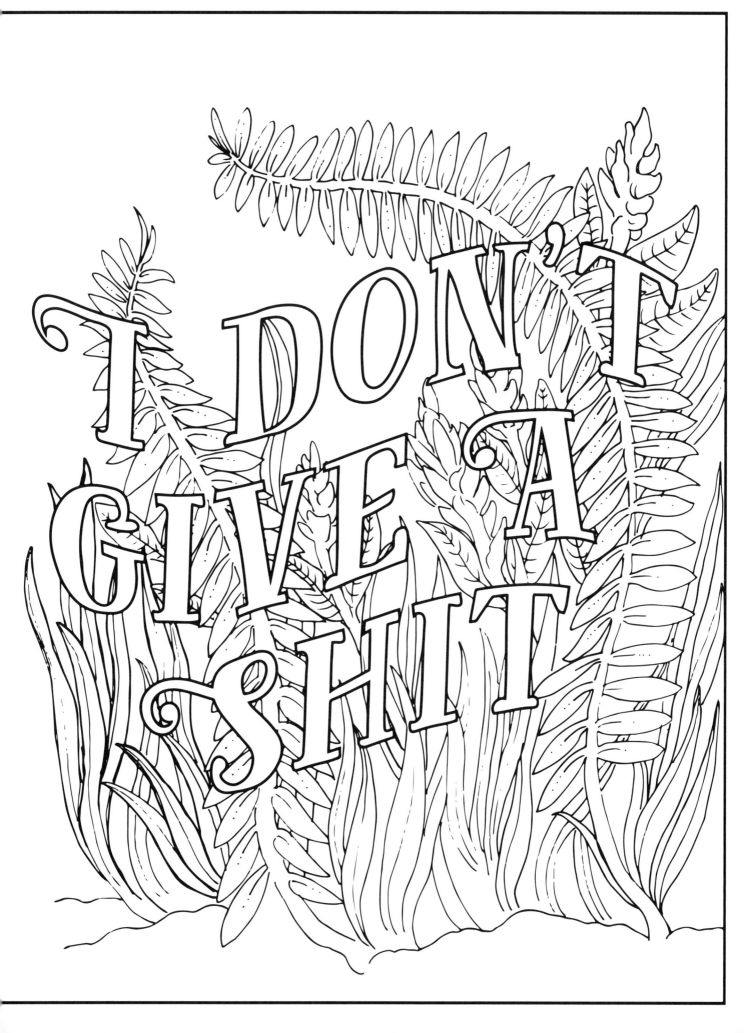

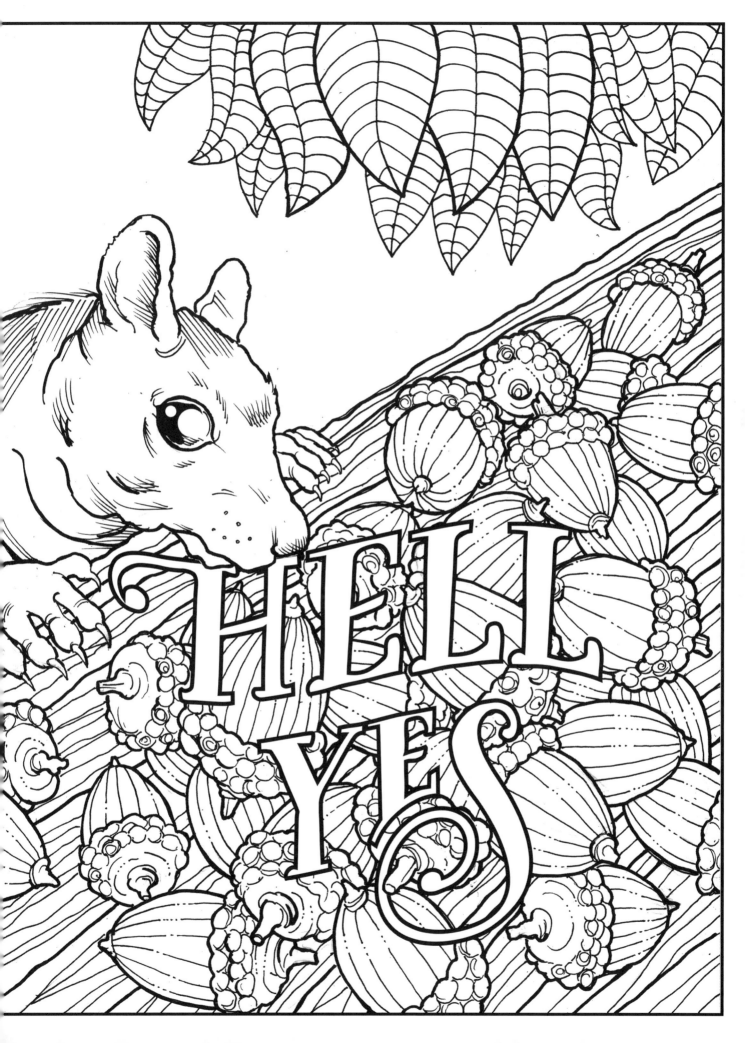

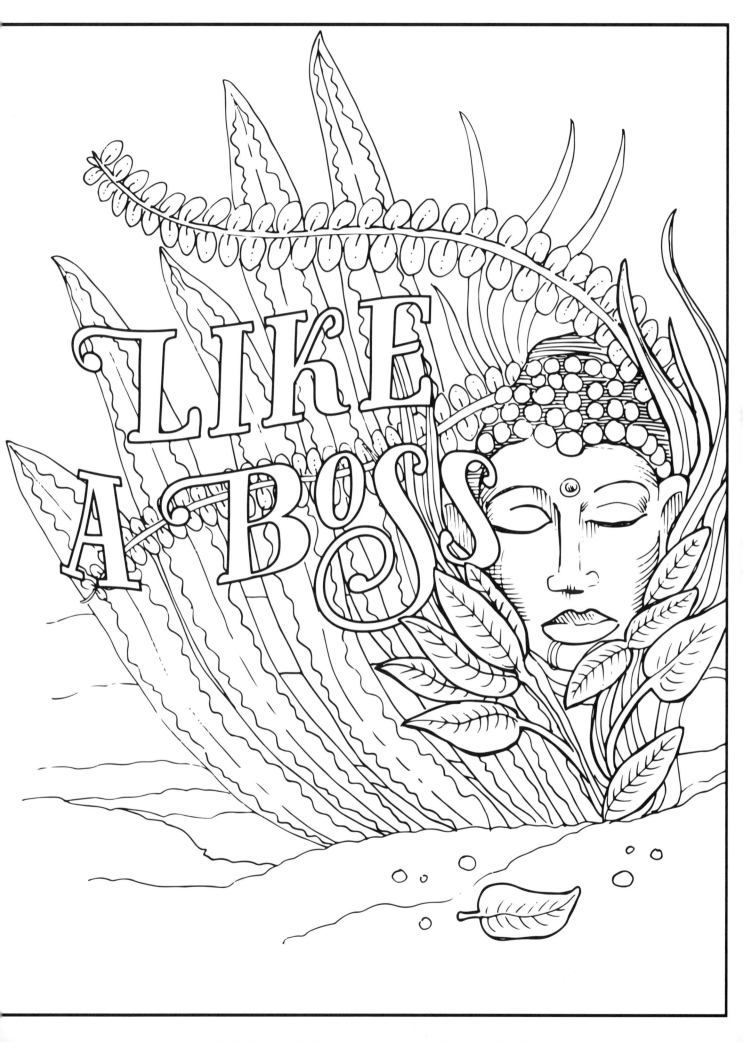

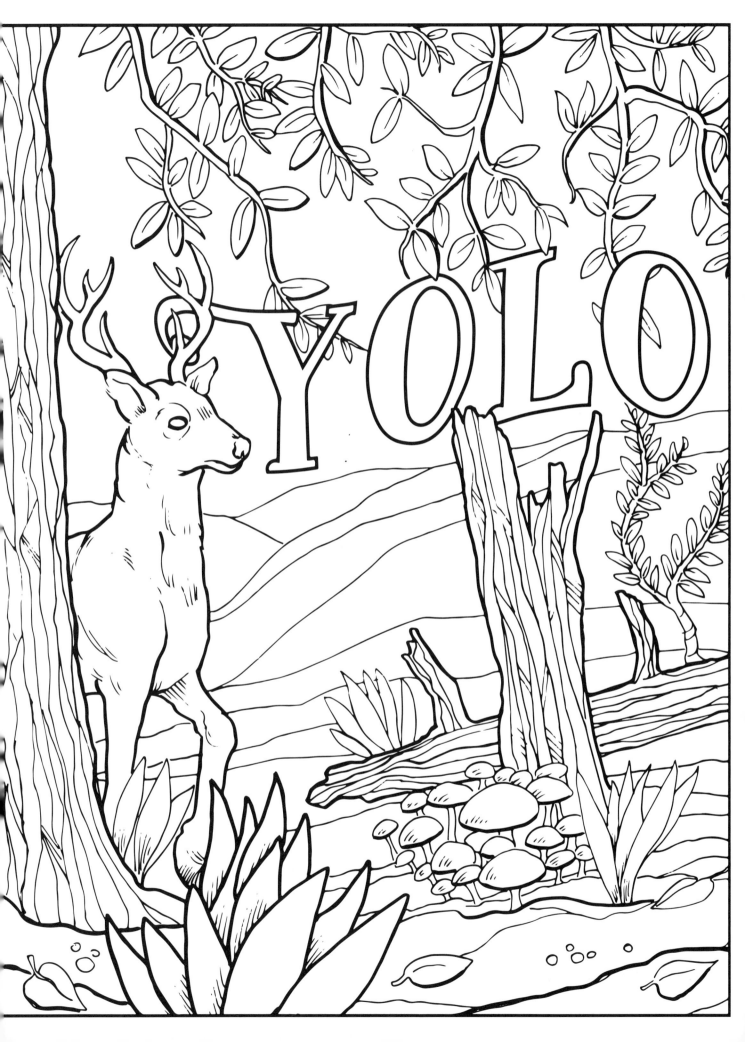

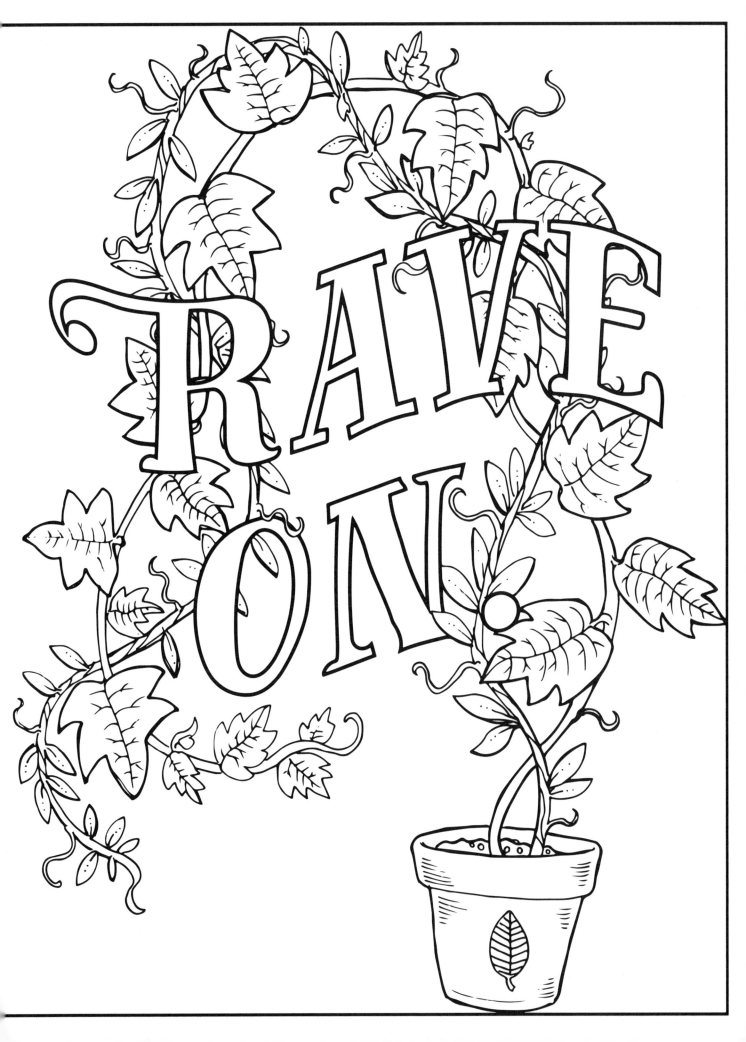

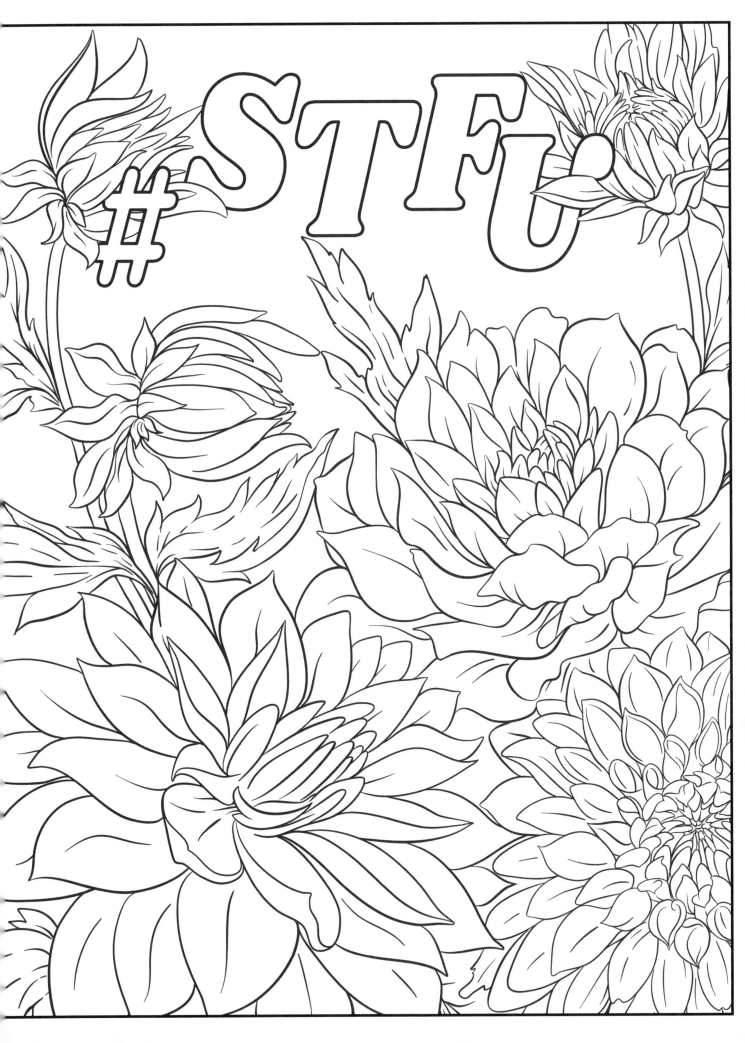

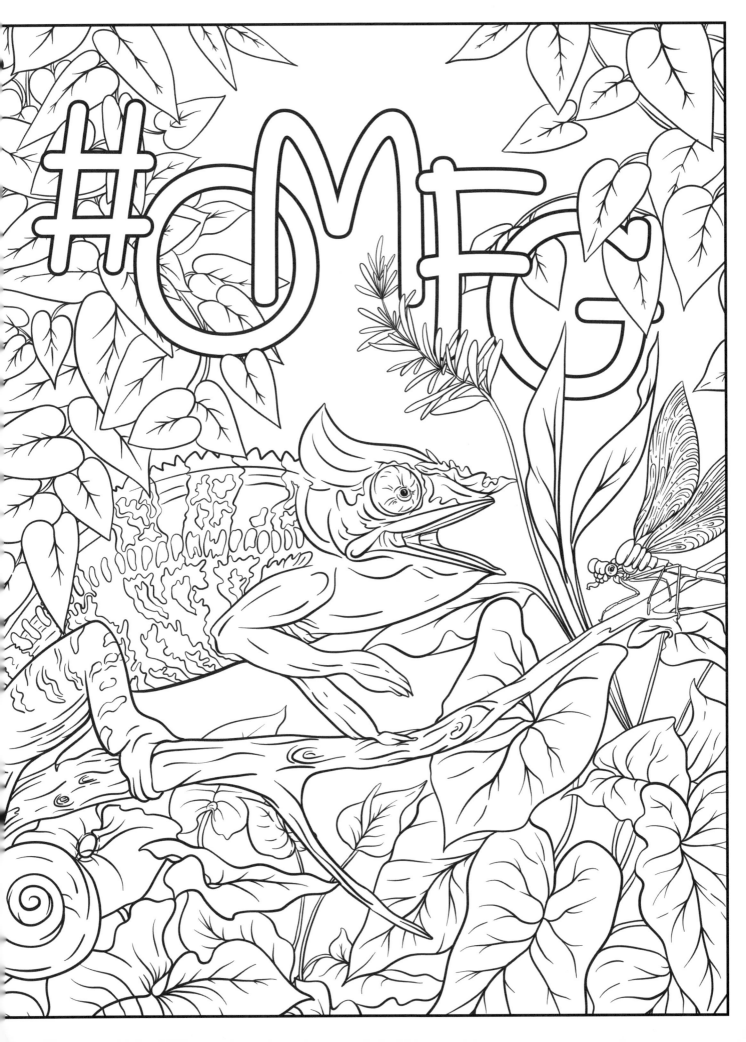

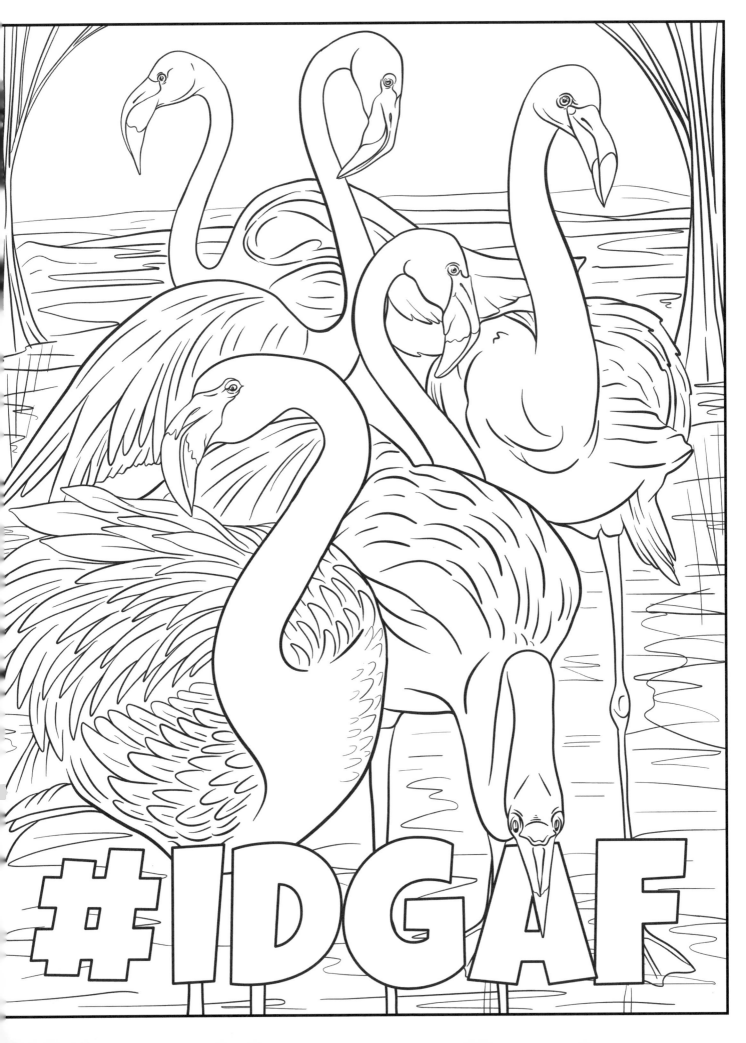

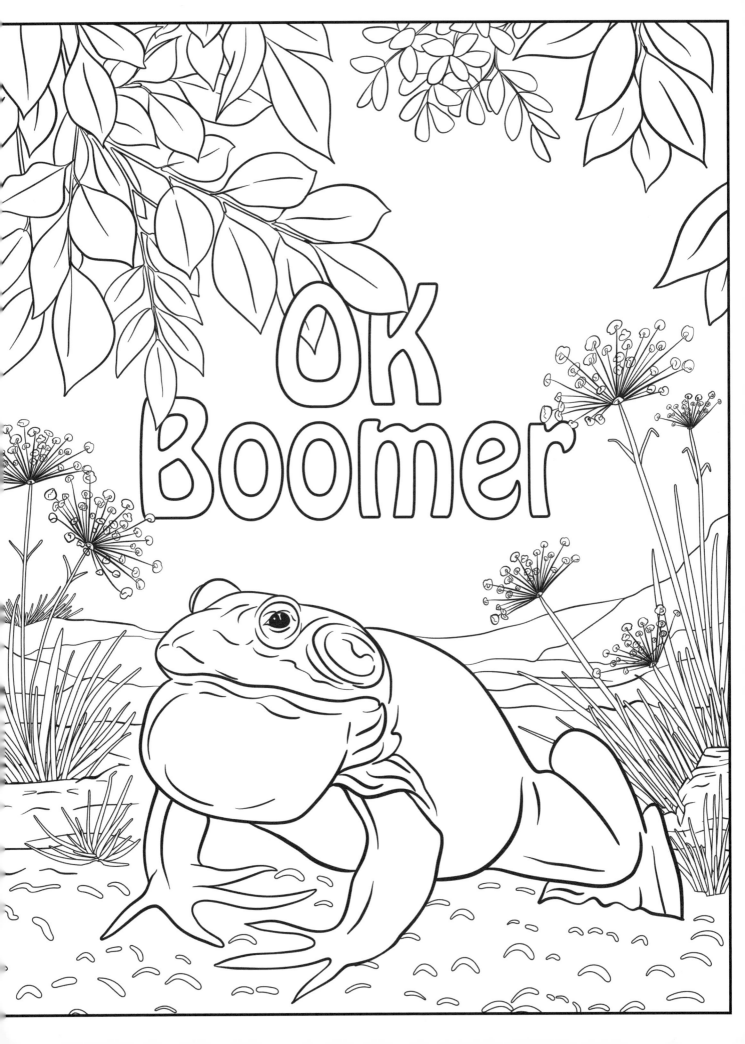

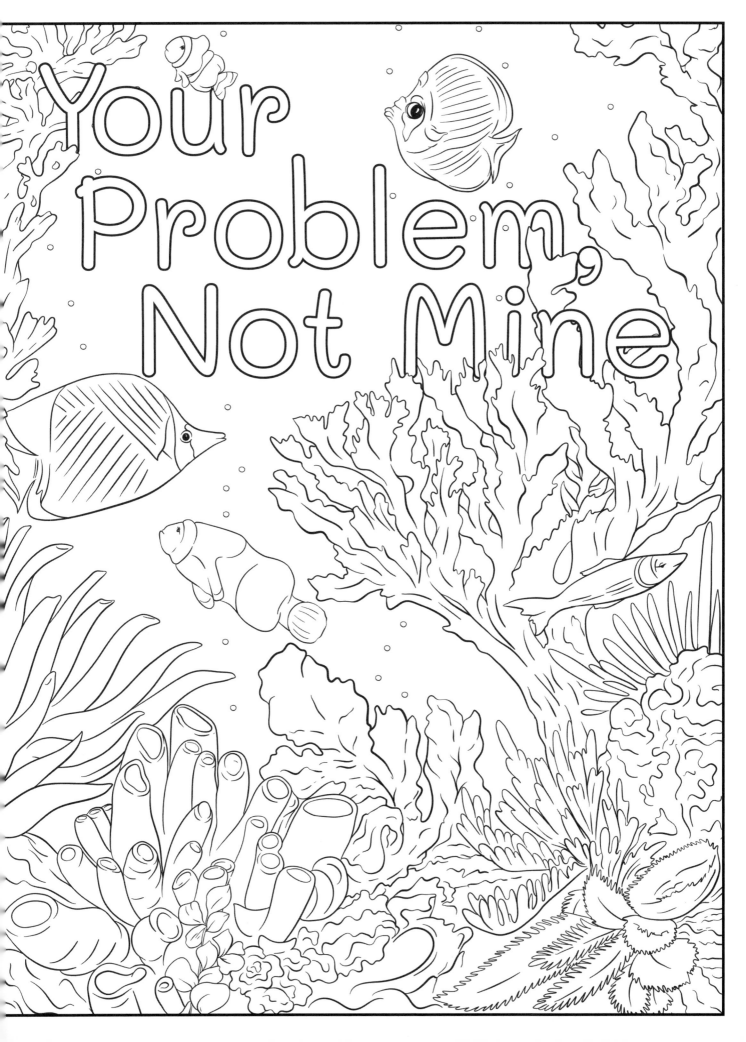

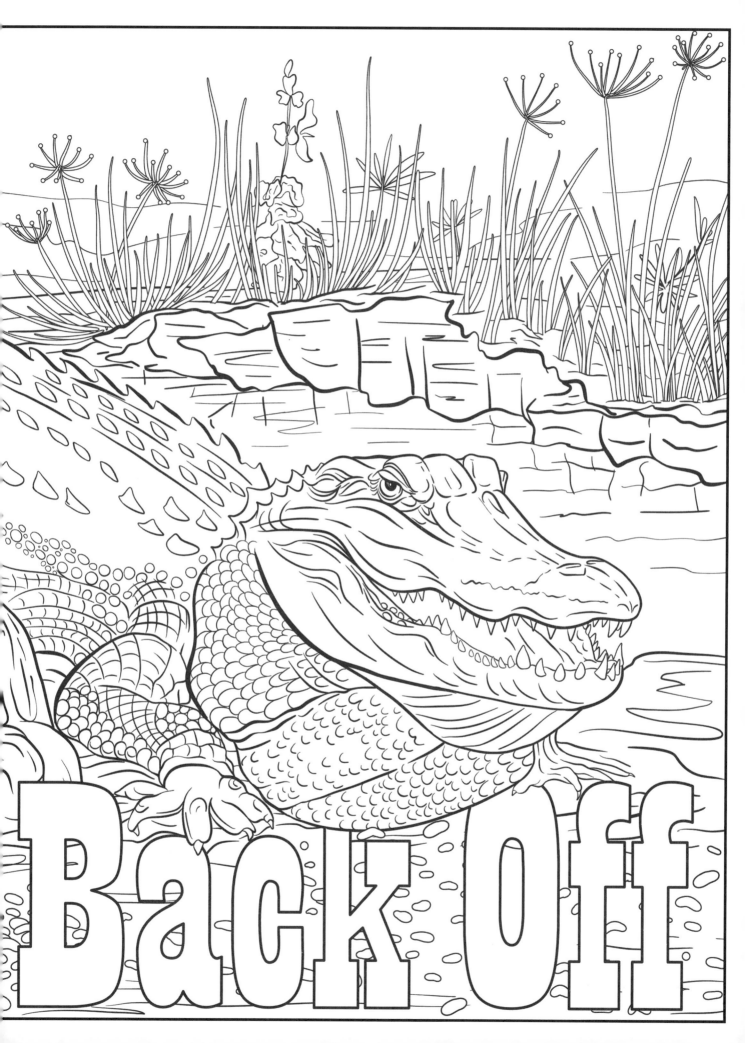

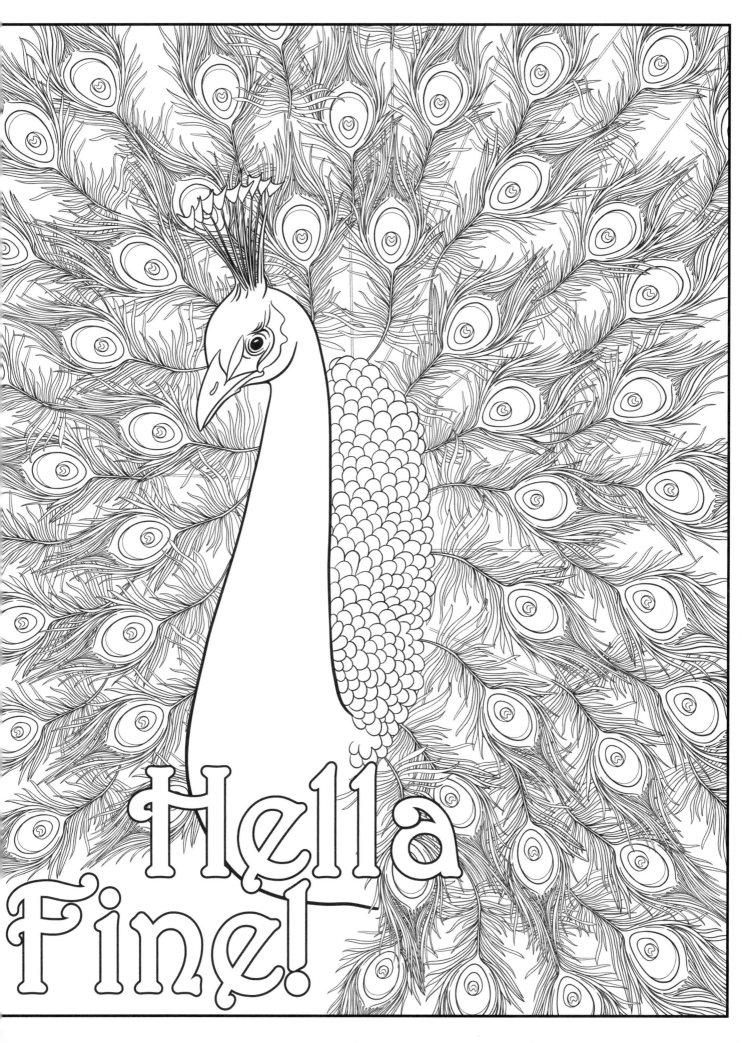

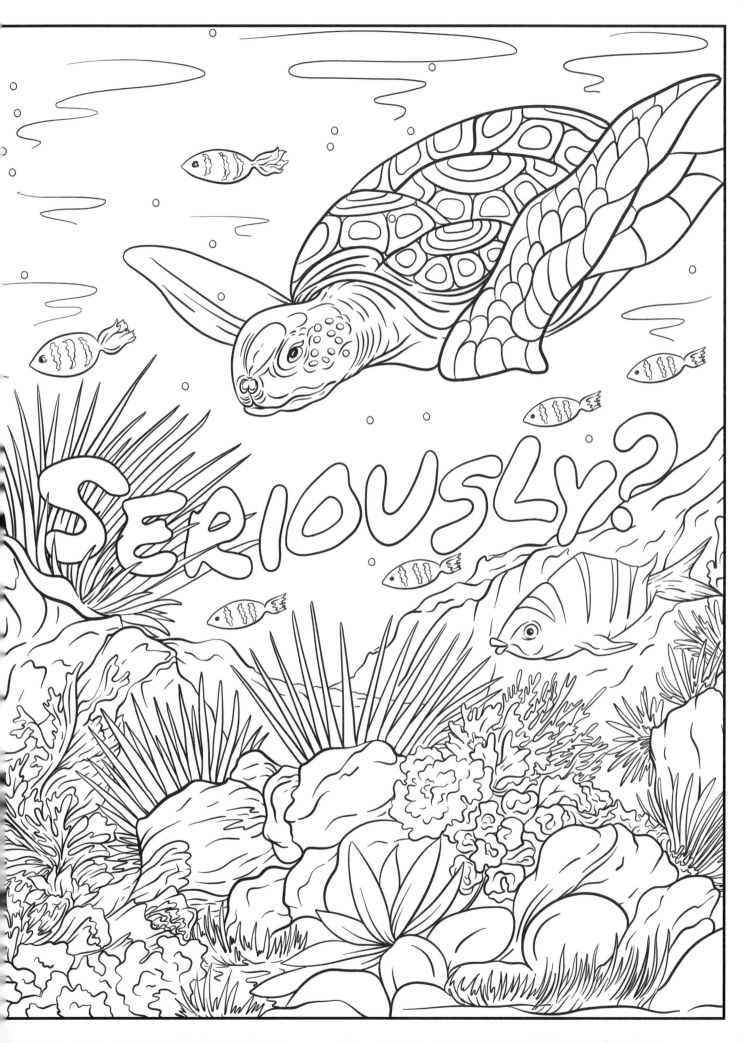

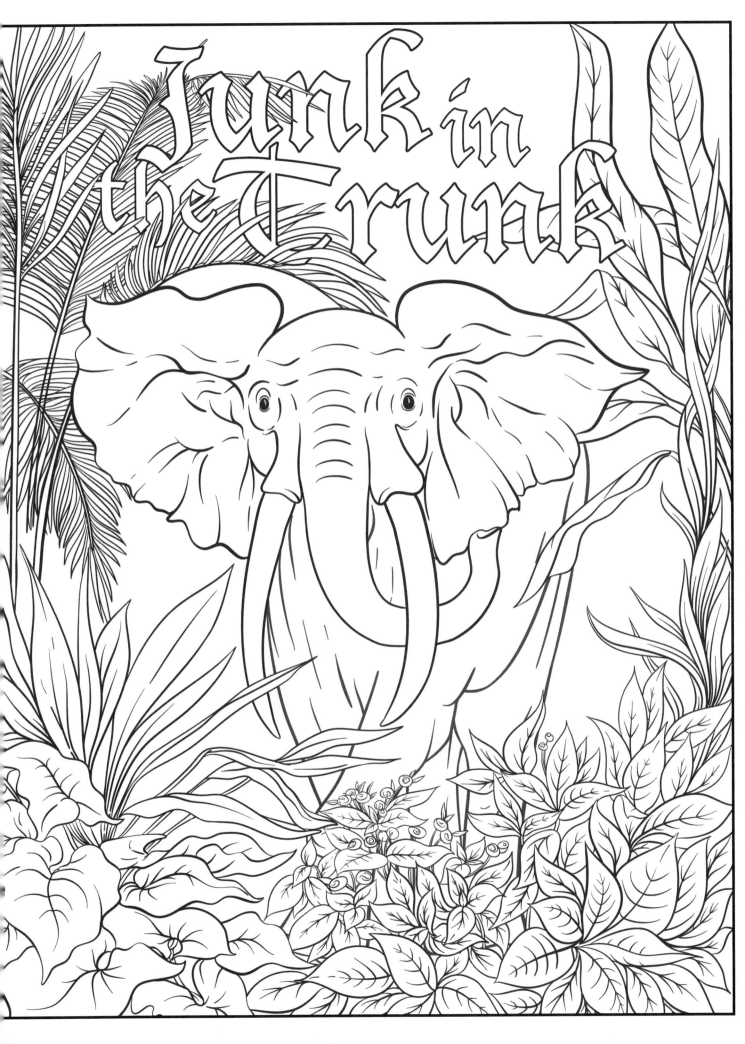

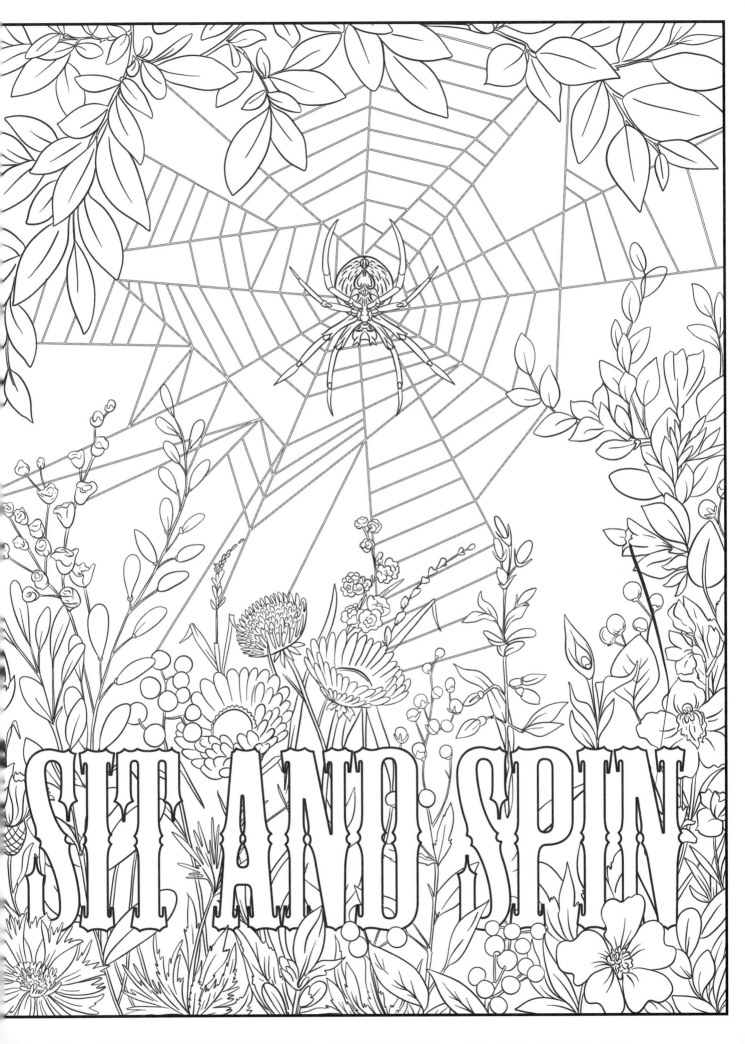

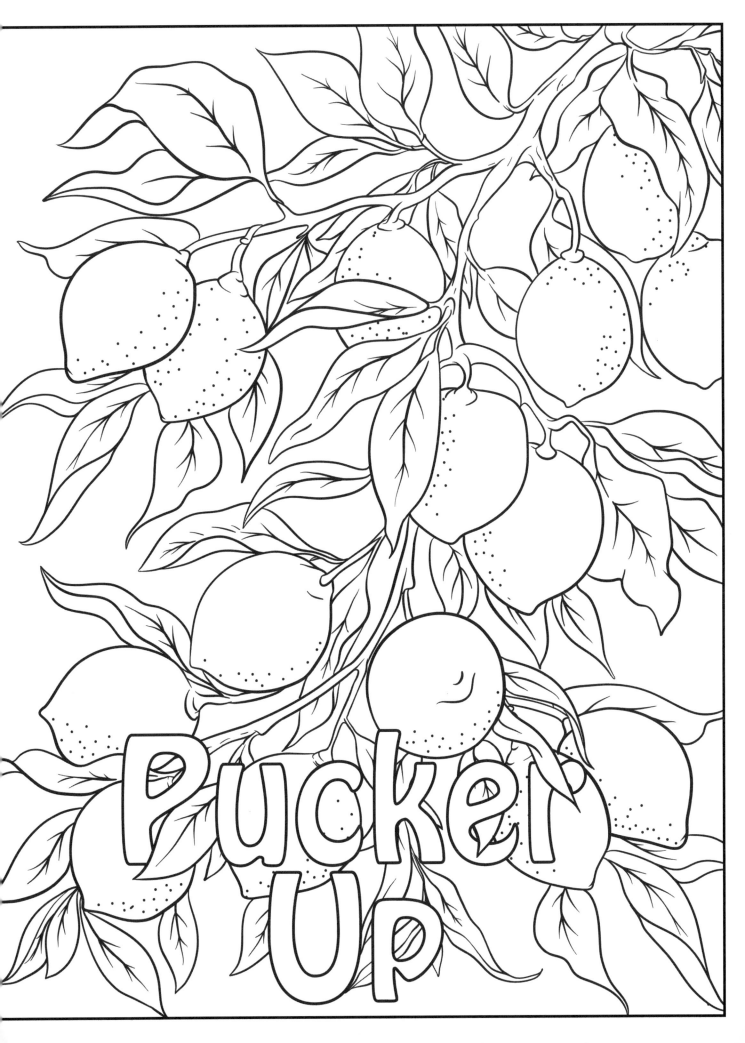

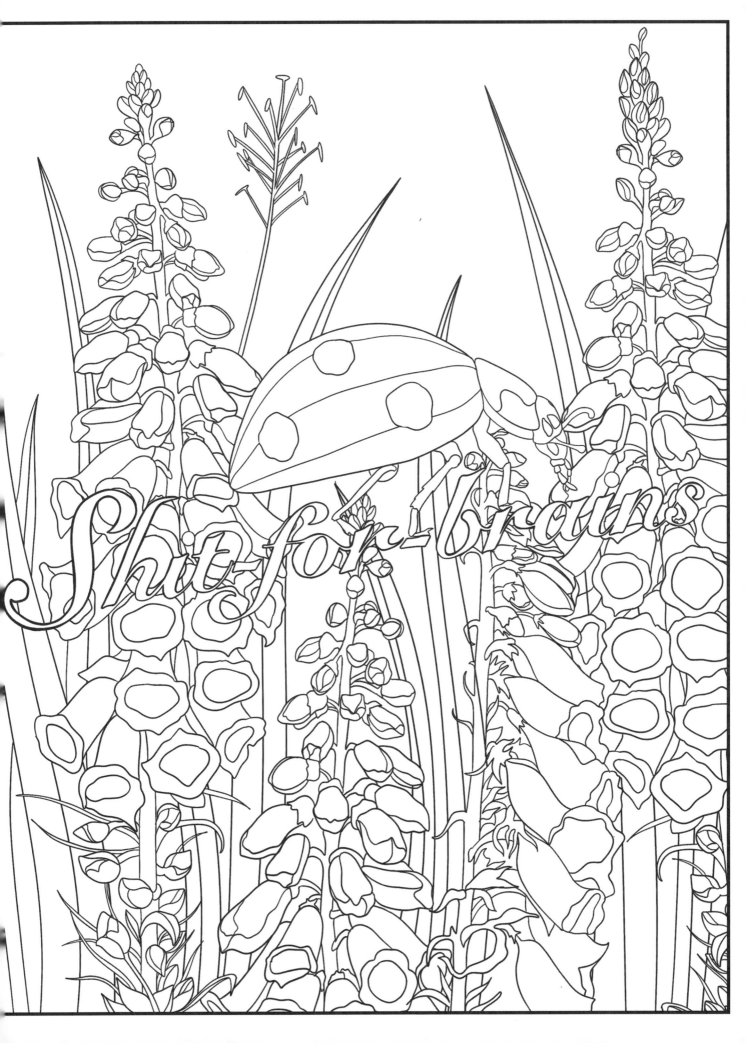

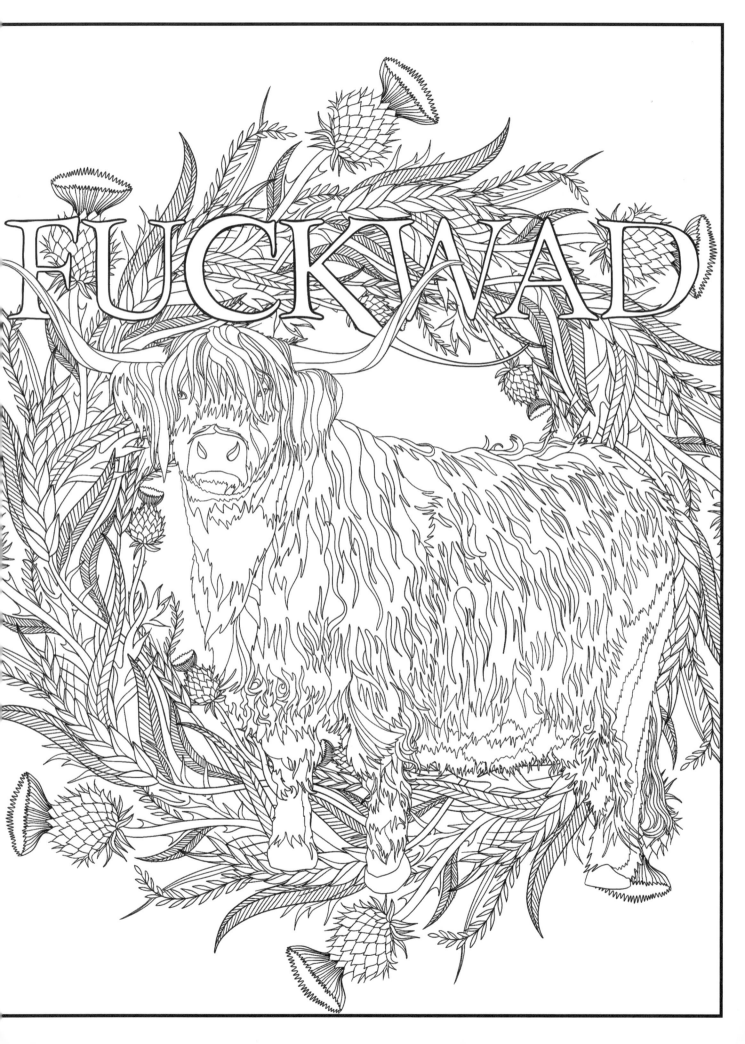

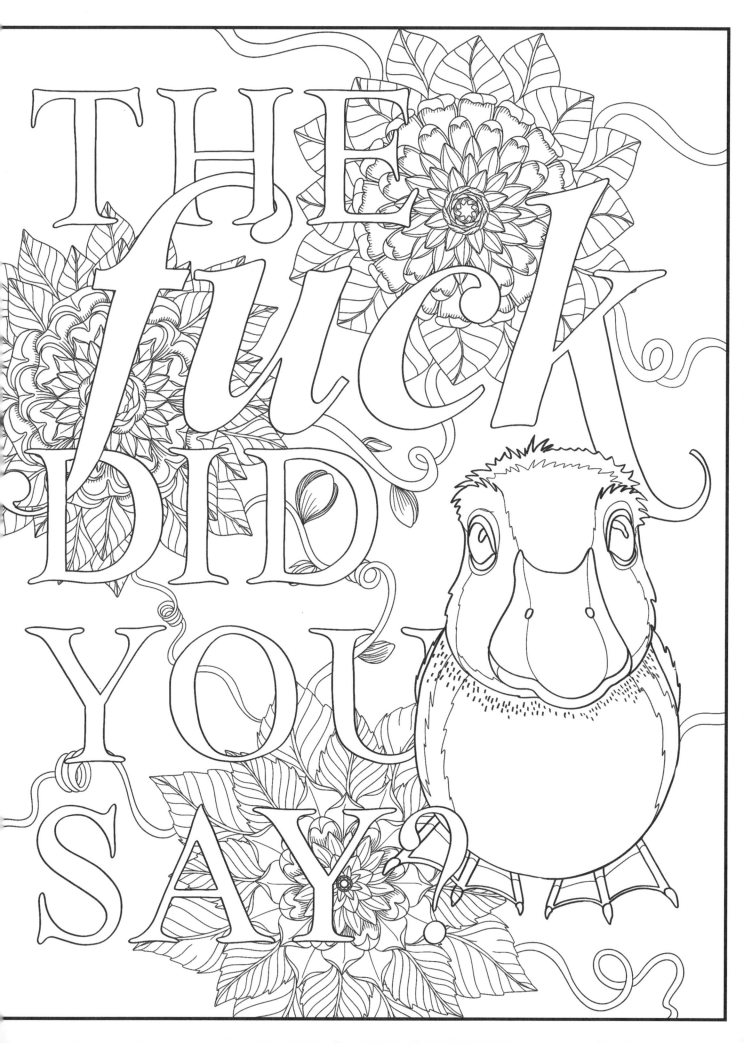

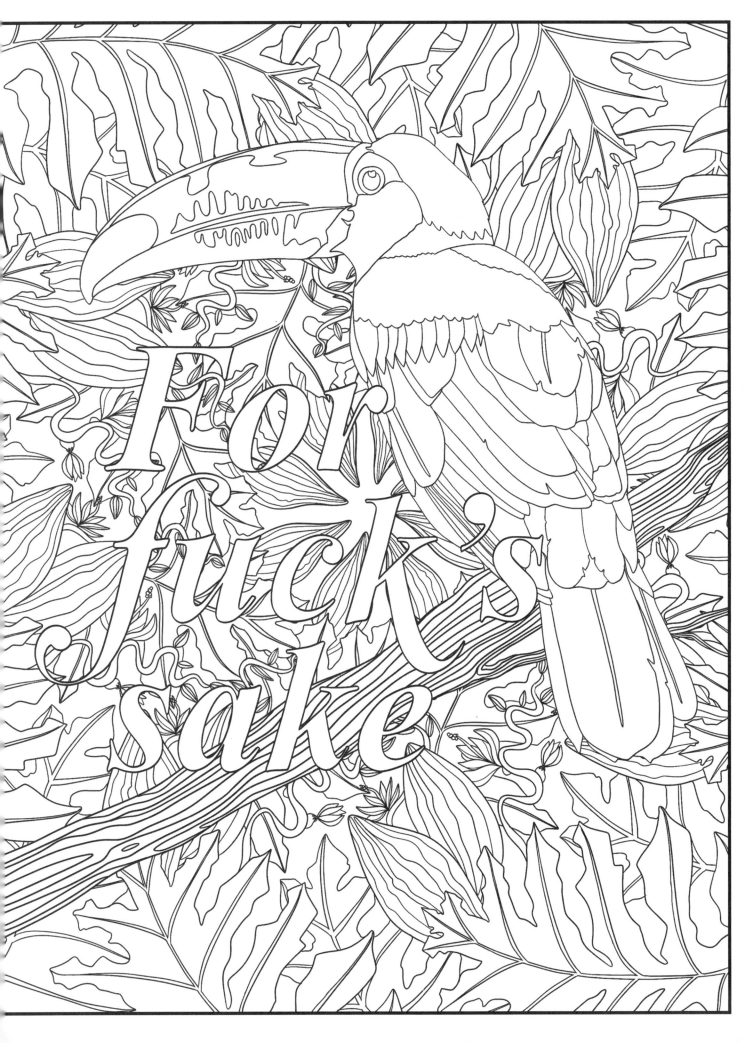

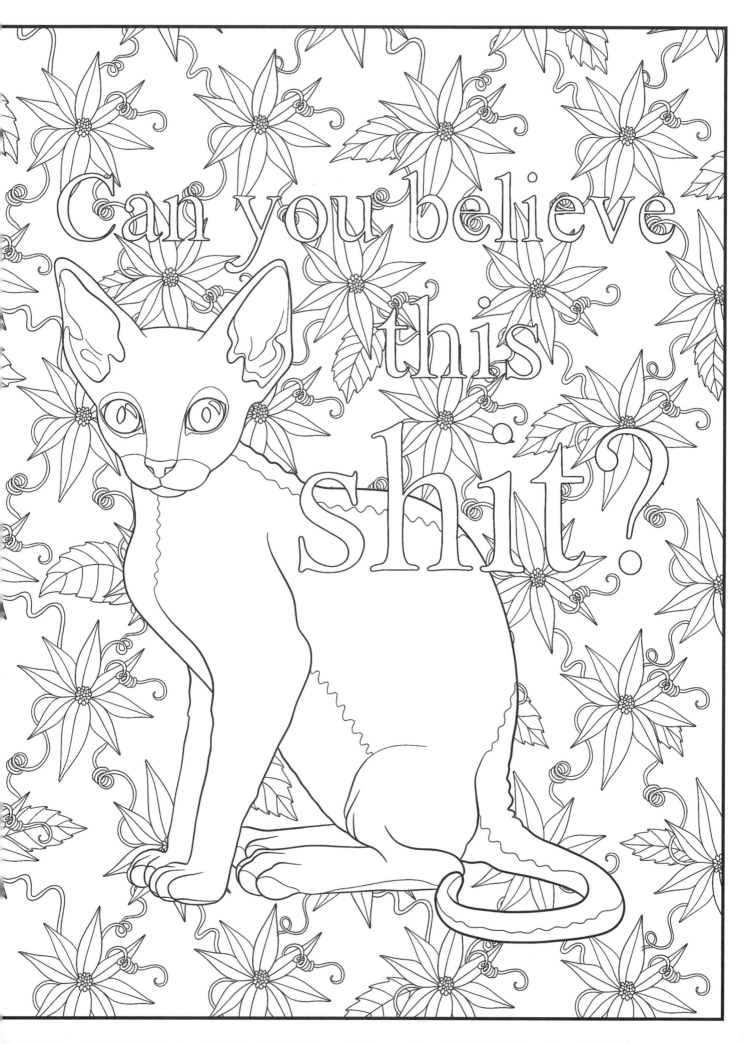

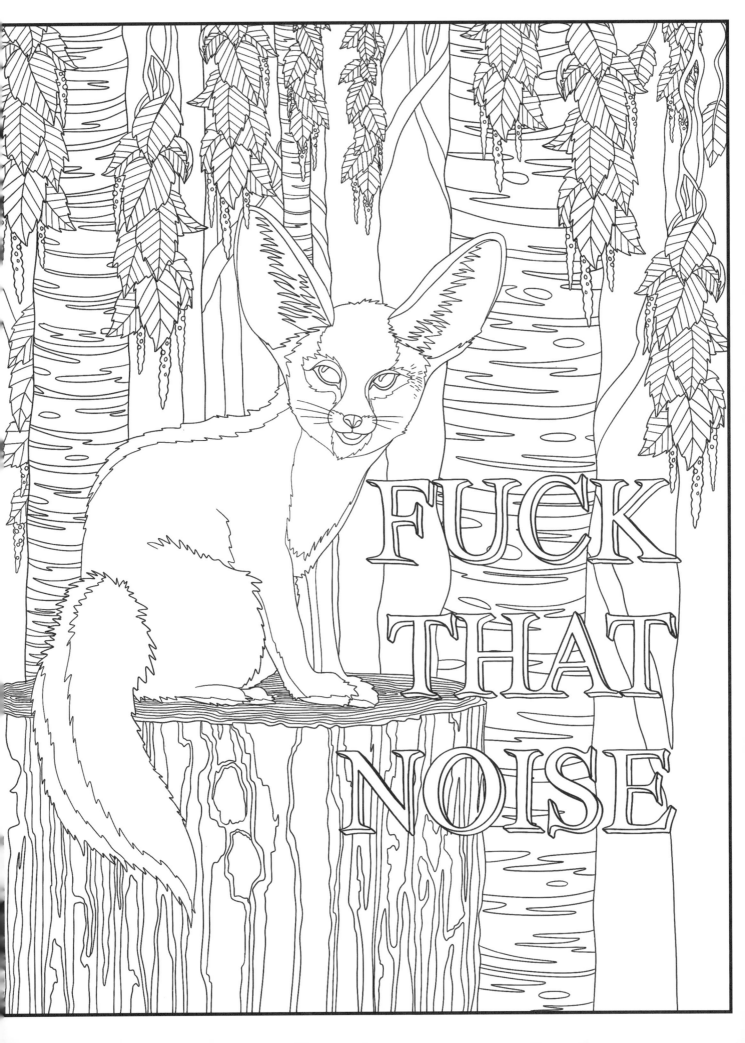

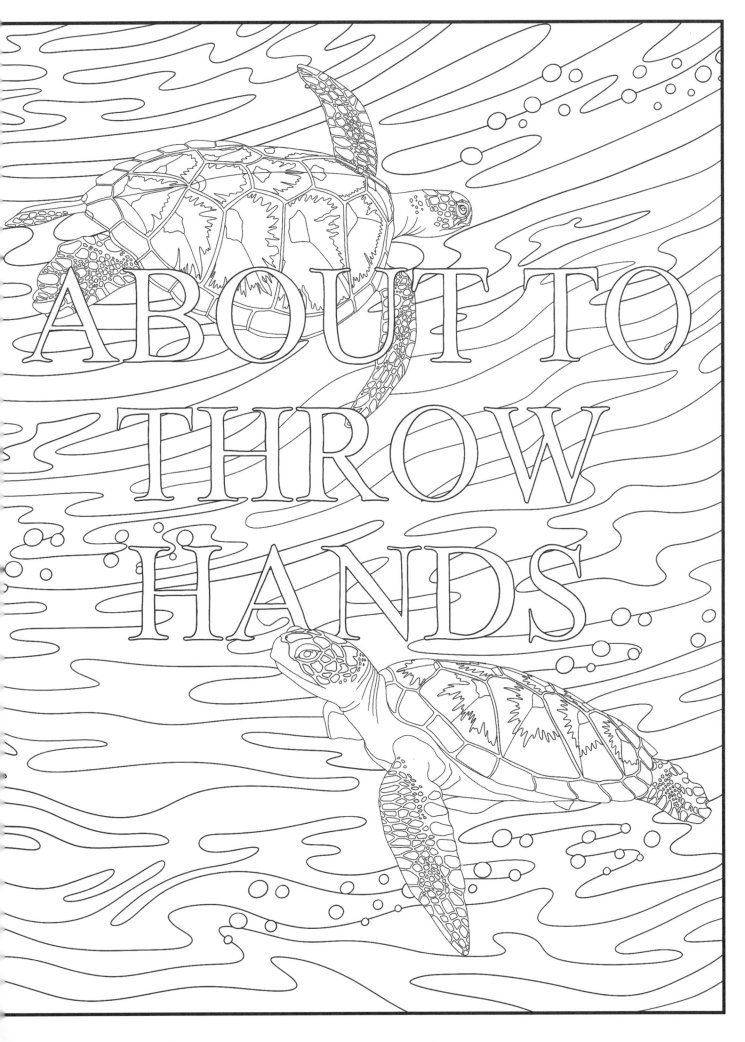

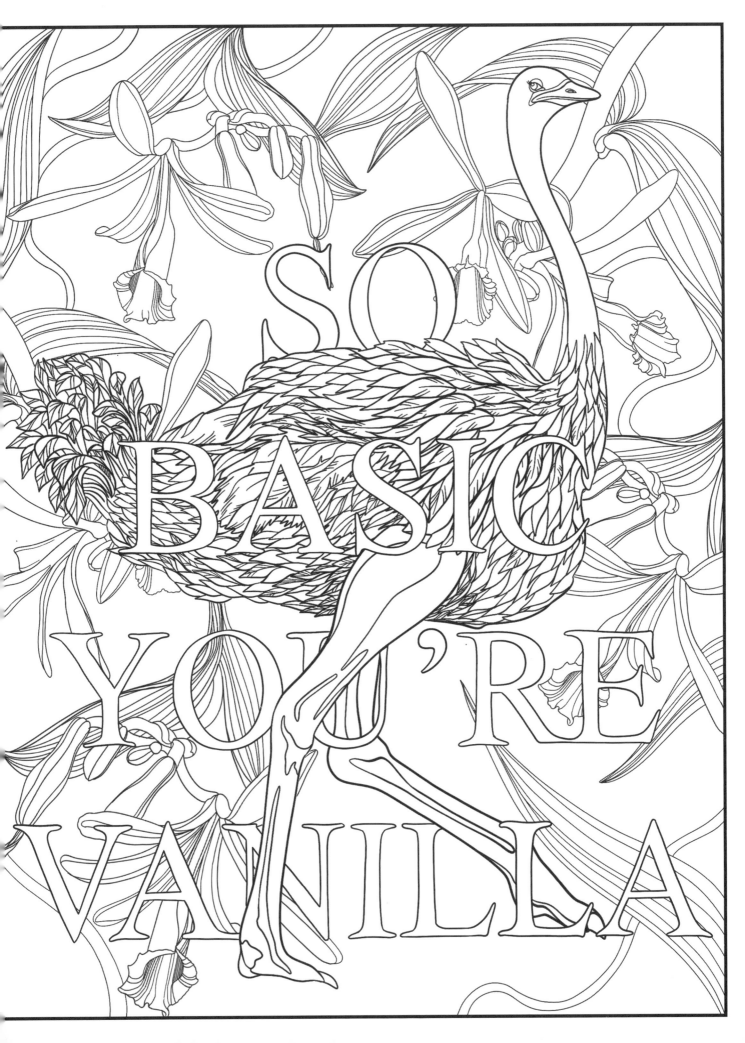

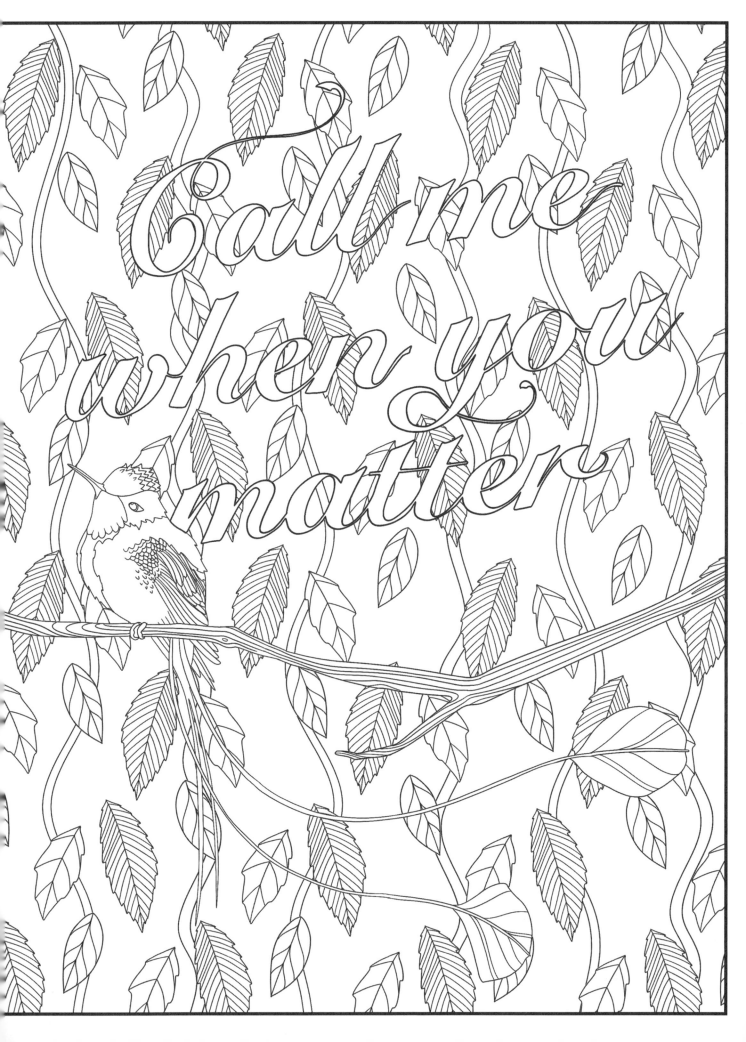

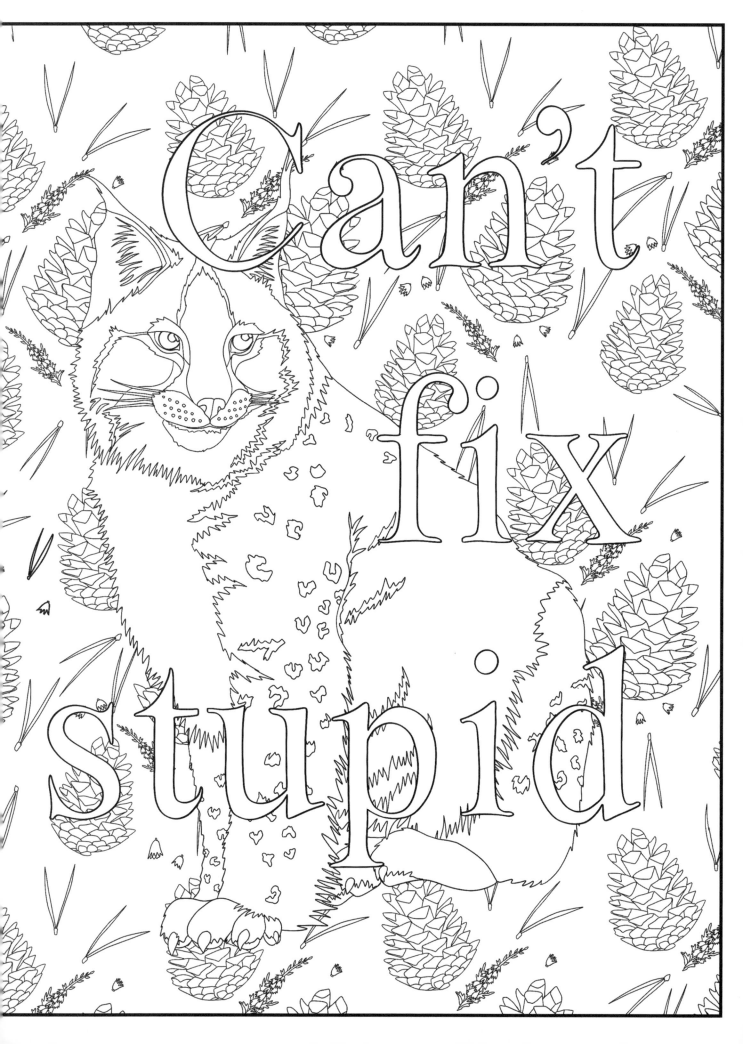

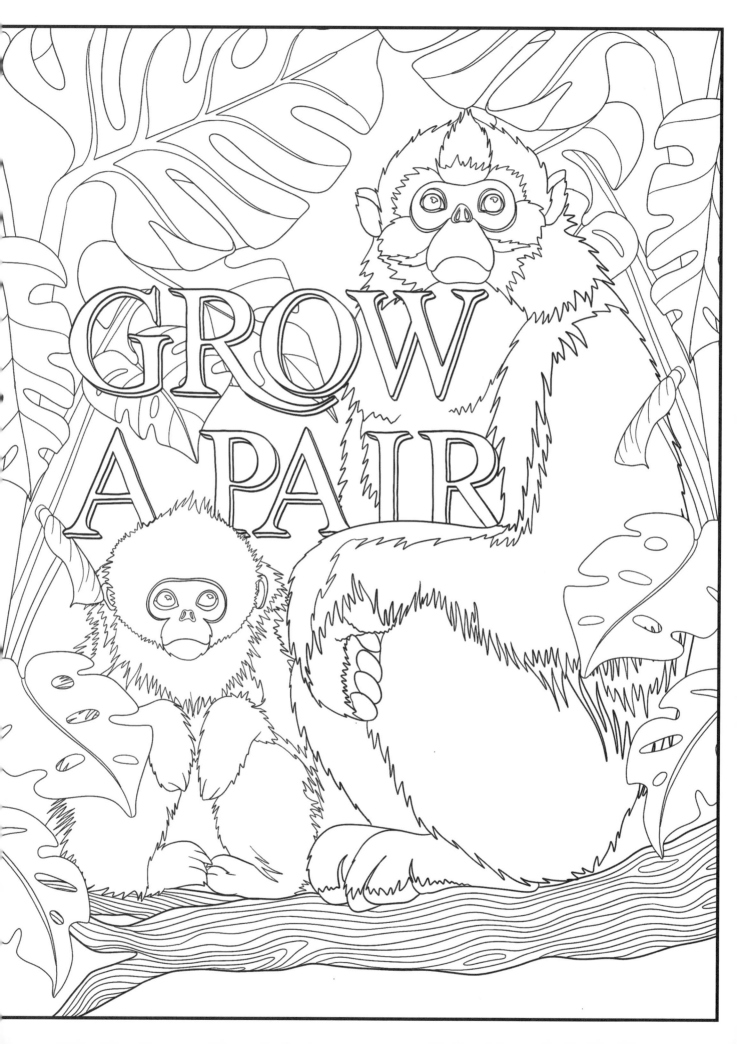

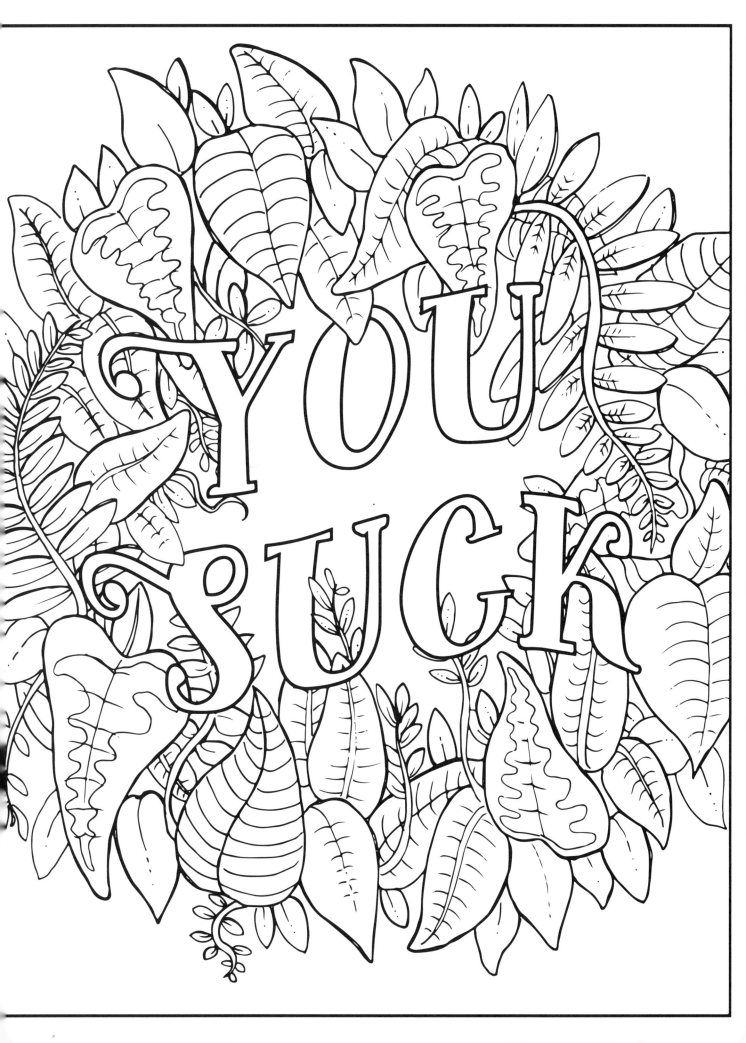

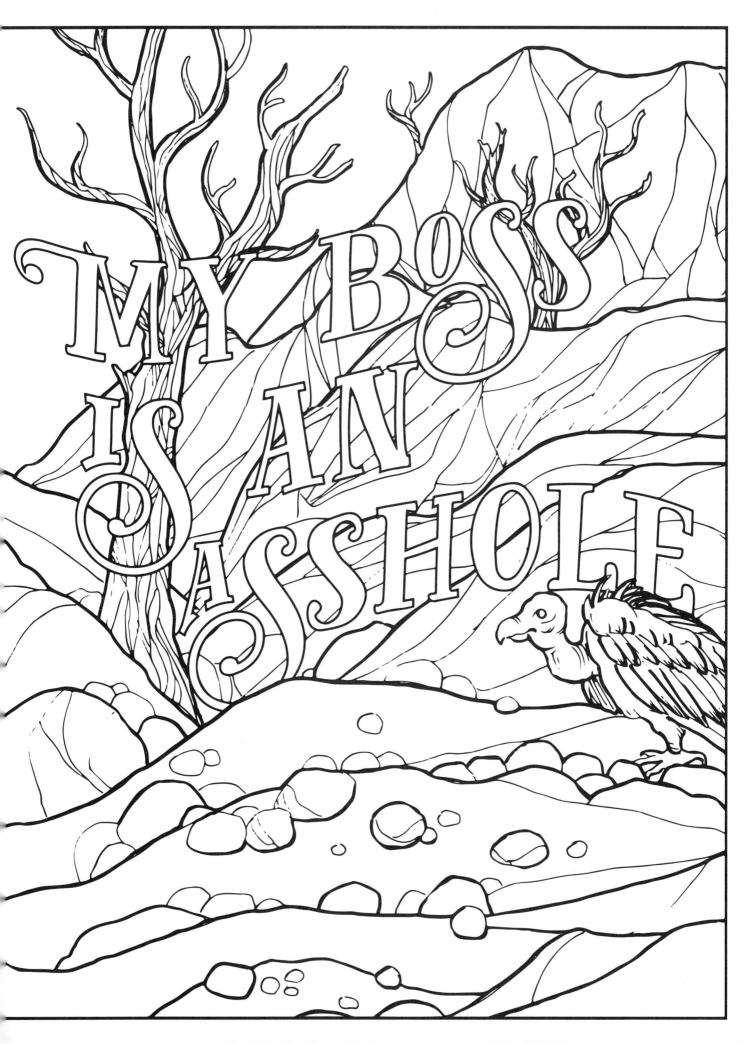

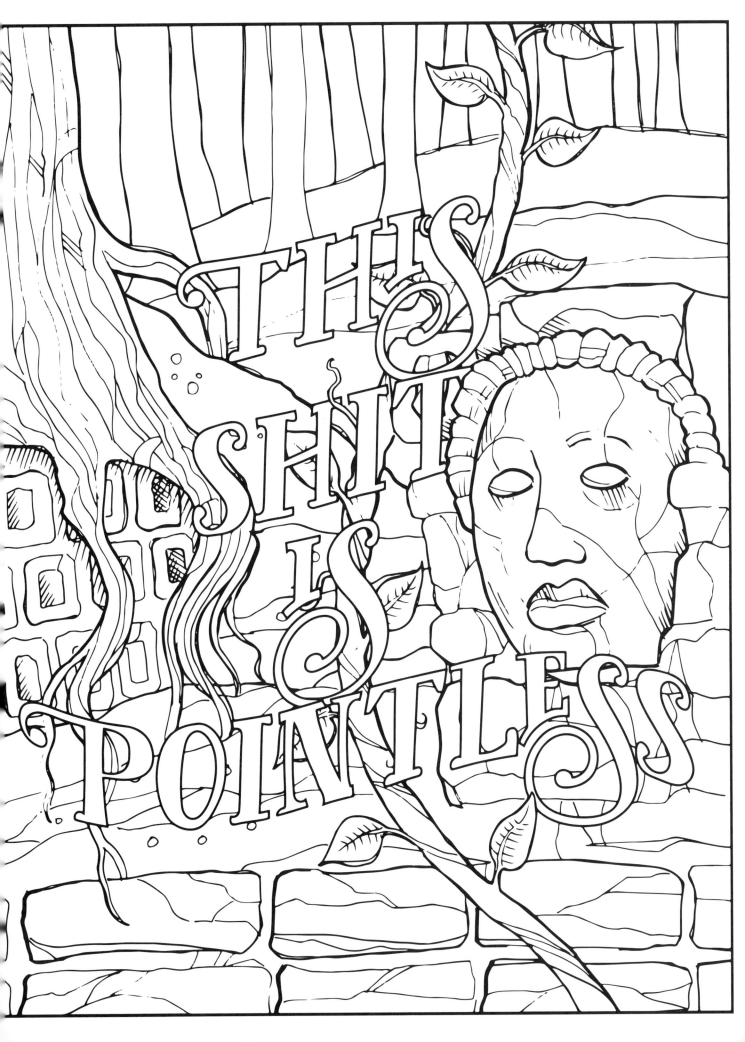

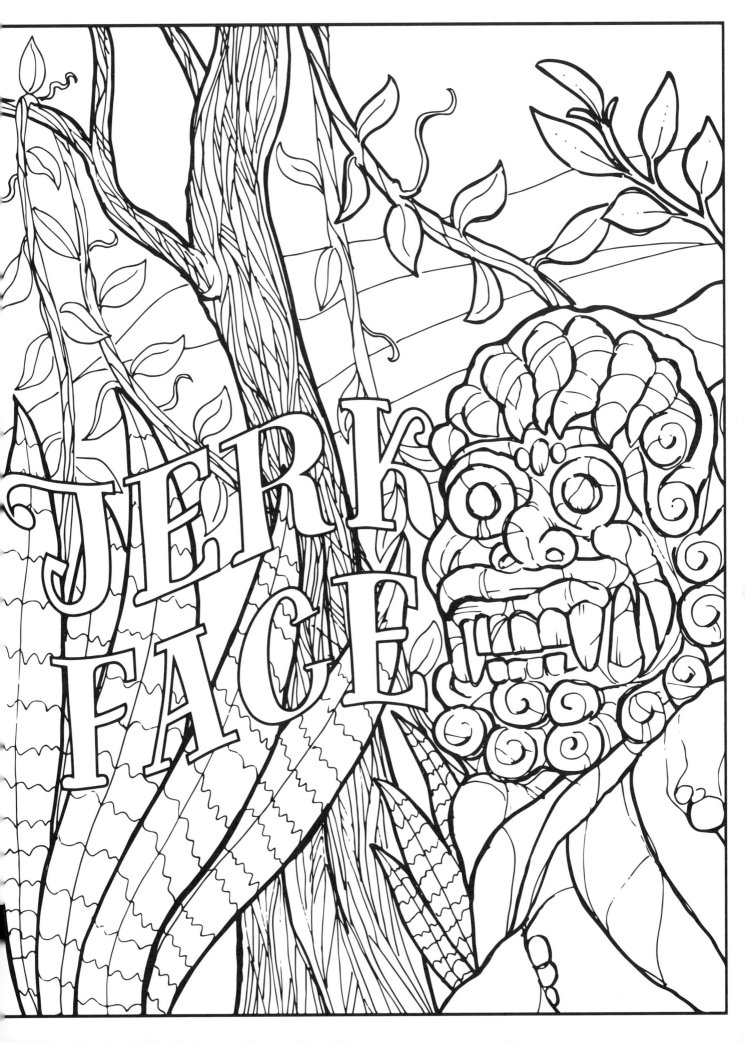

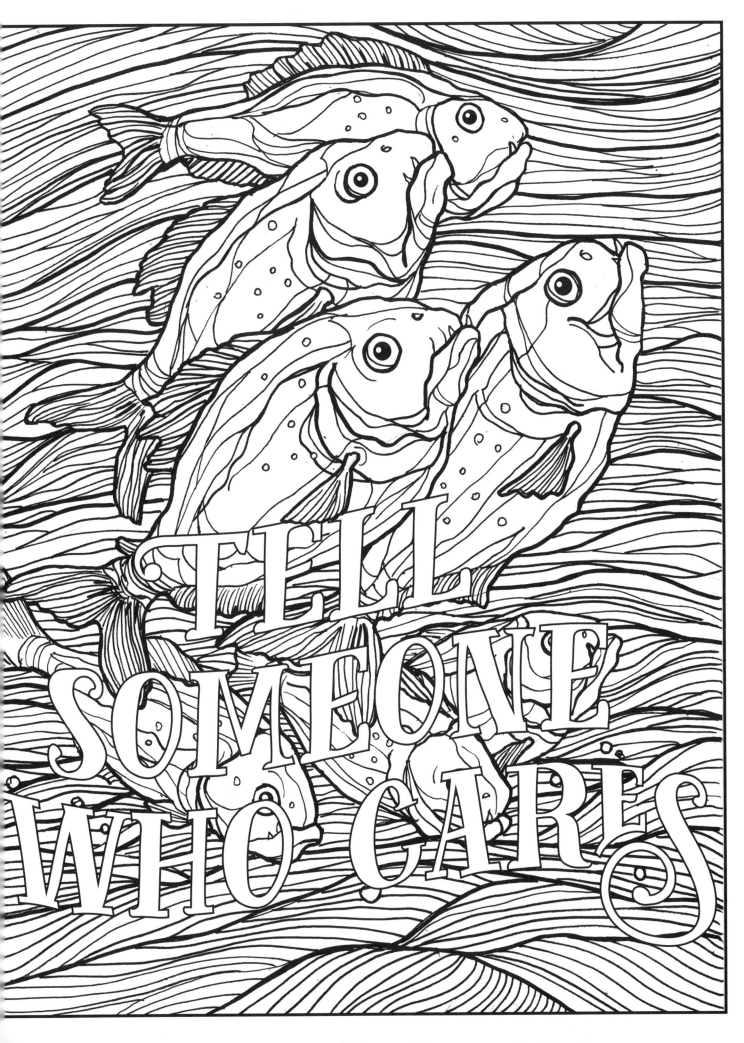

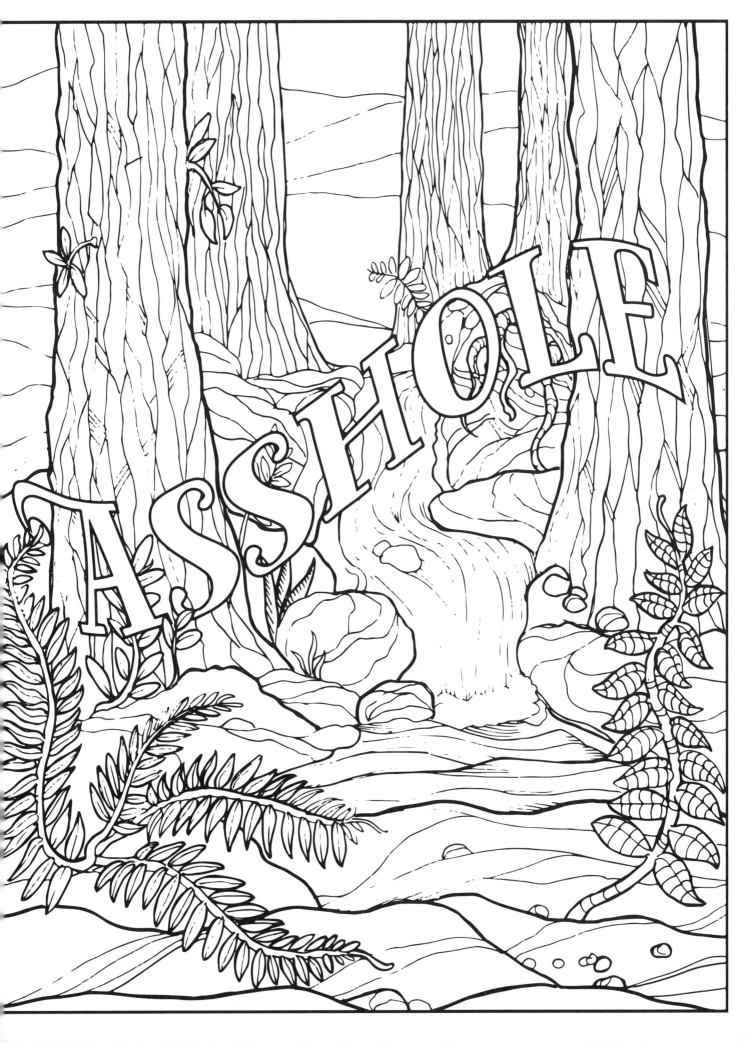

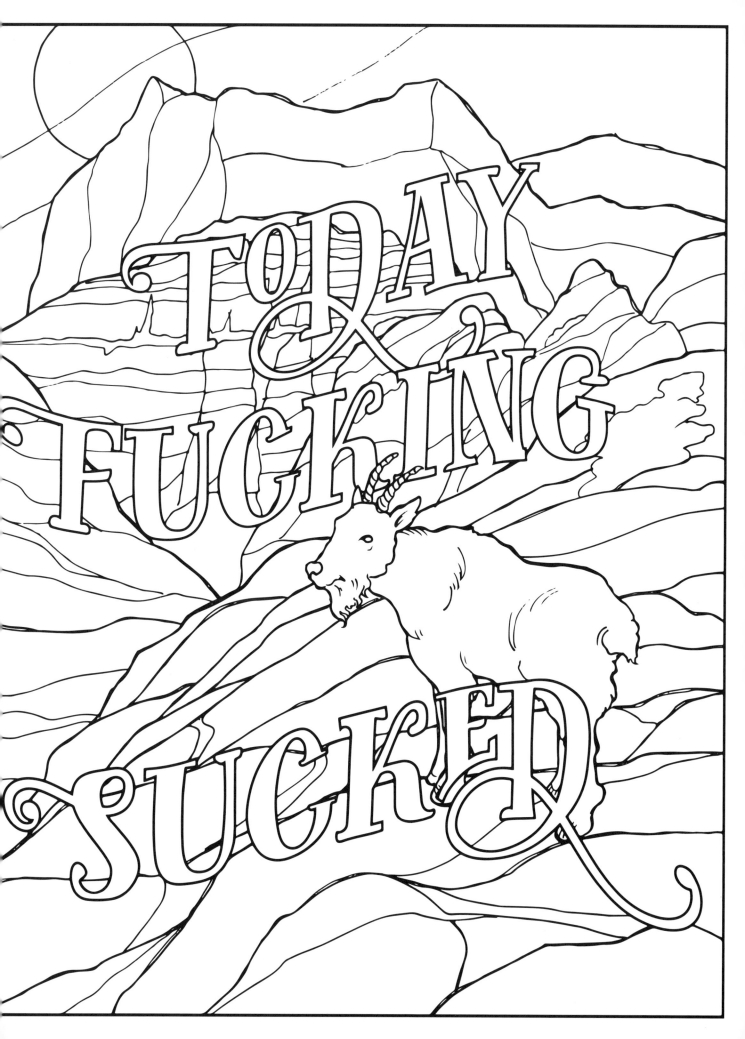

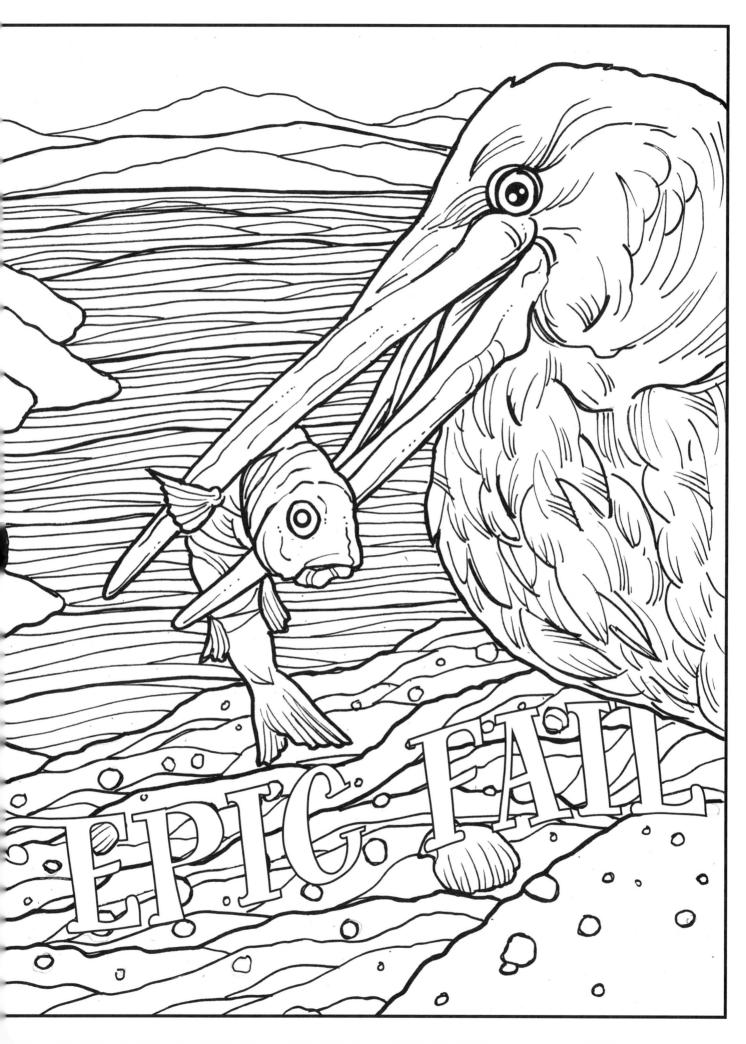

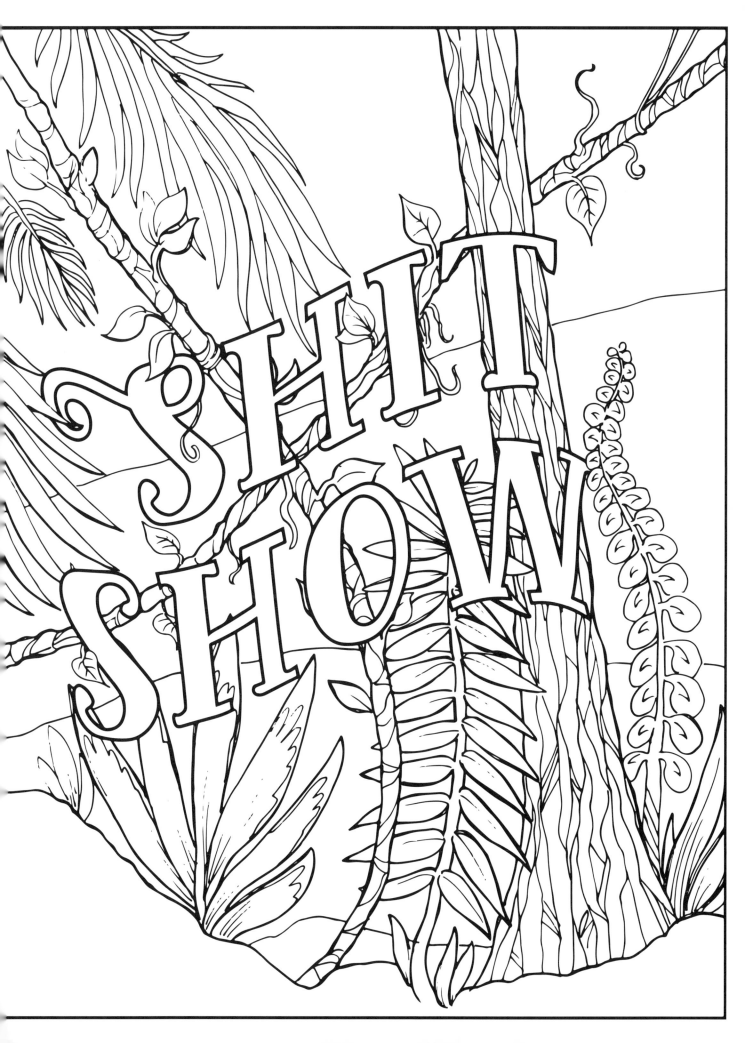

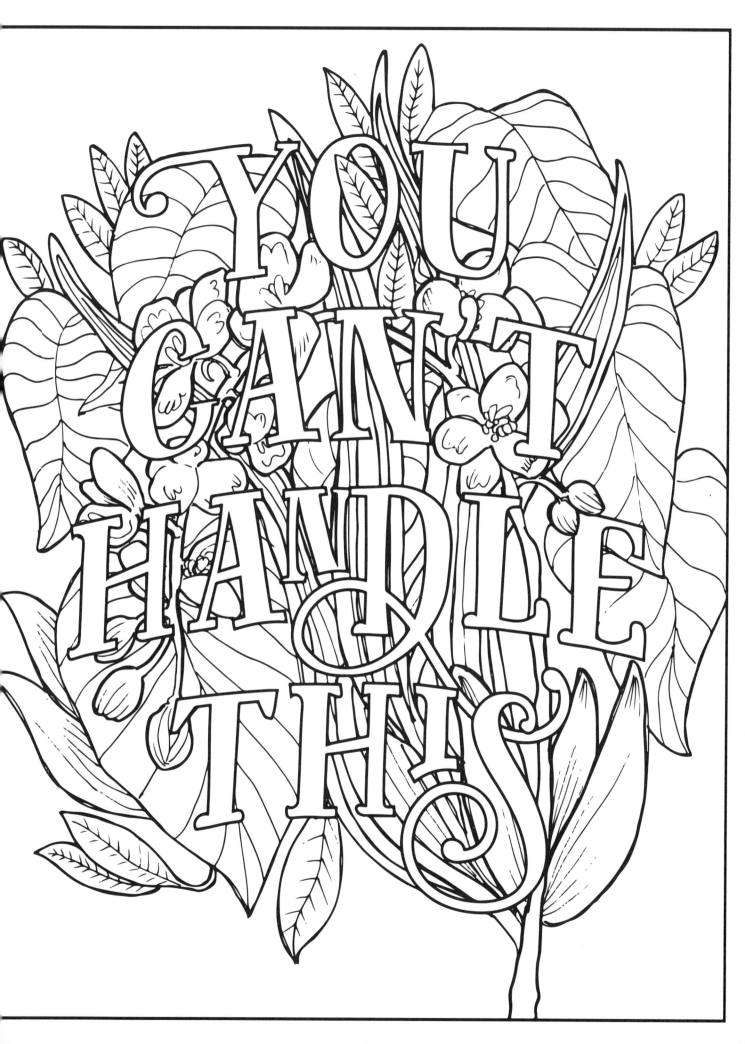

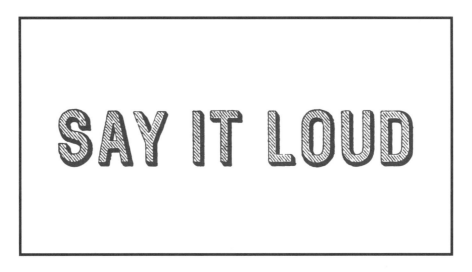

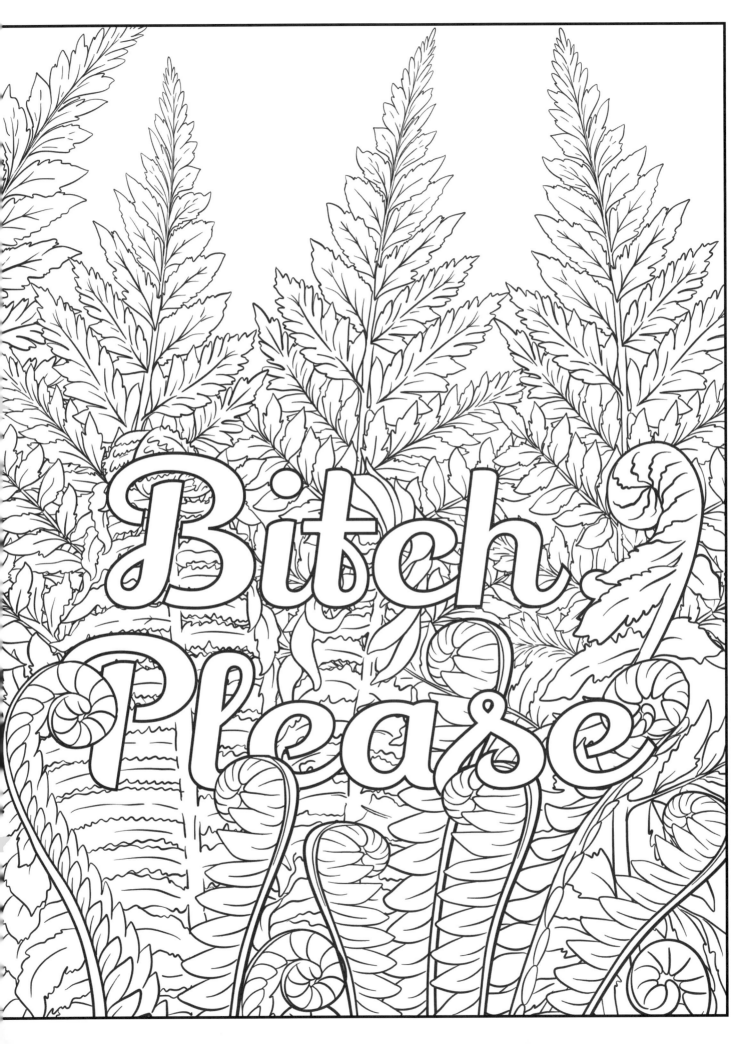

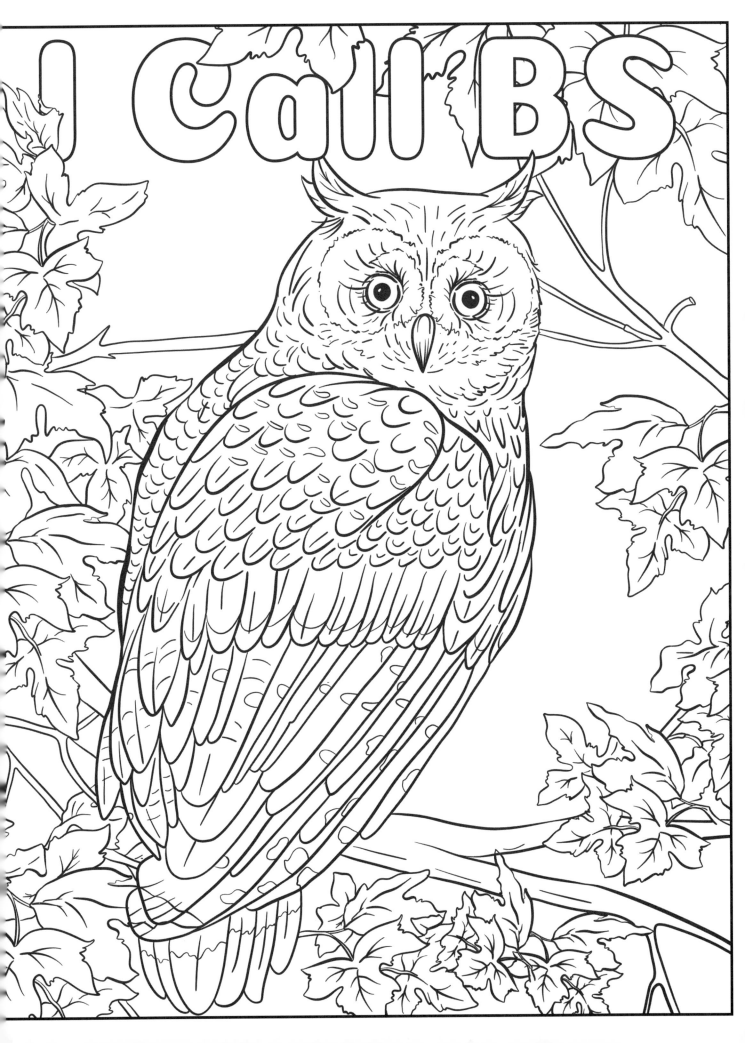

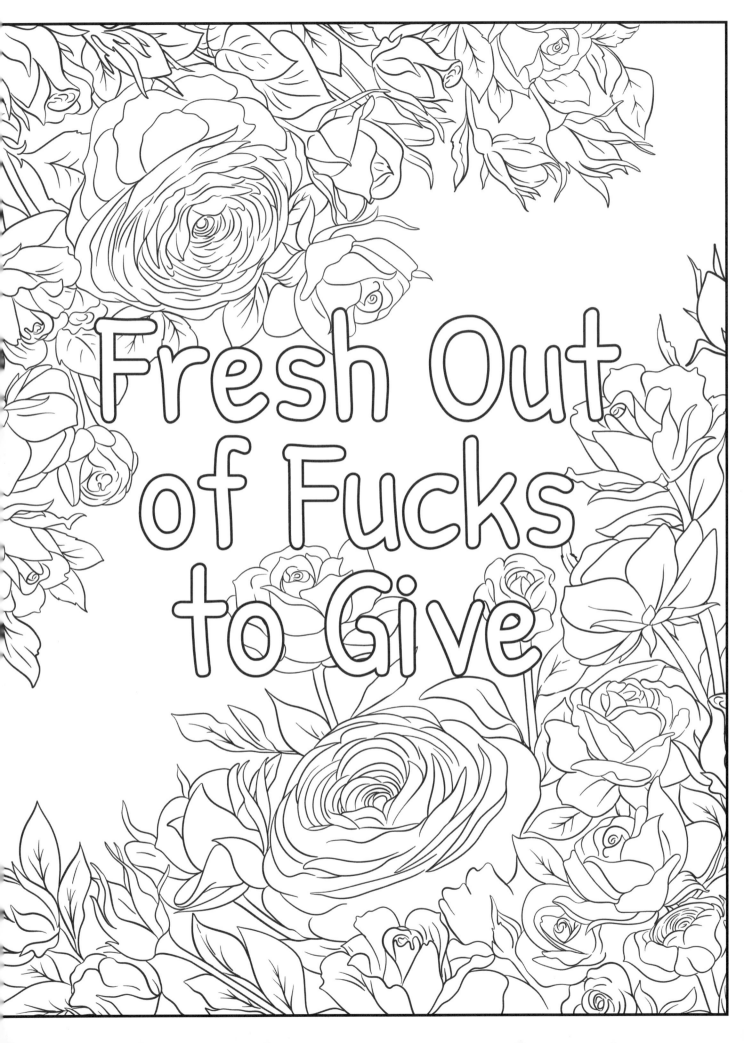

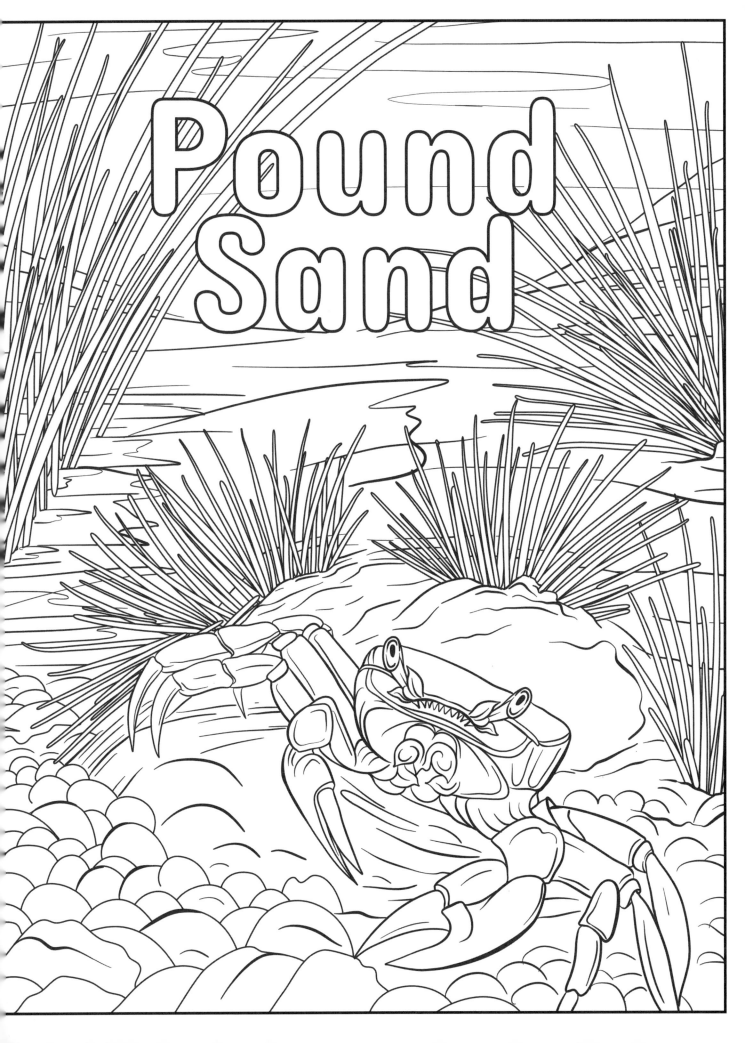

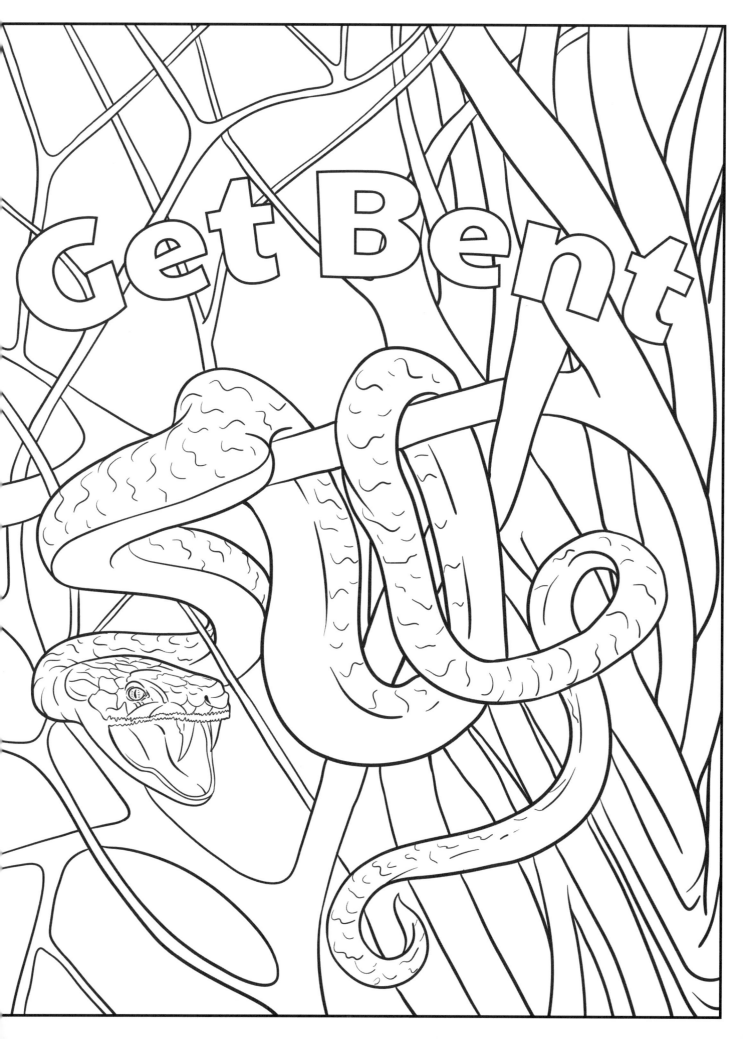

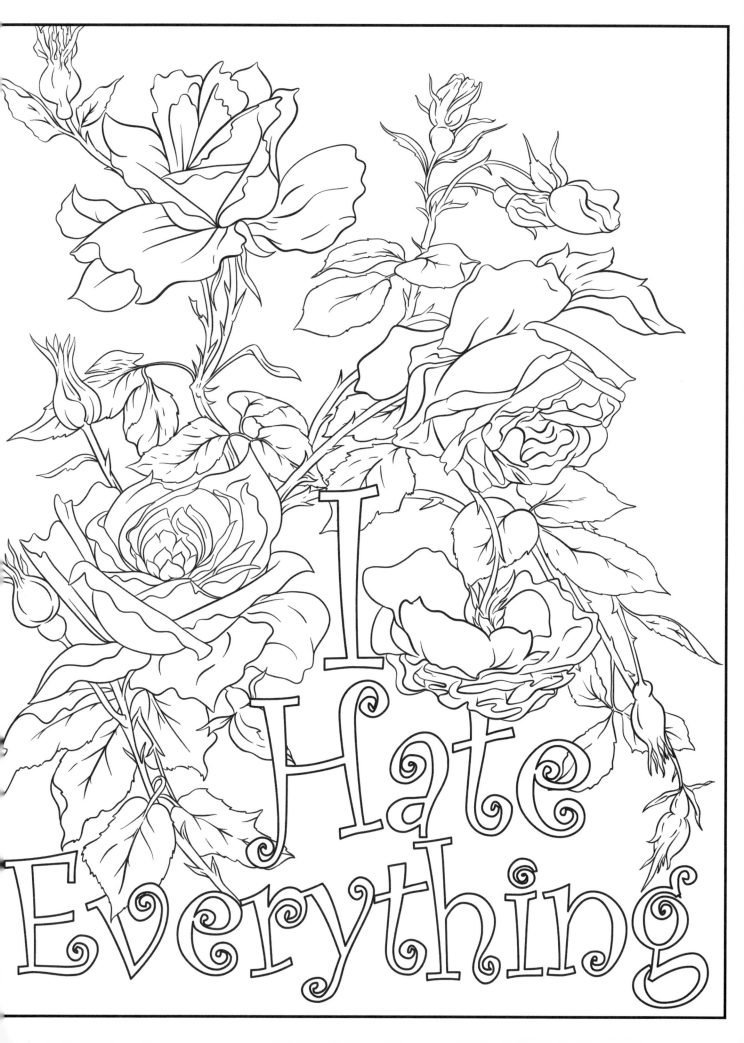

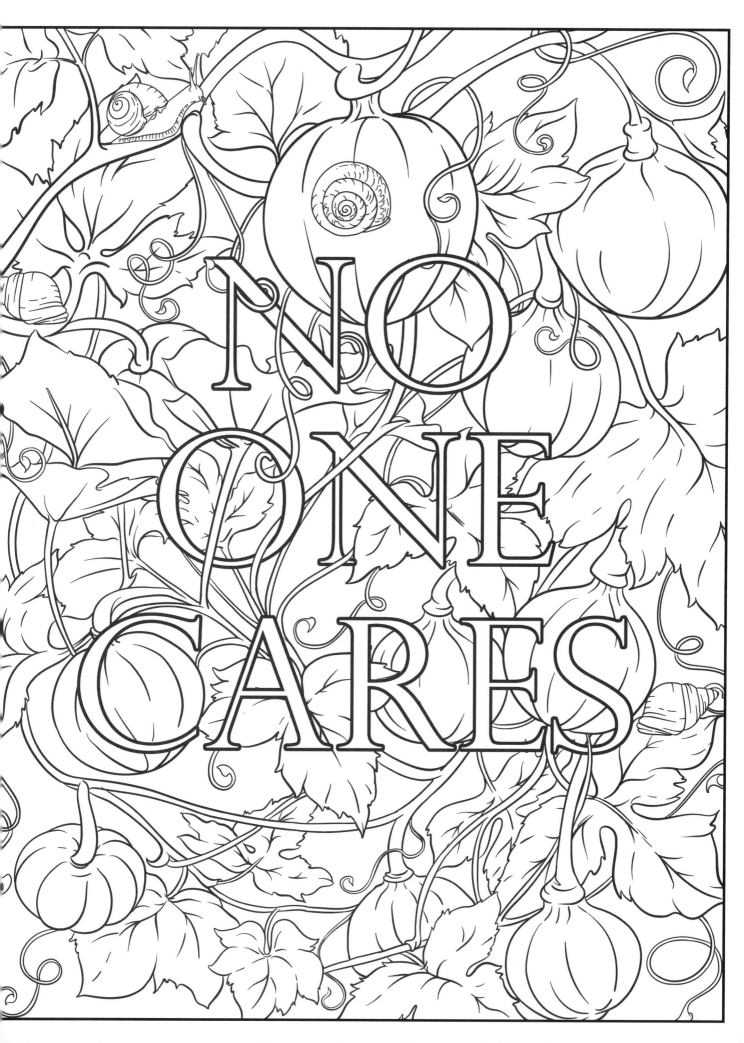

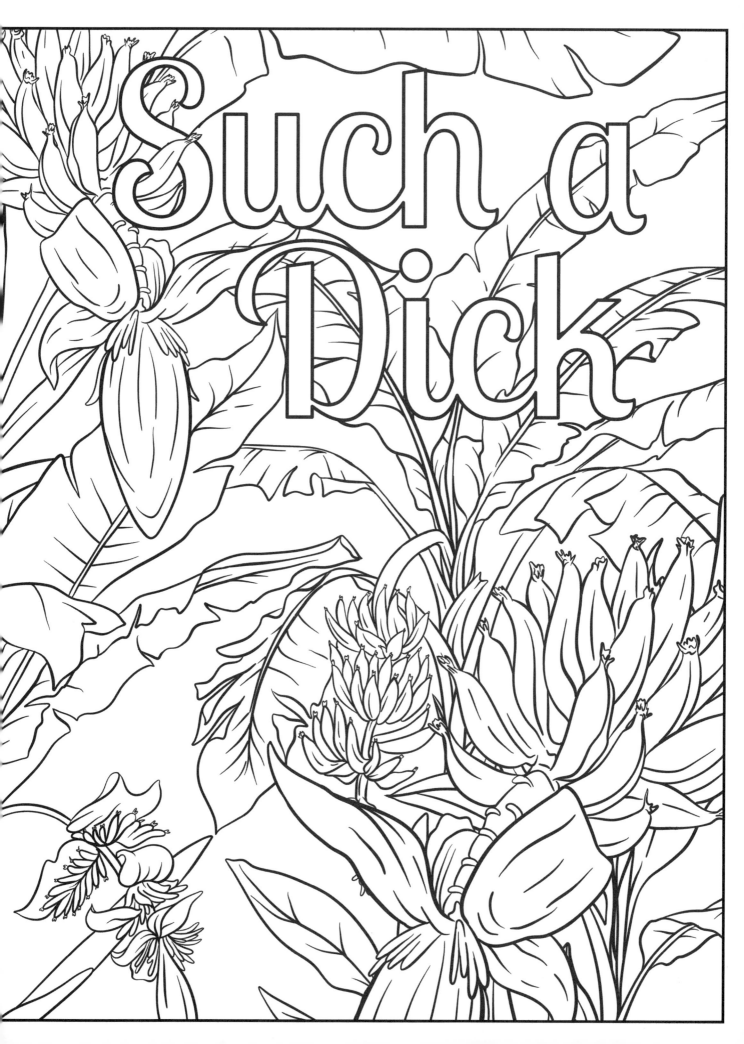

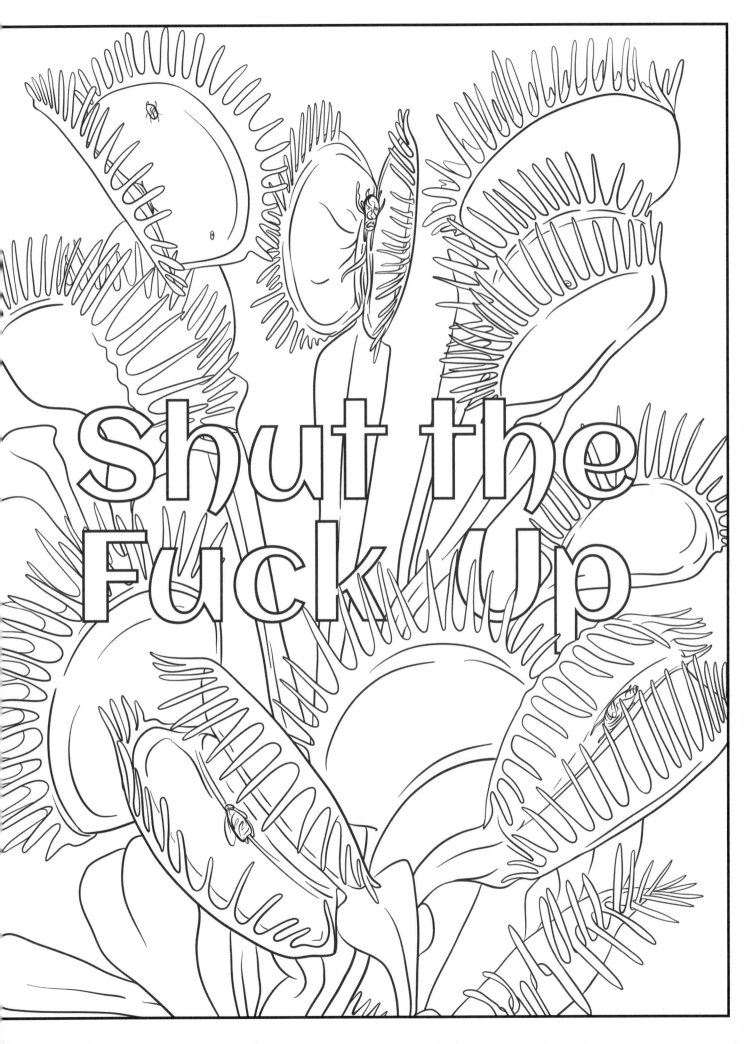

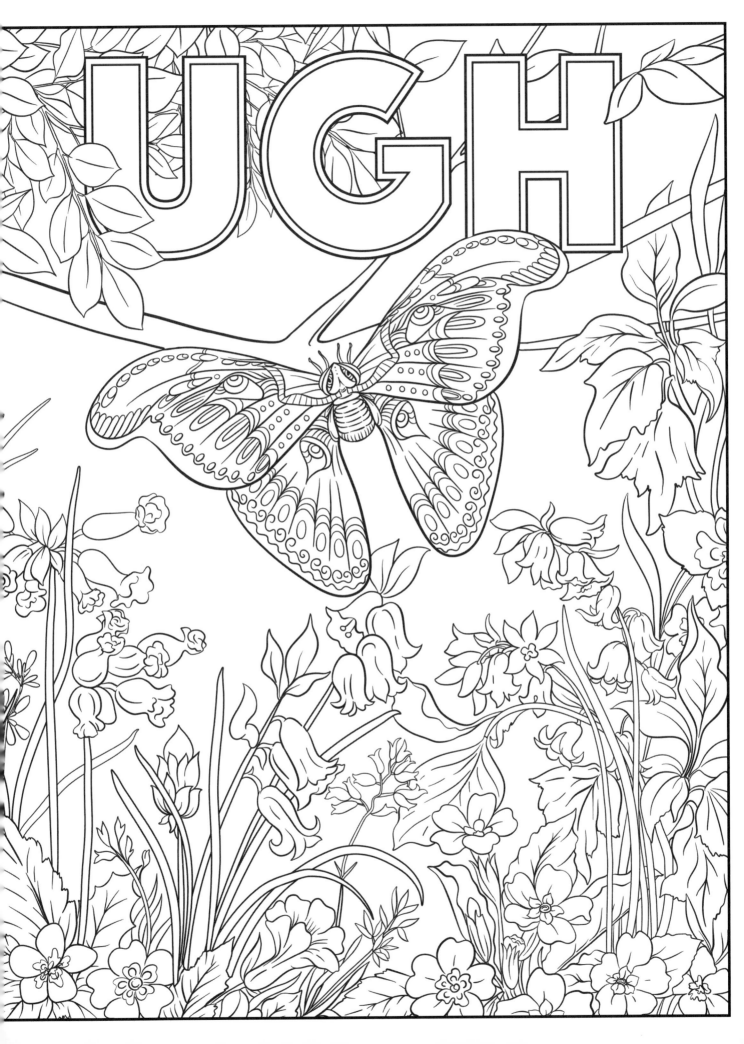

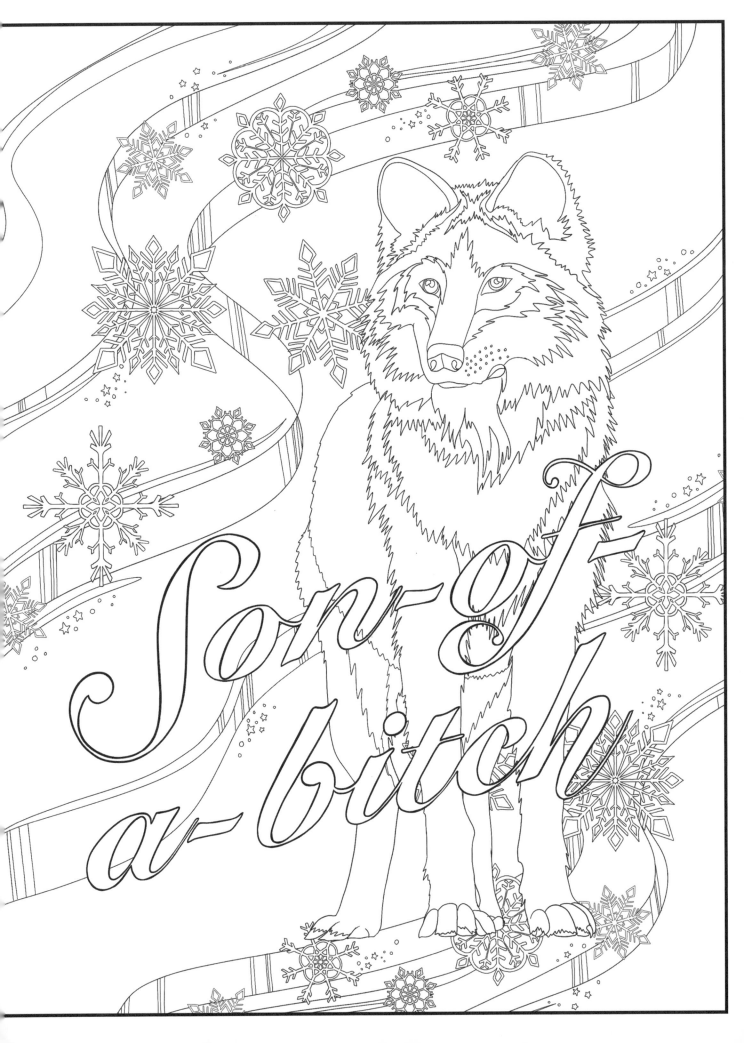

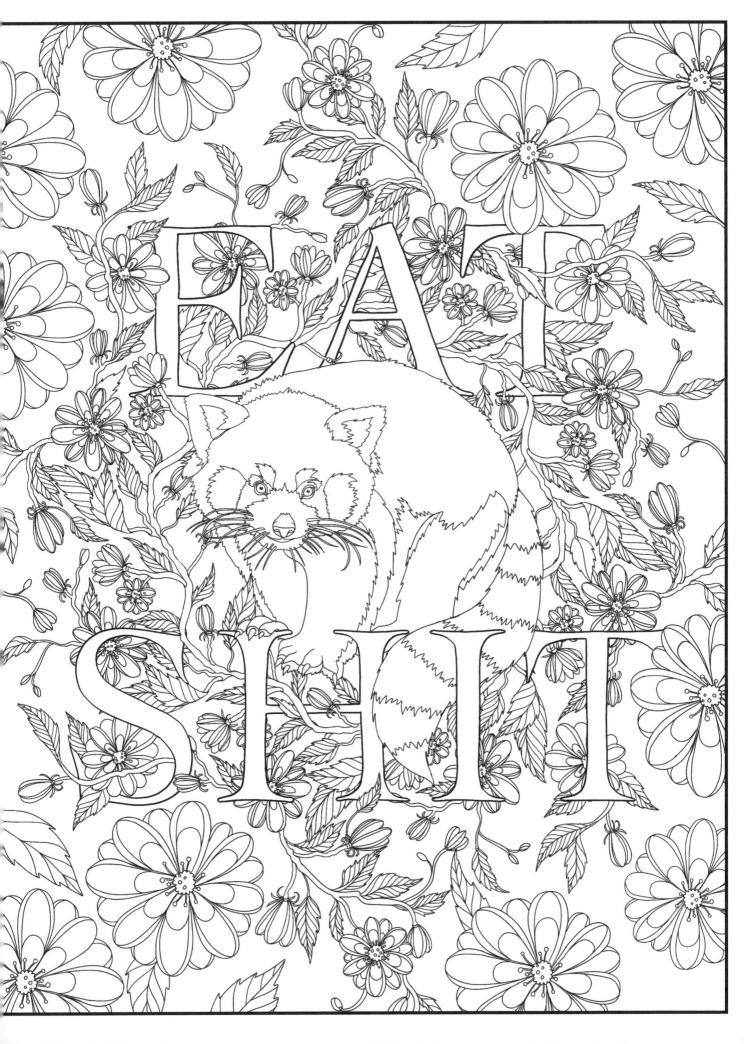

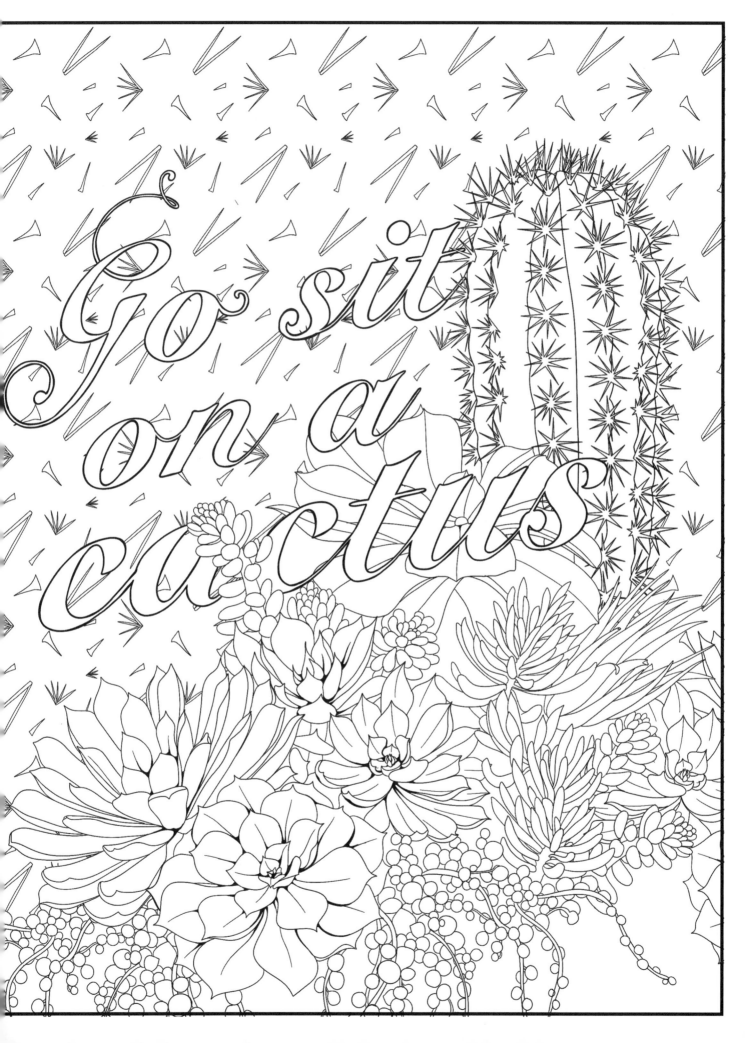

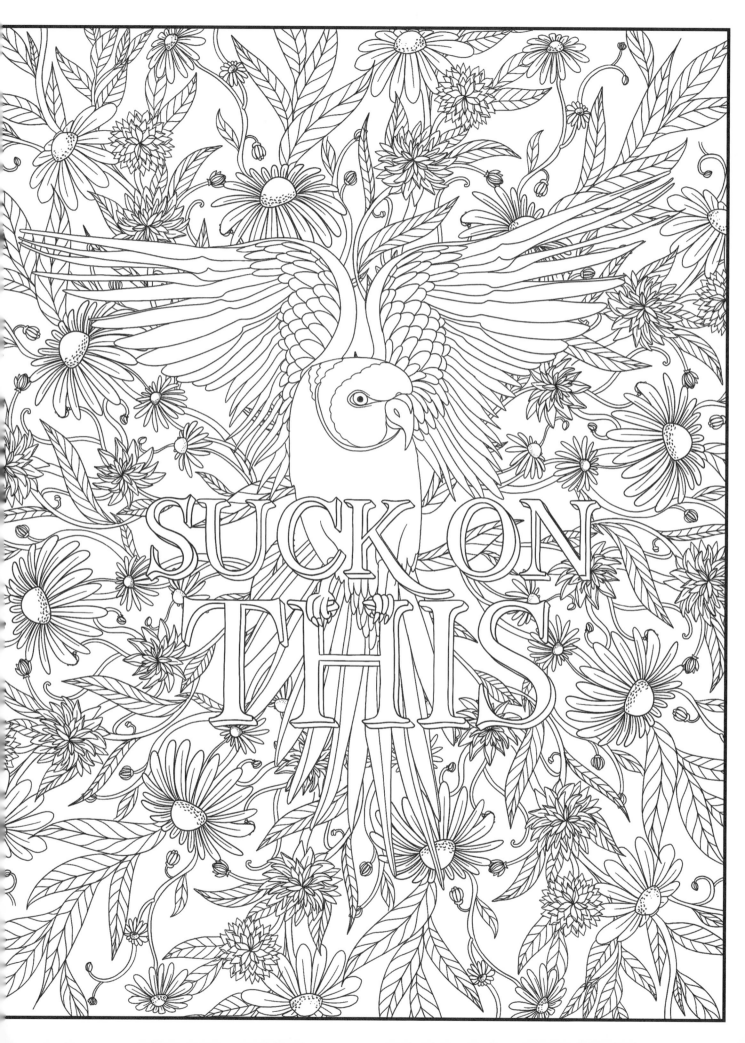

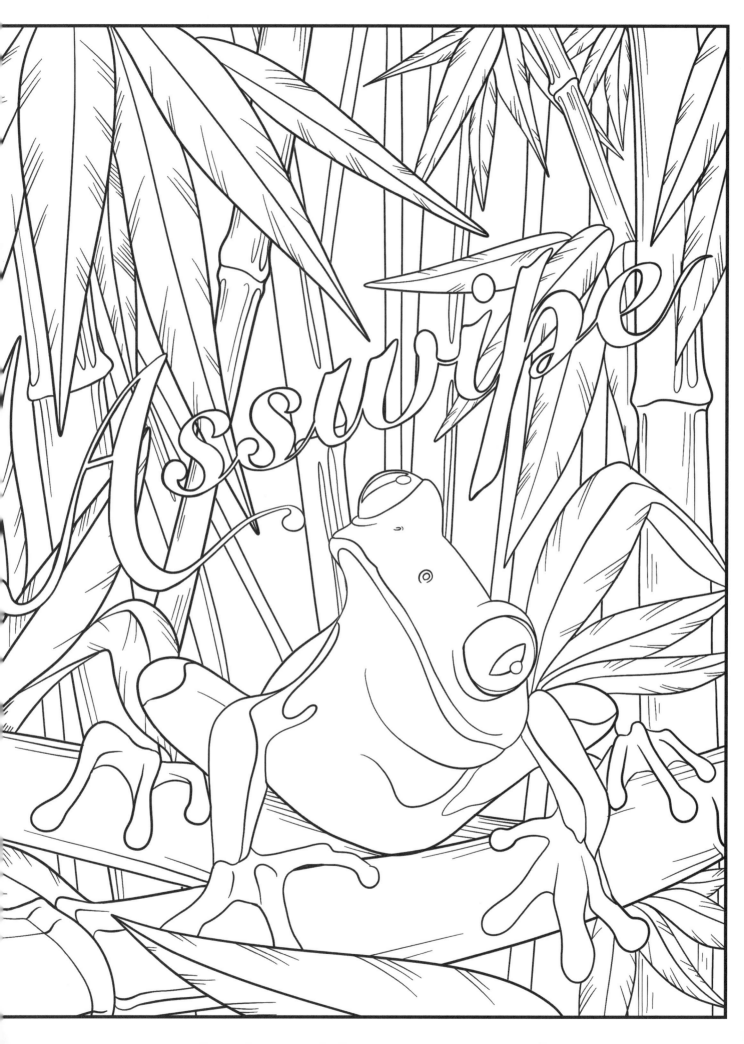

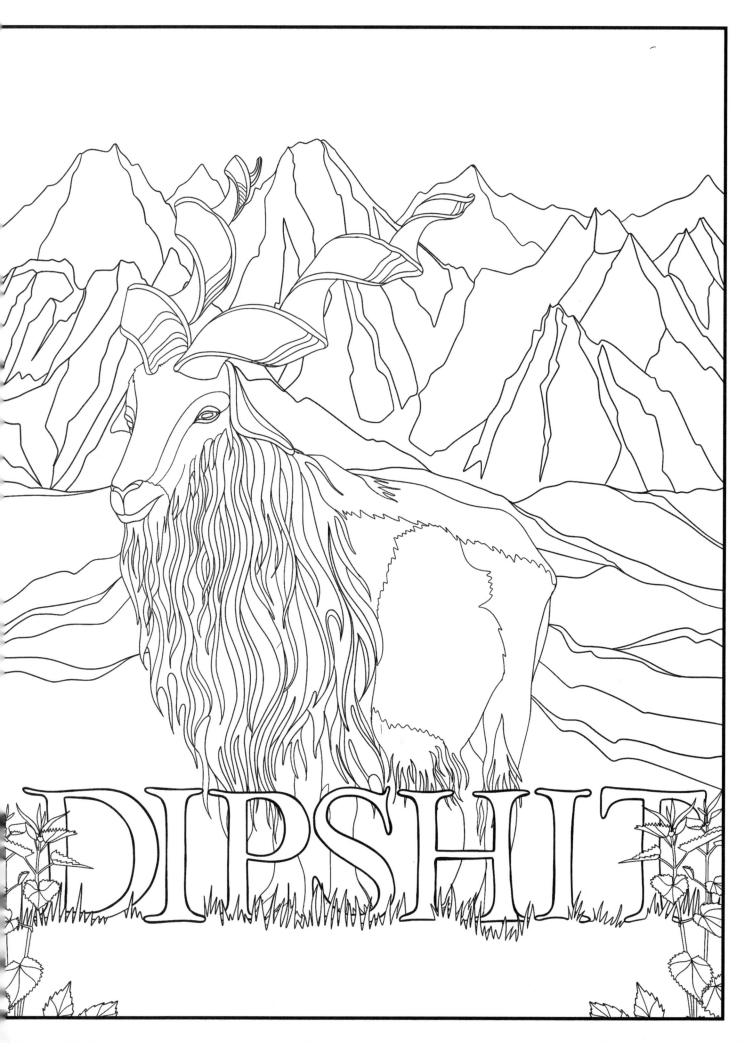

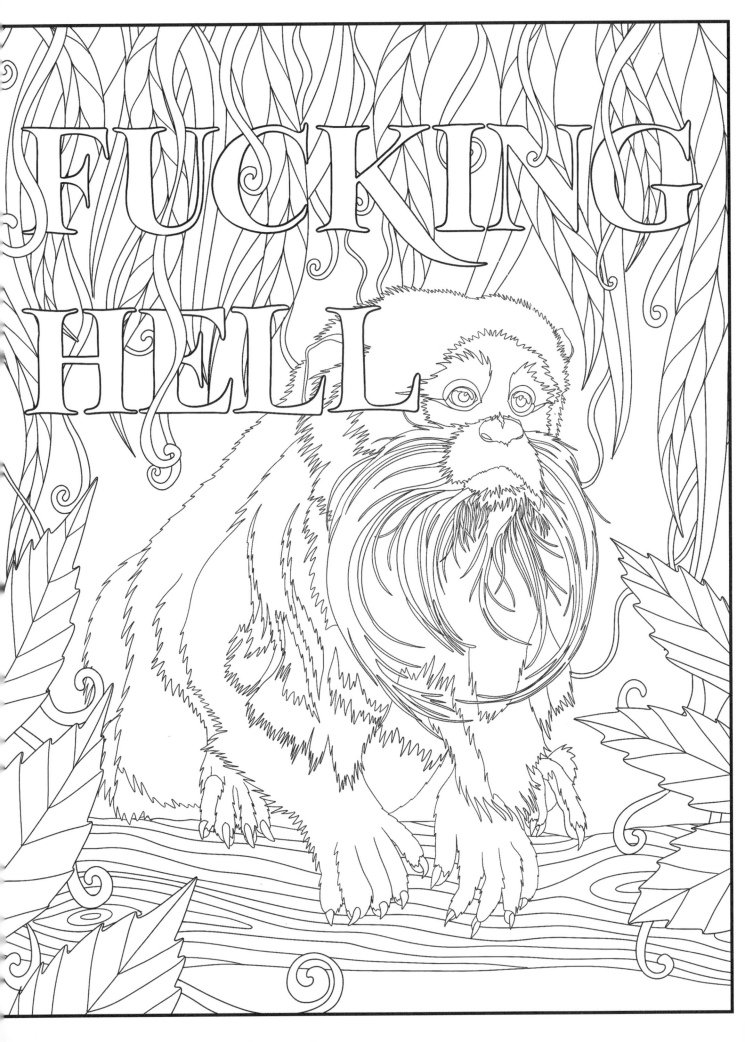

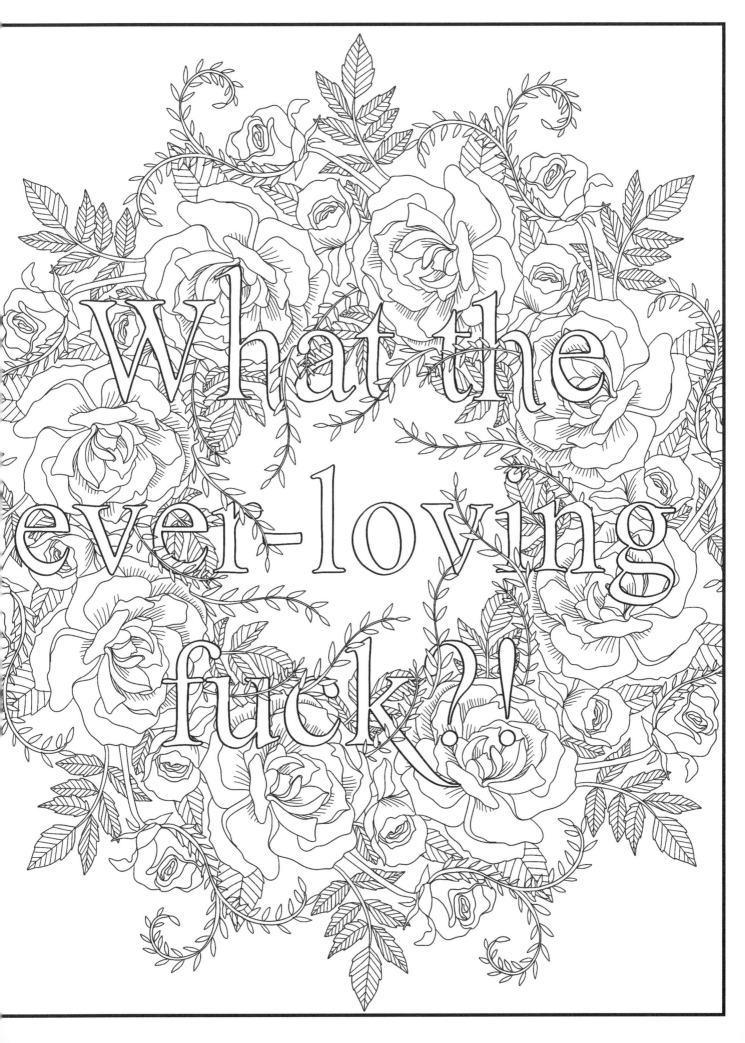

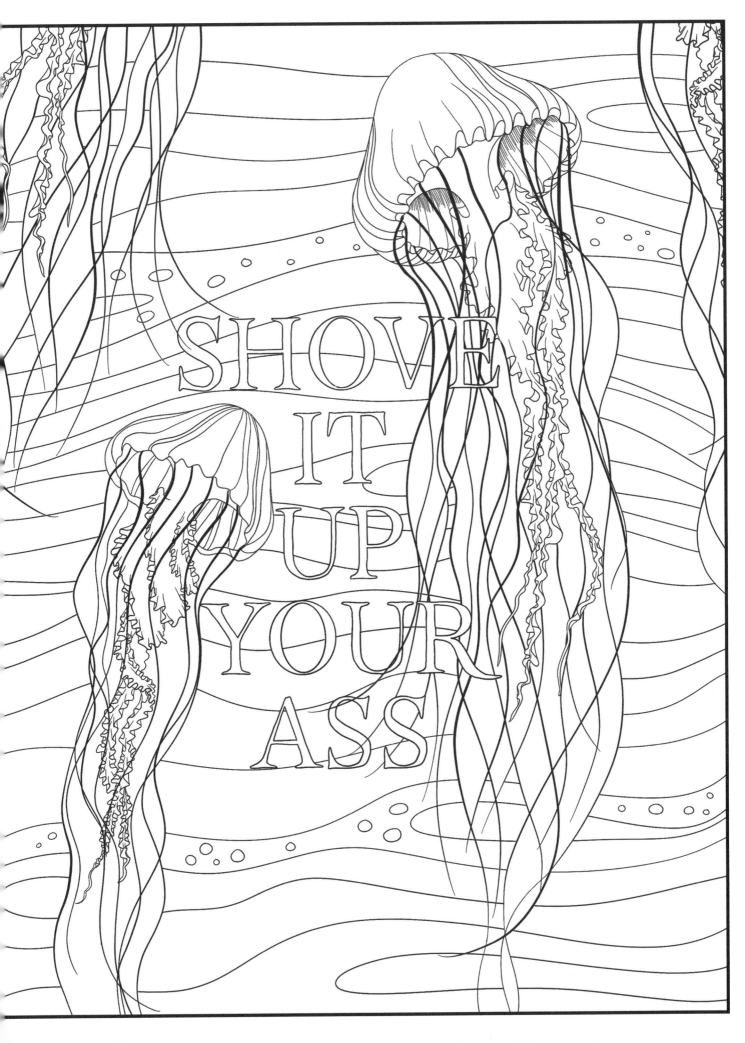

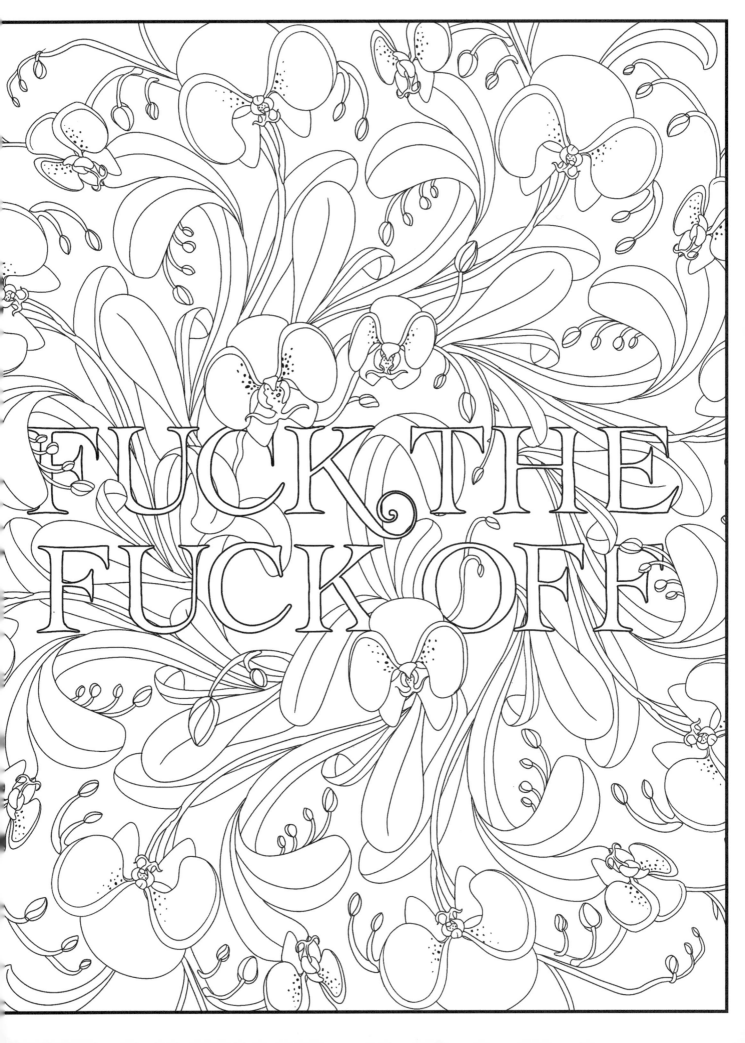

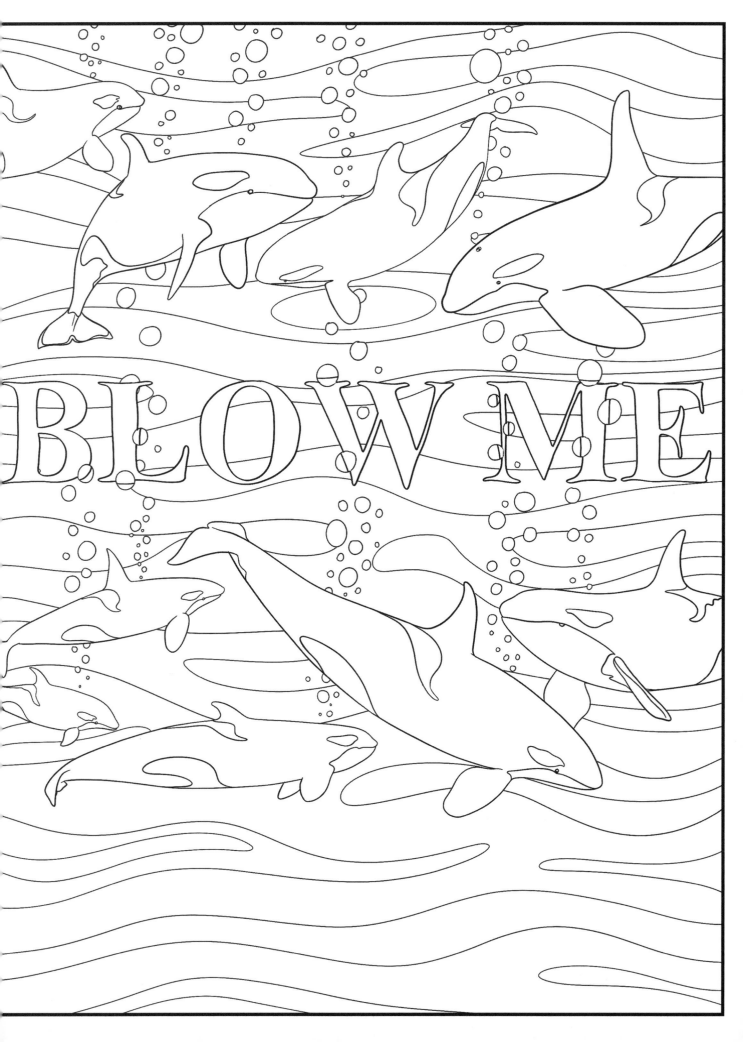

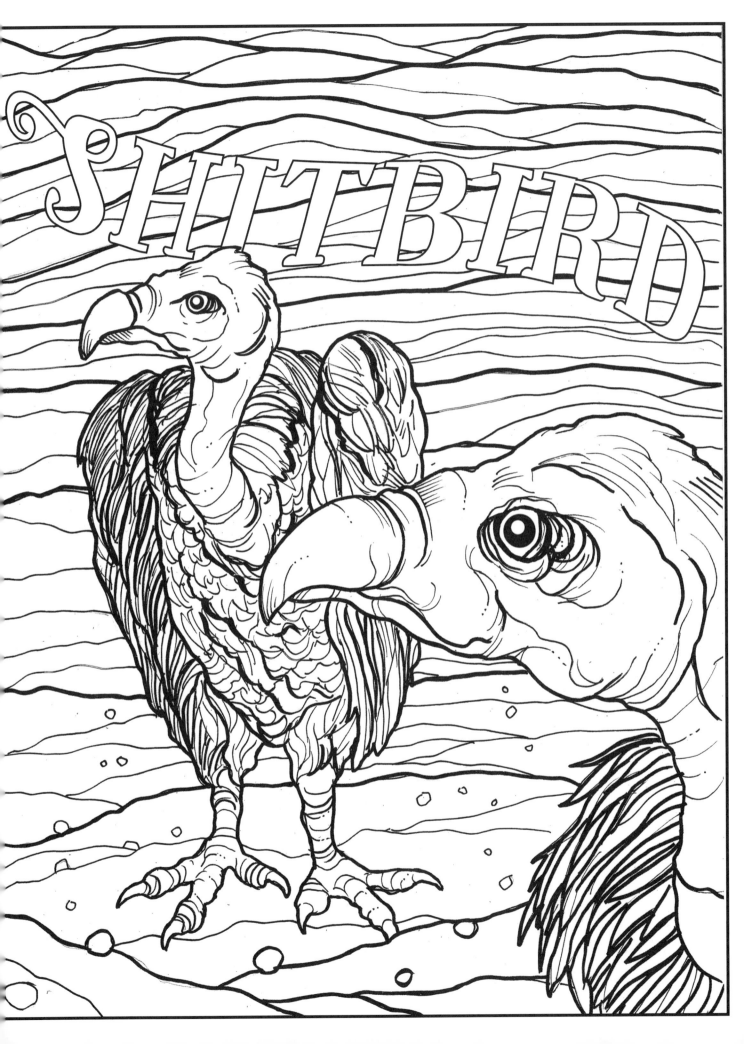

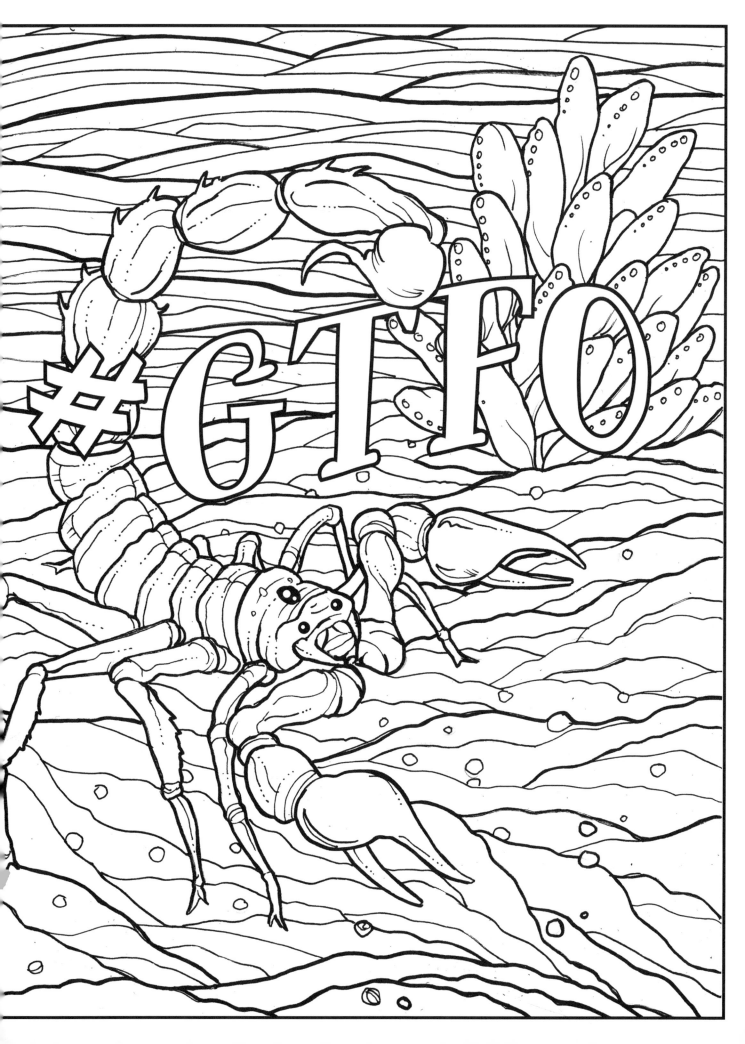

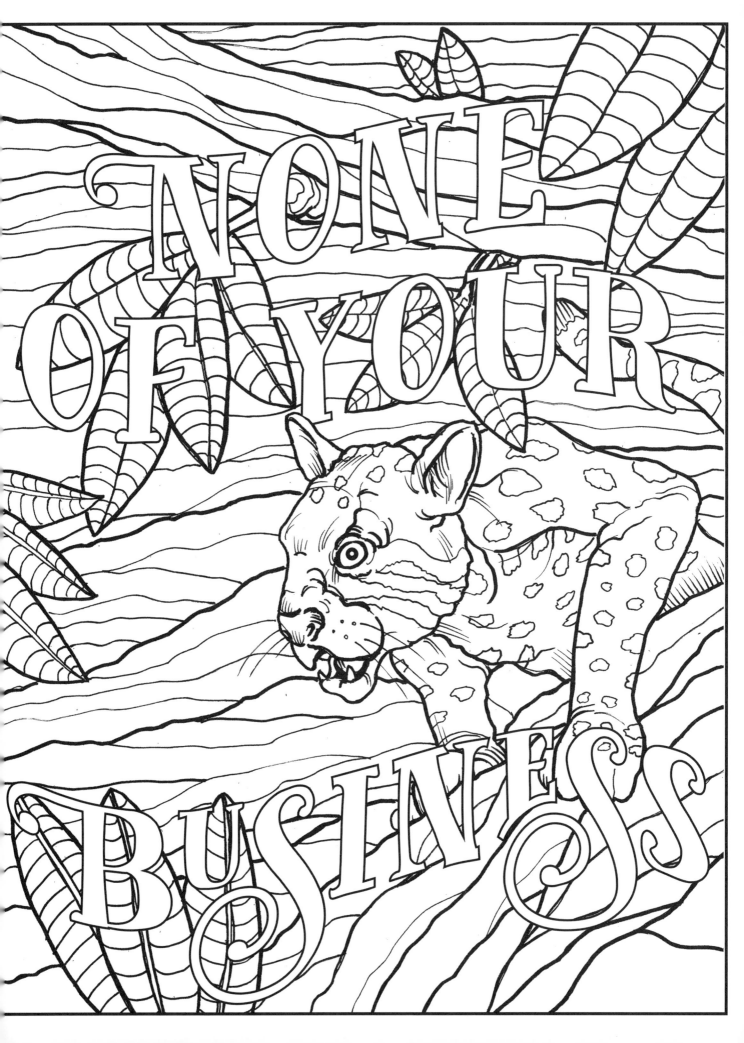

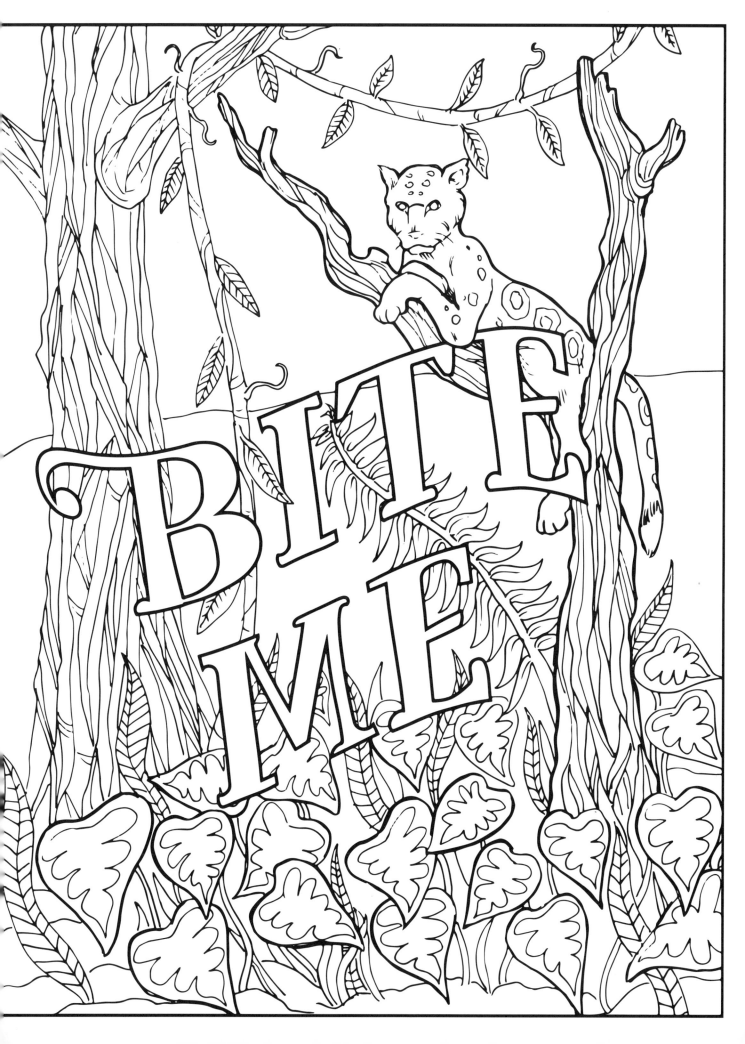

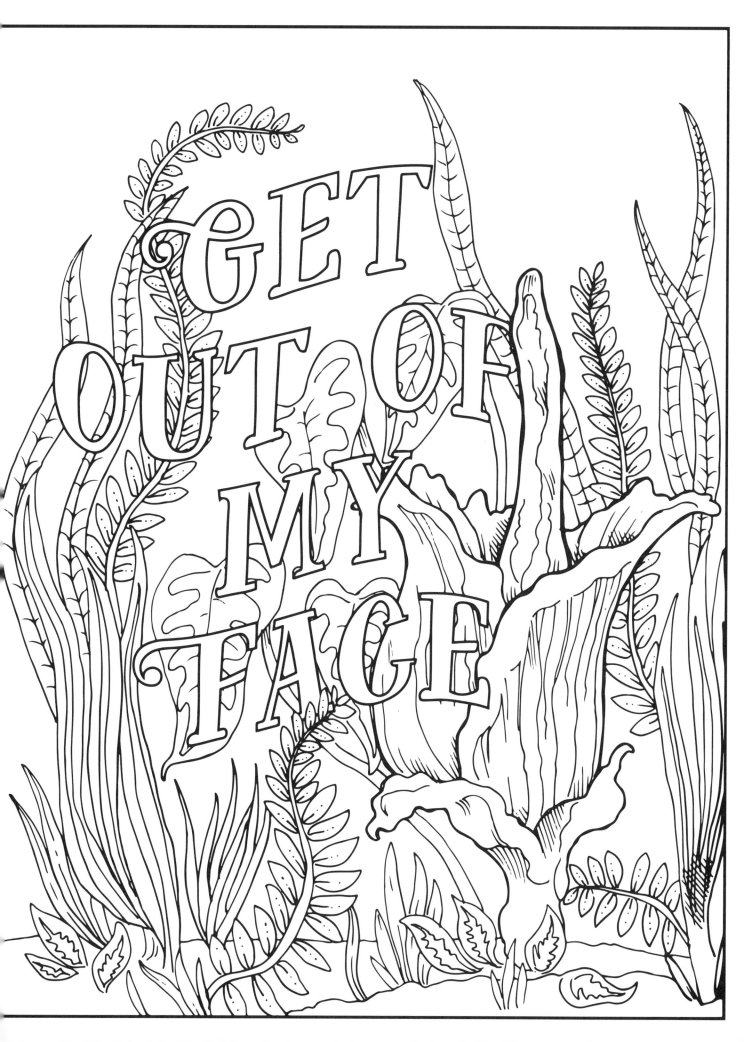

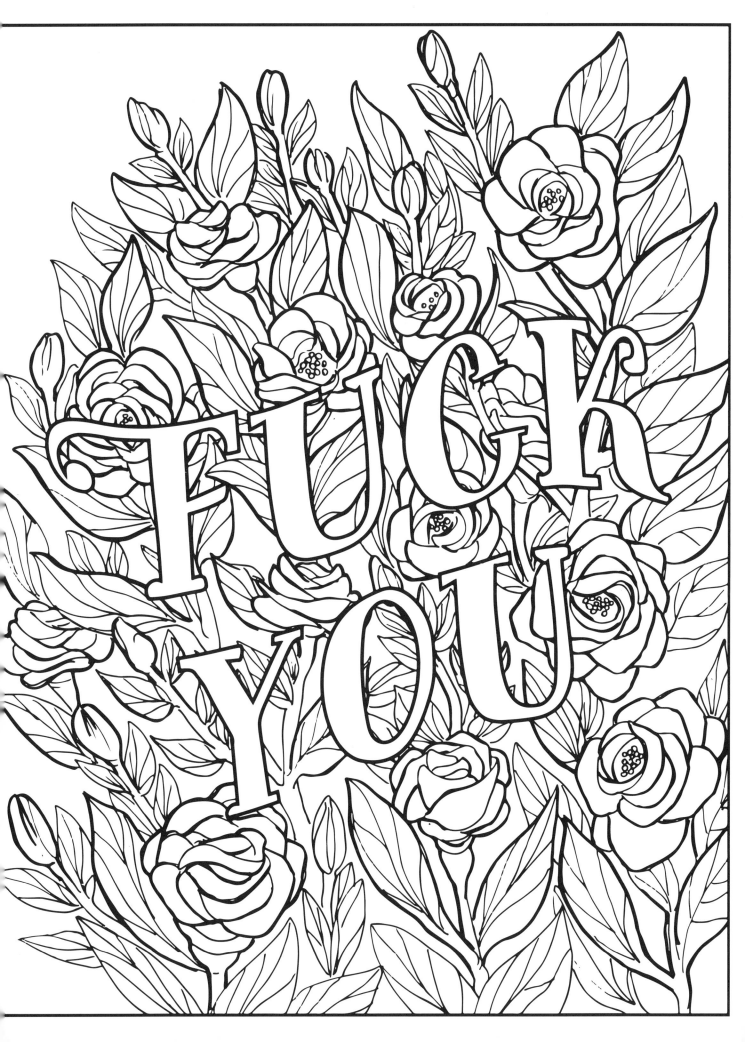

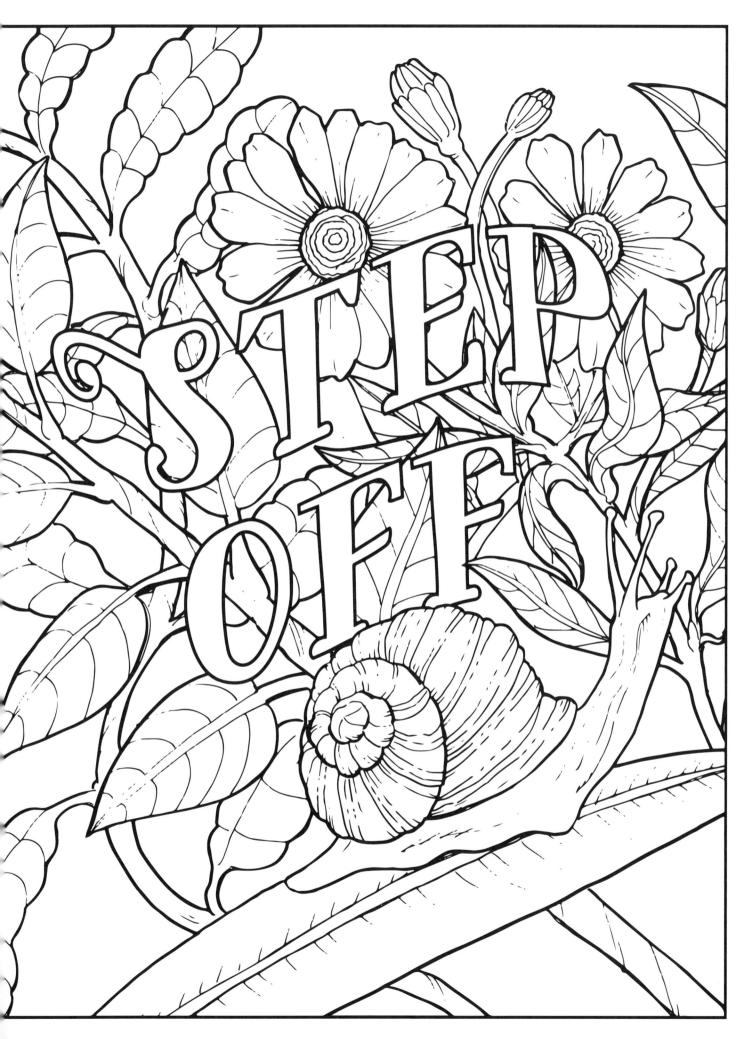

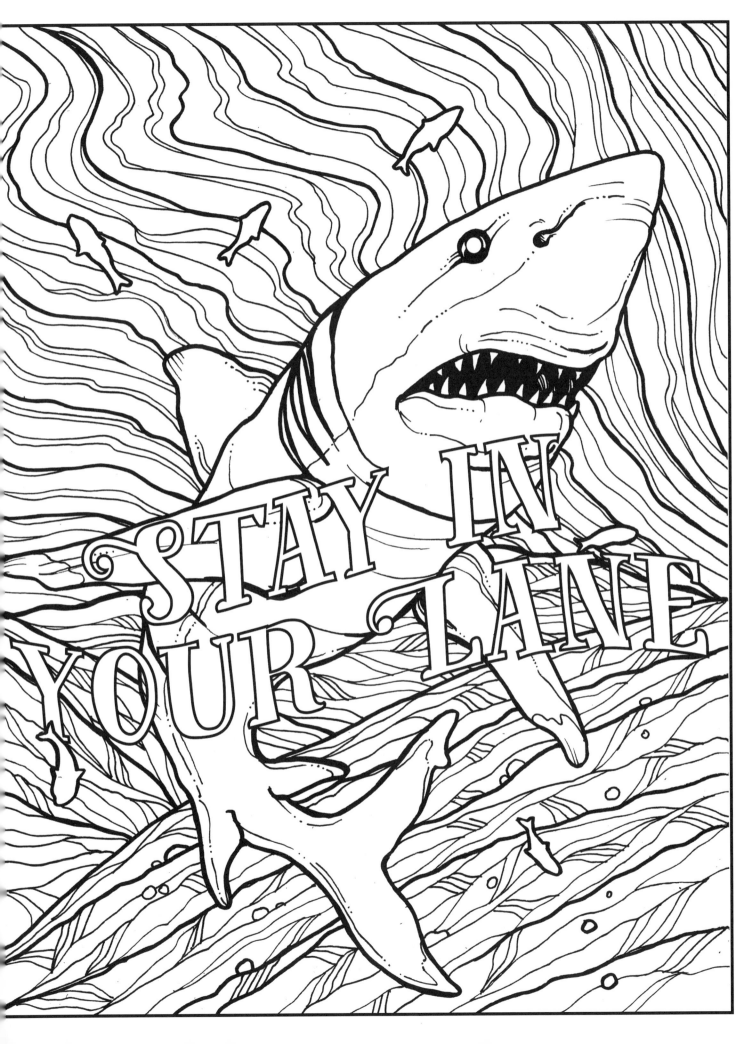

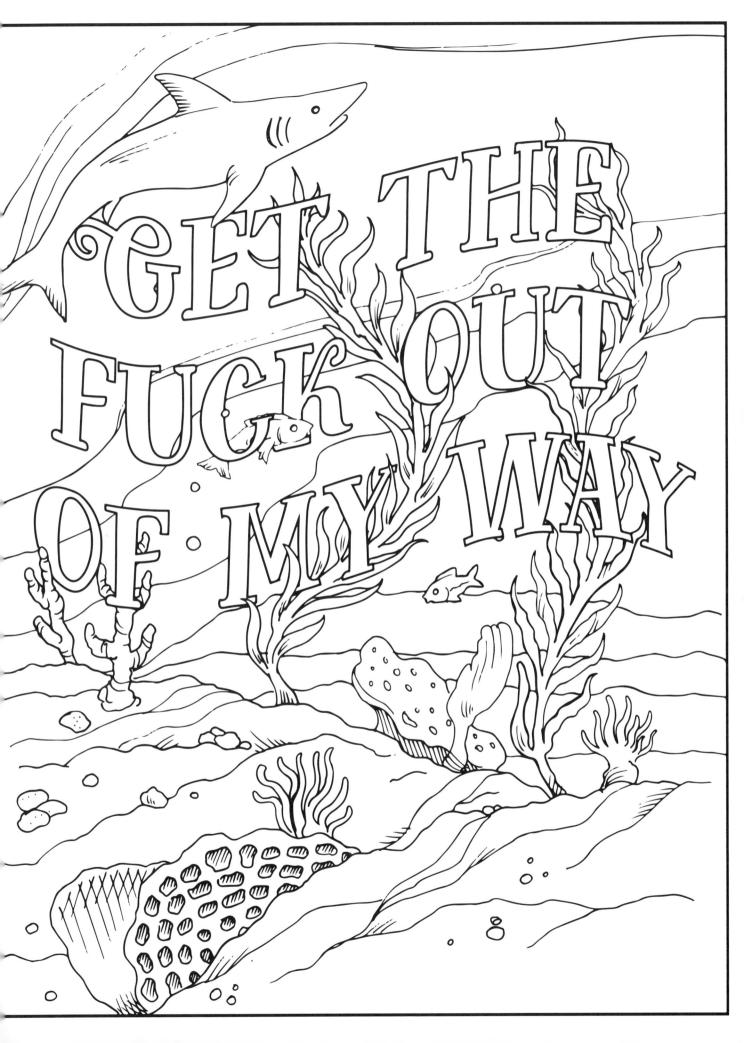

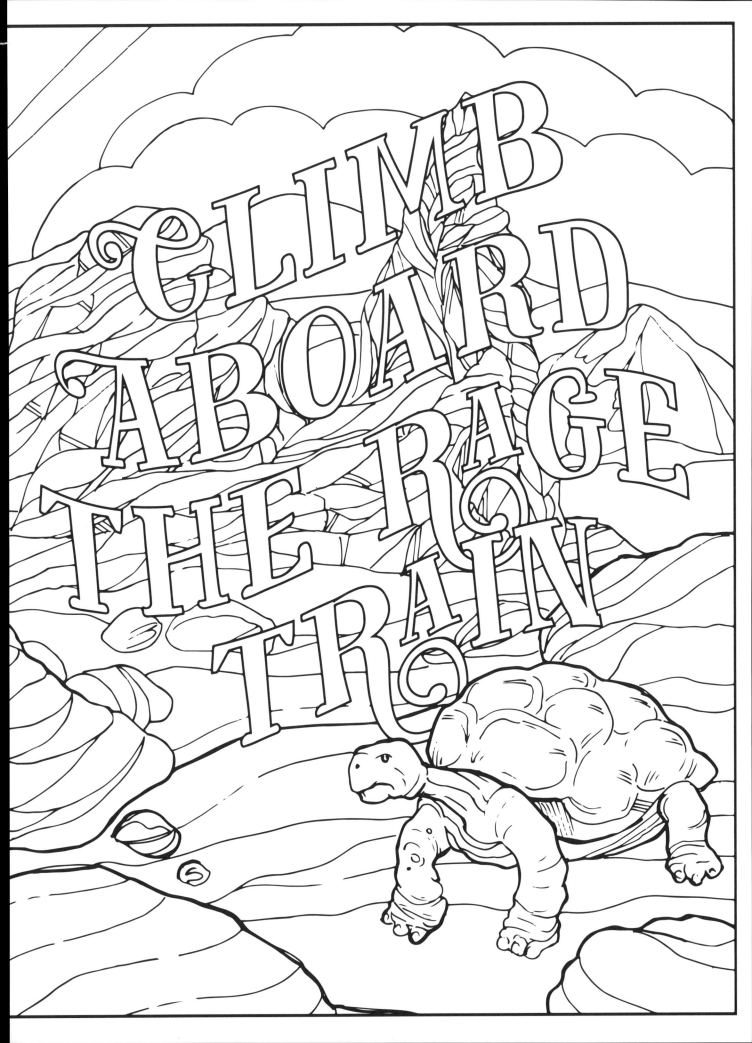

PROFANE
SELF-CARE

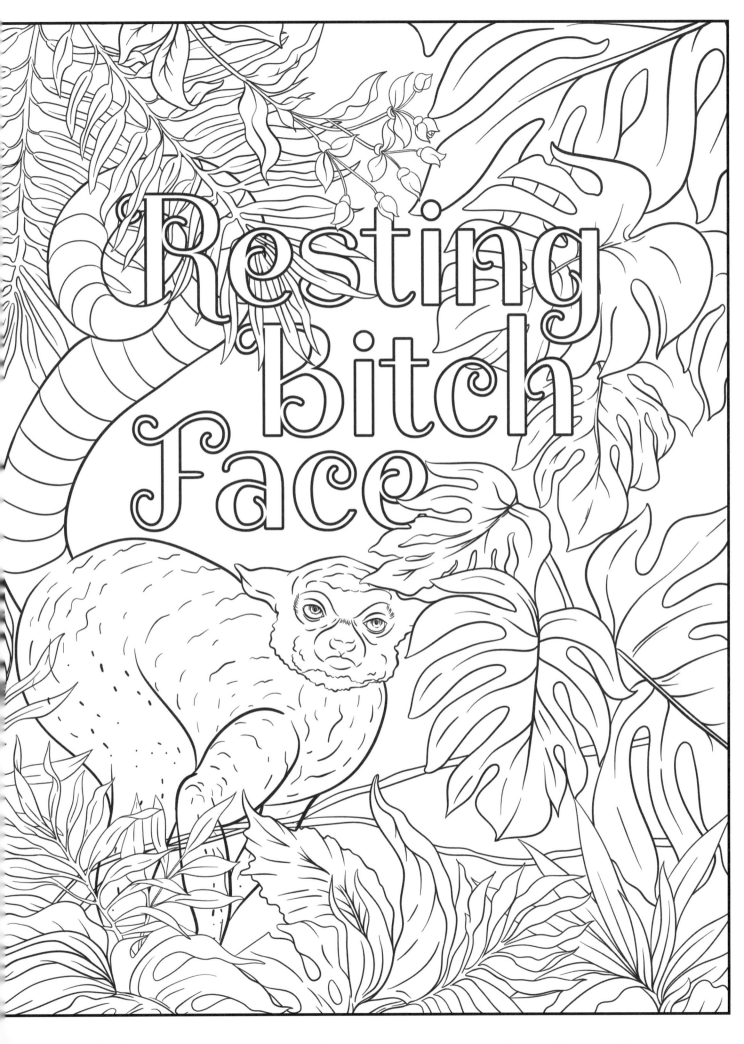

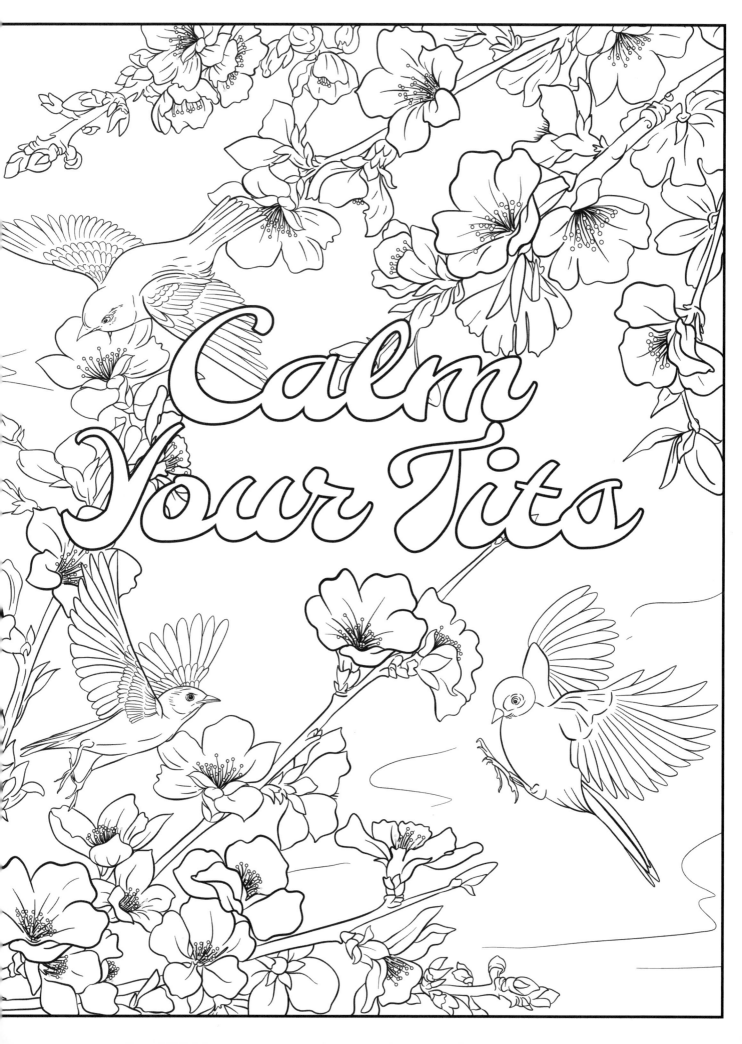

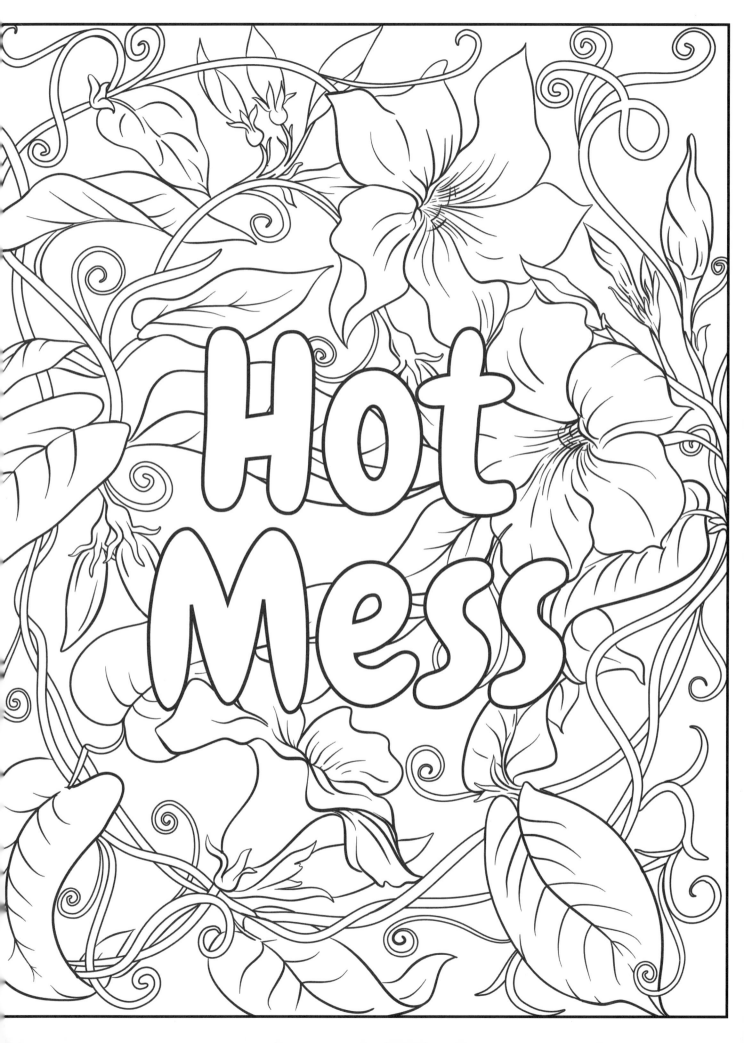

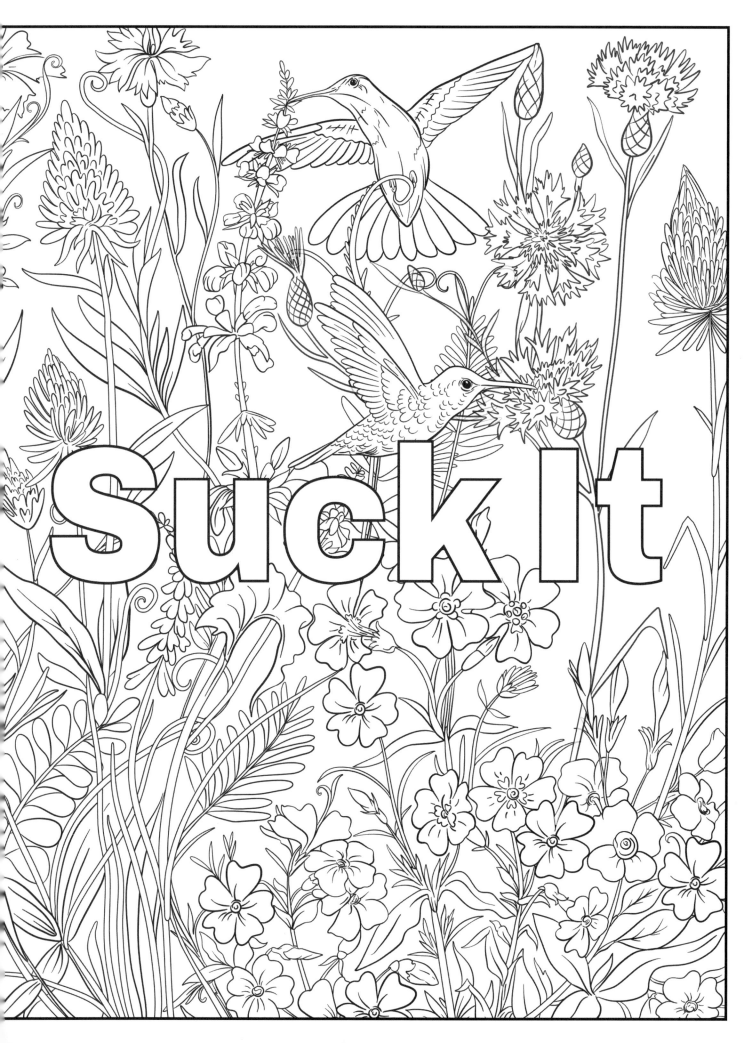

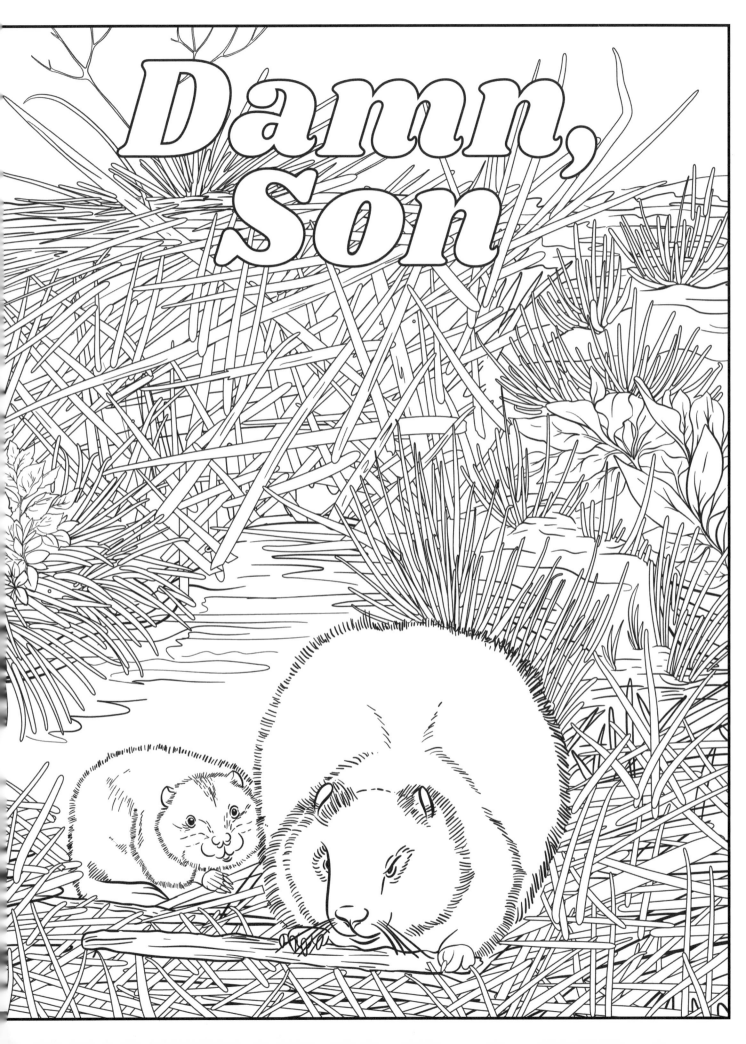

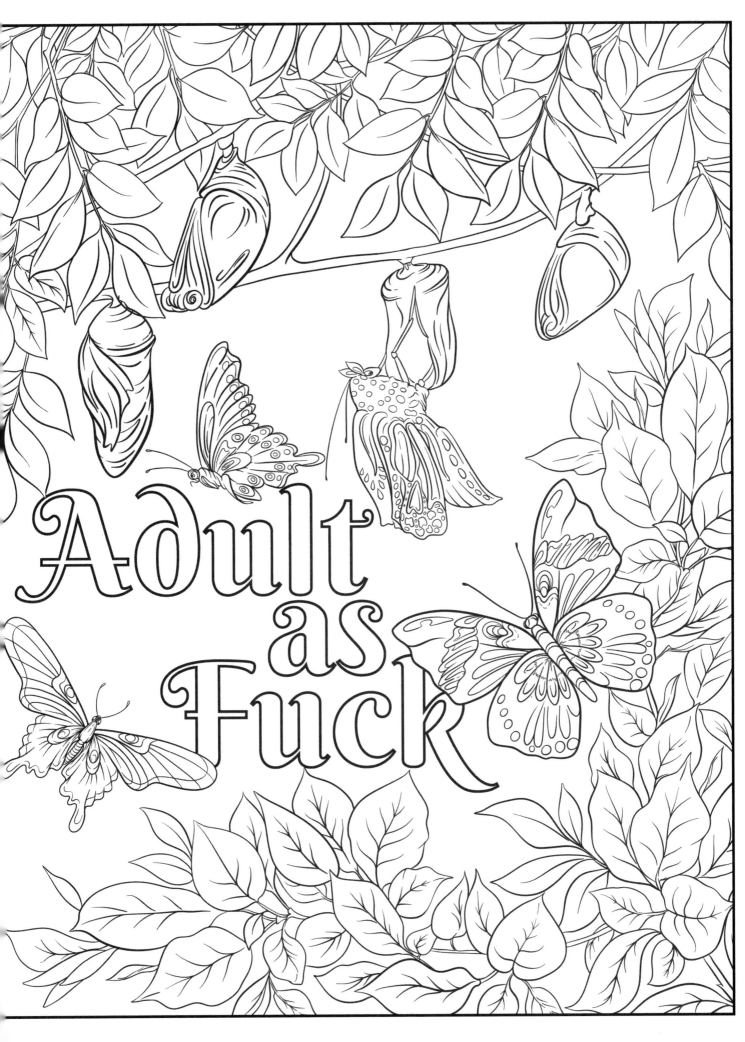

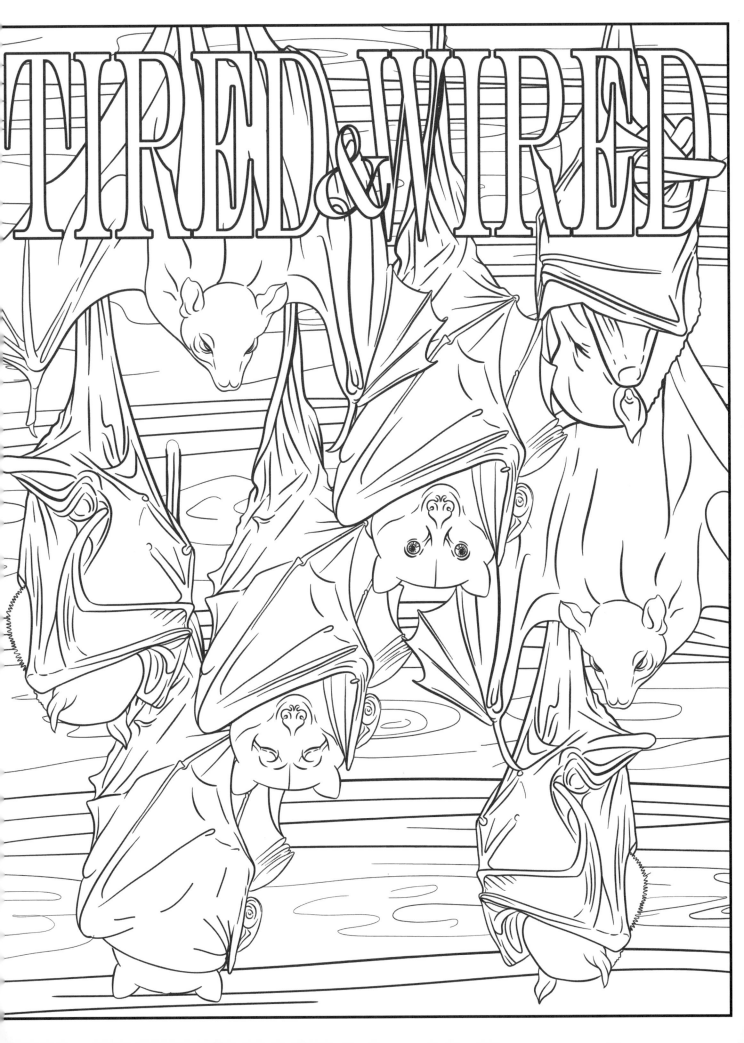

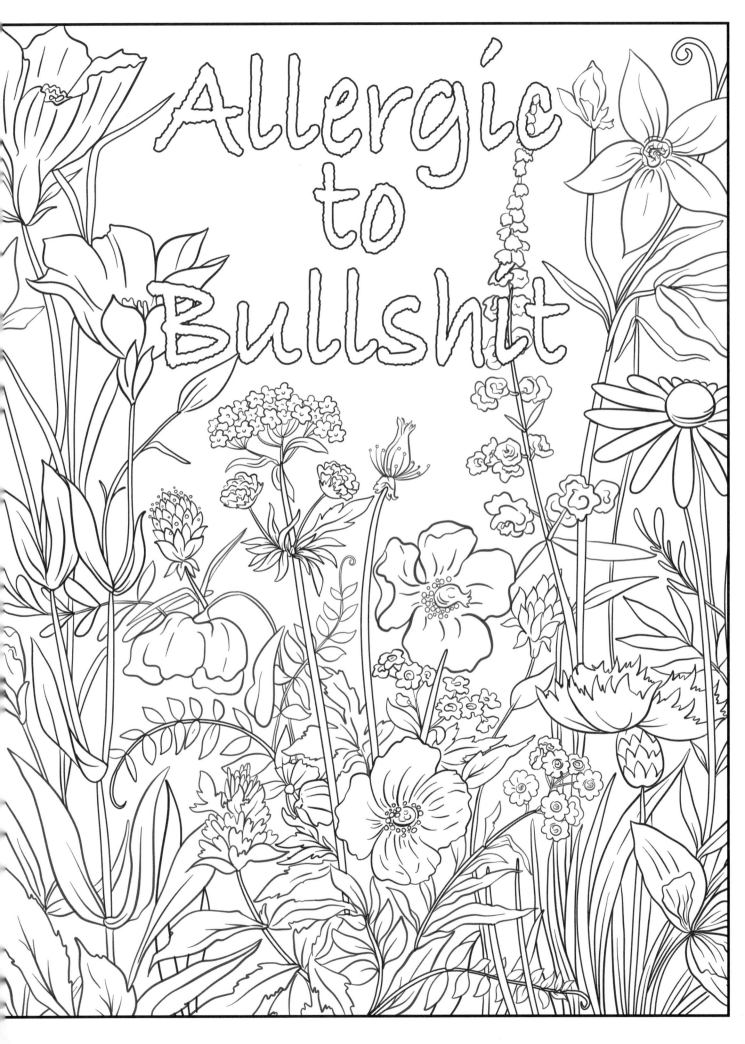

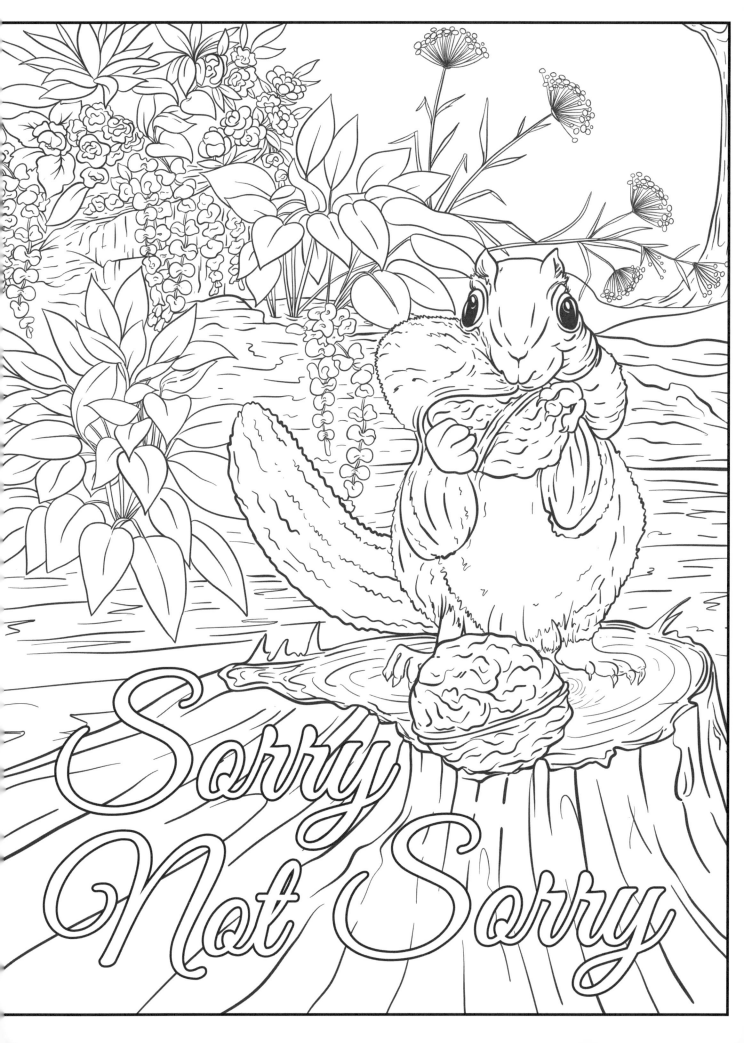

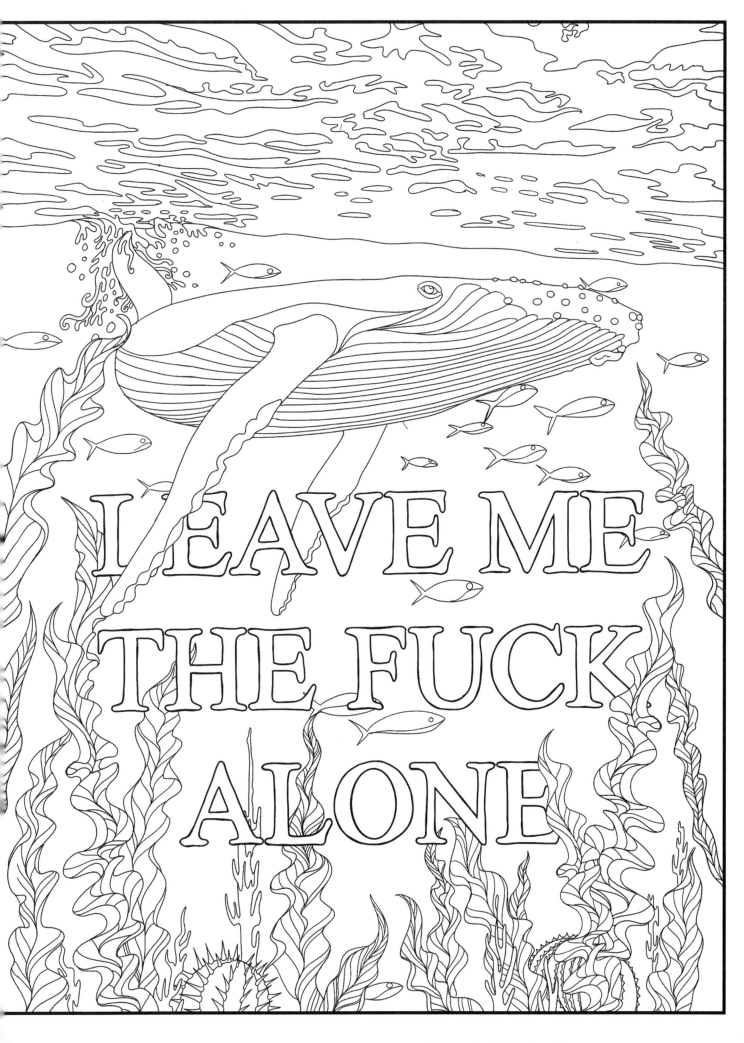

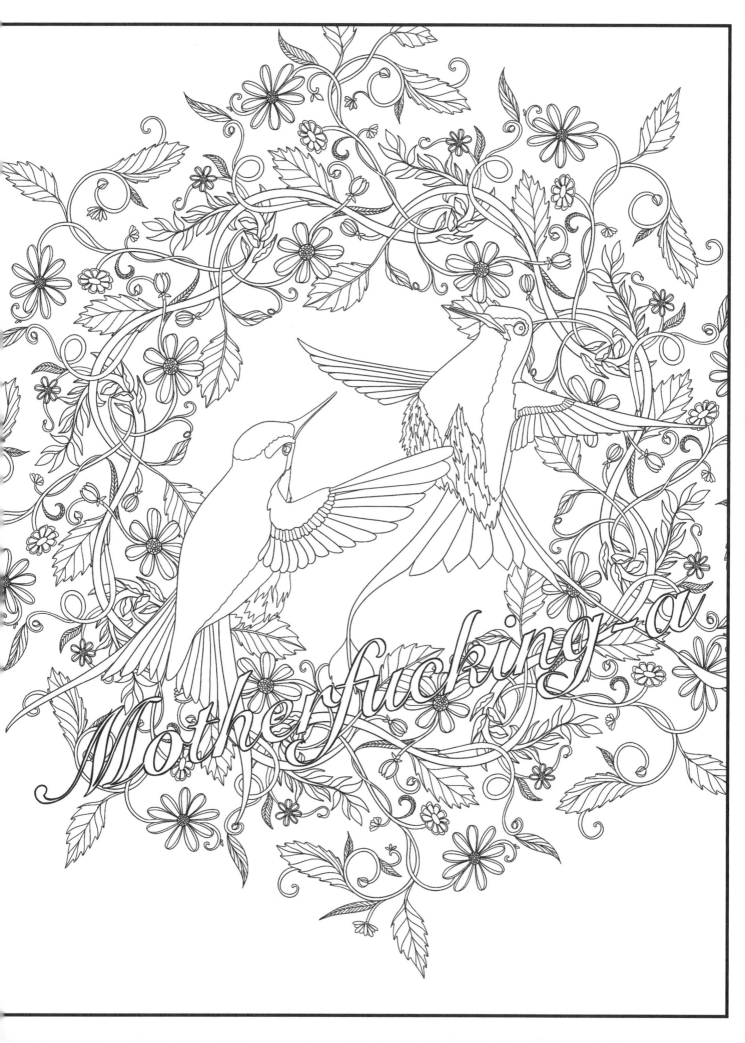

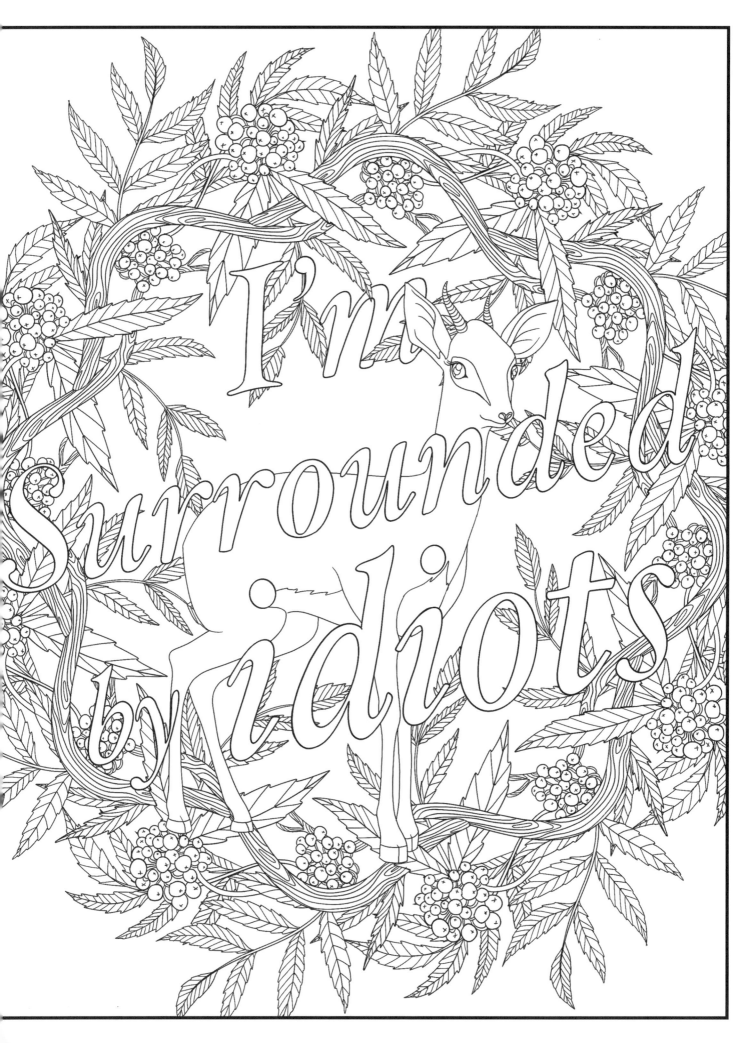

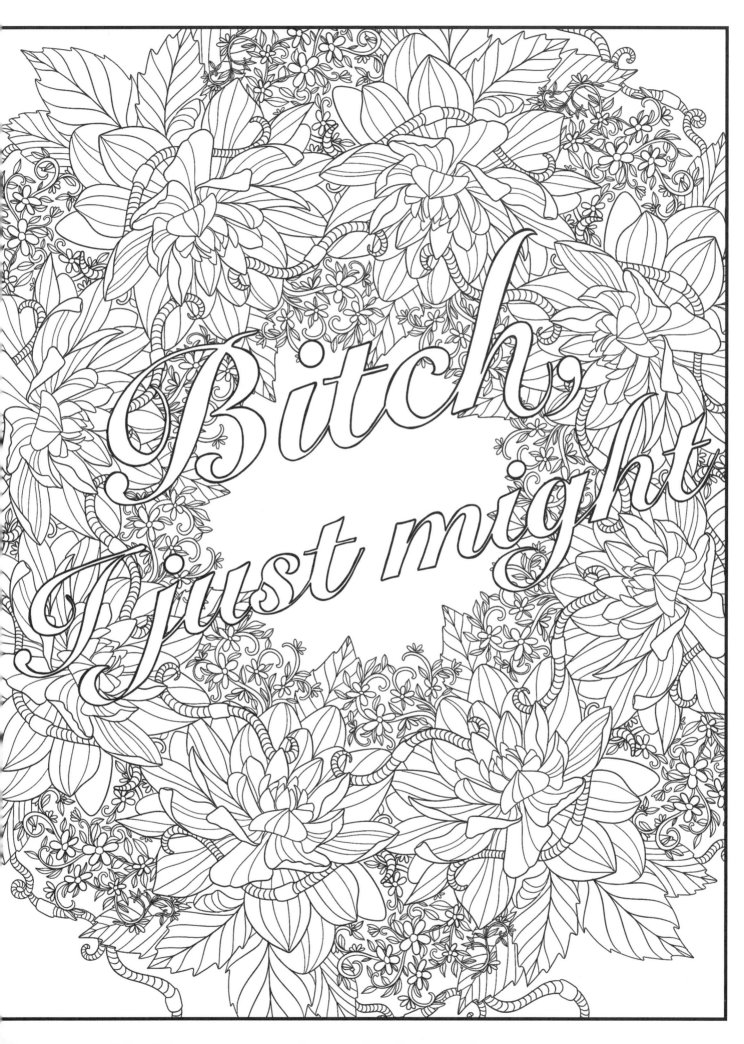

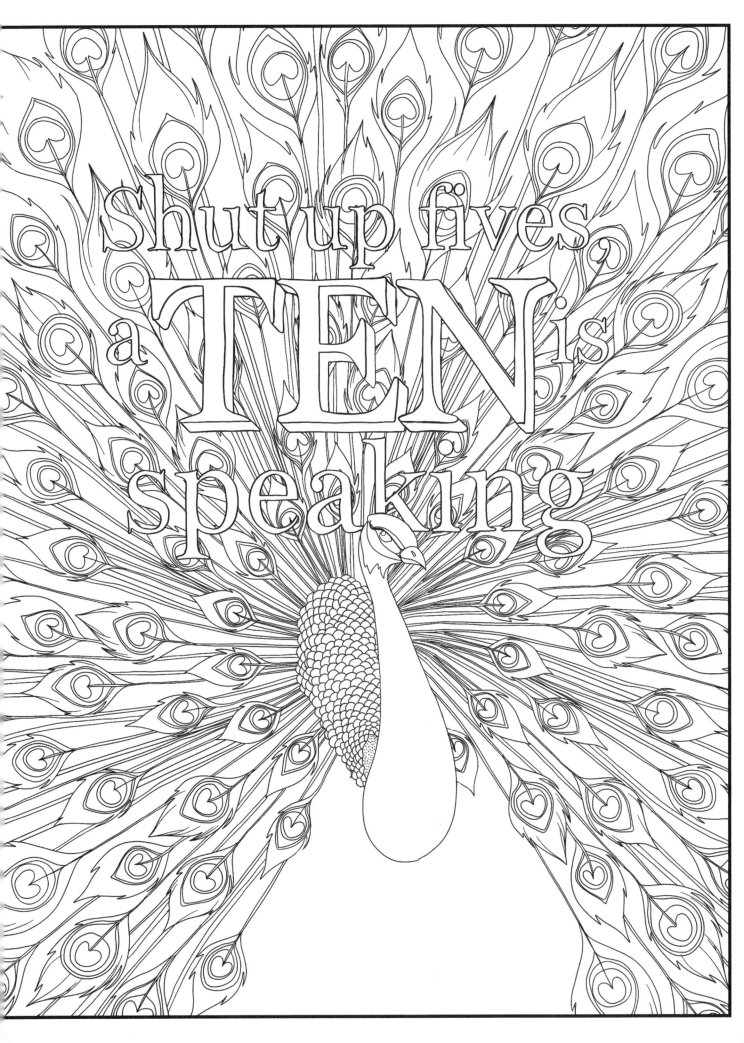

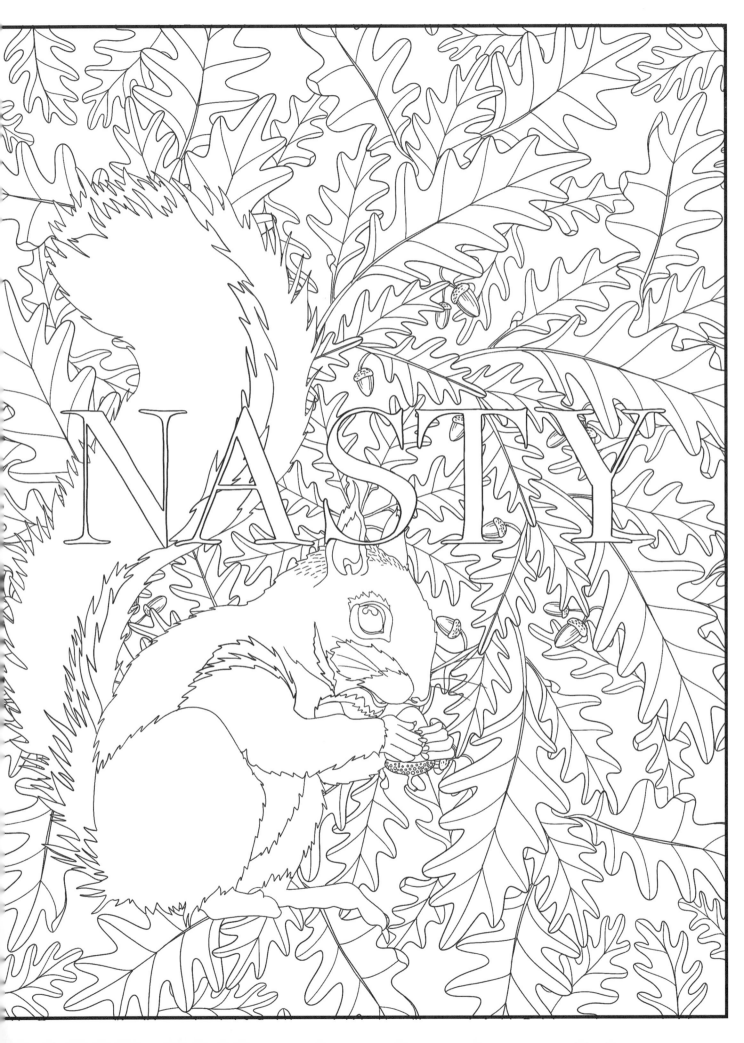

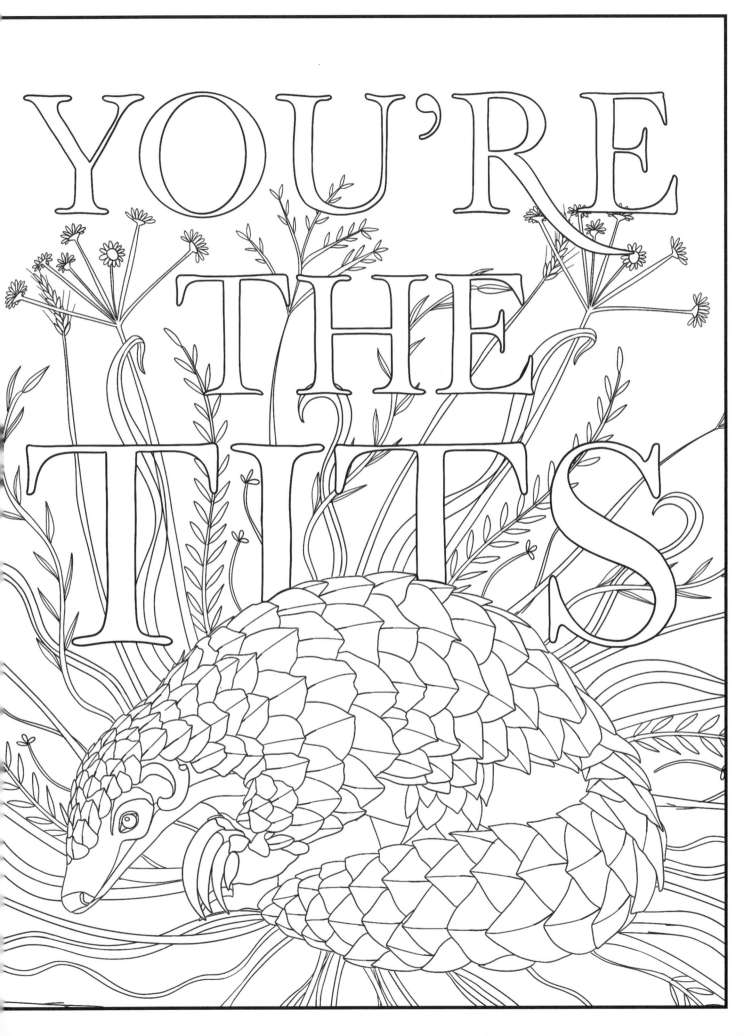

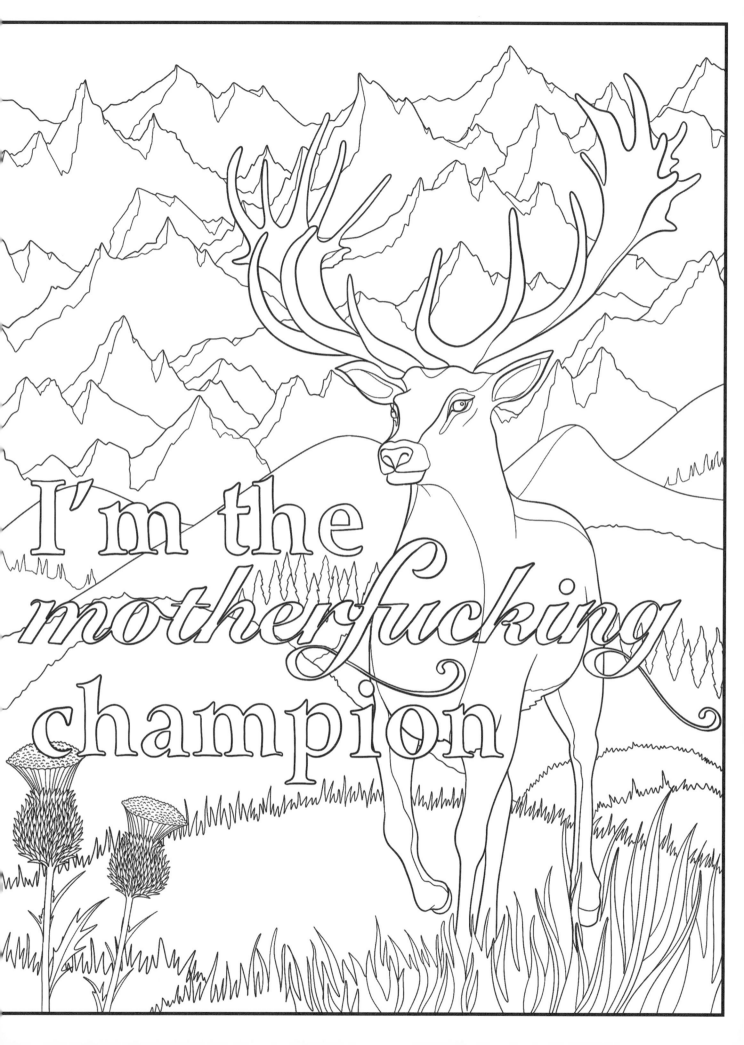

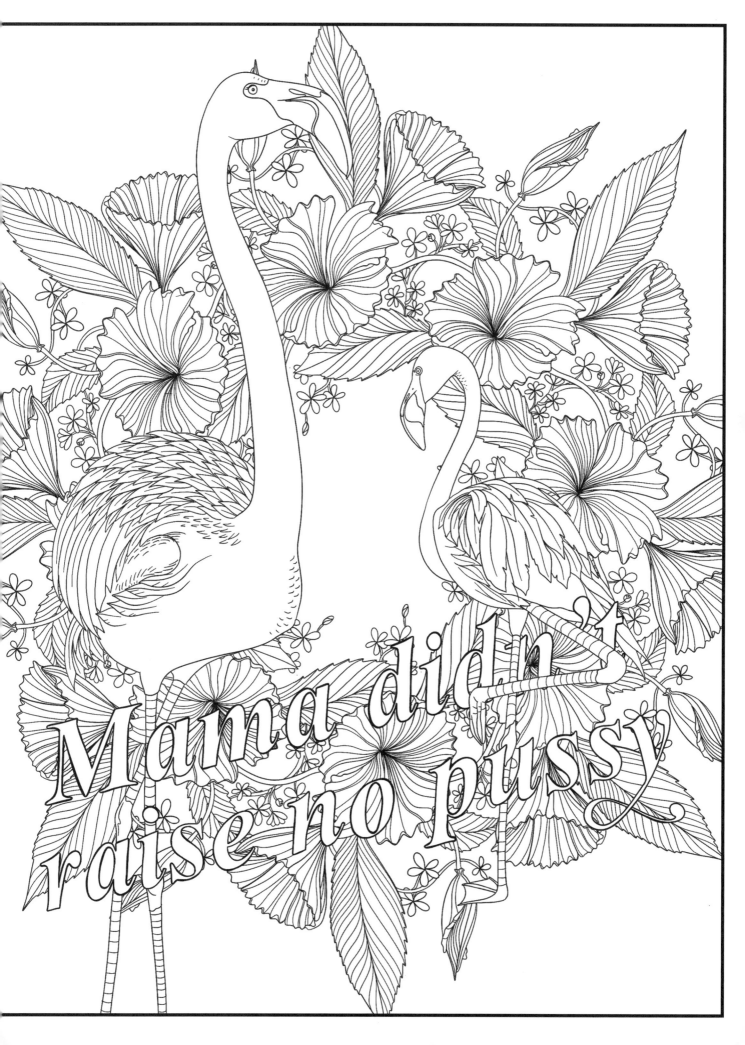

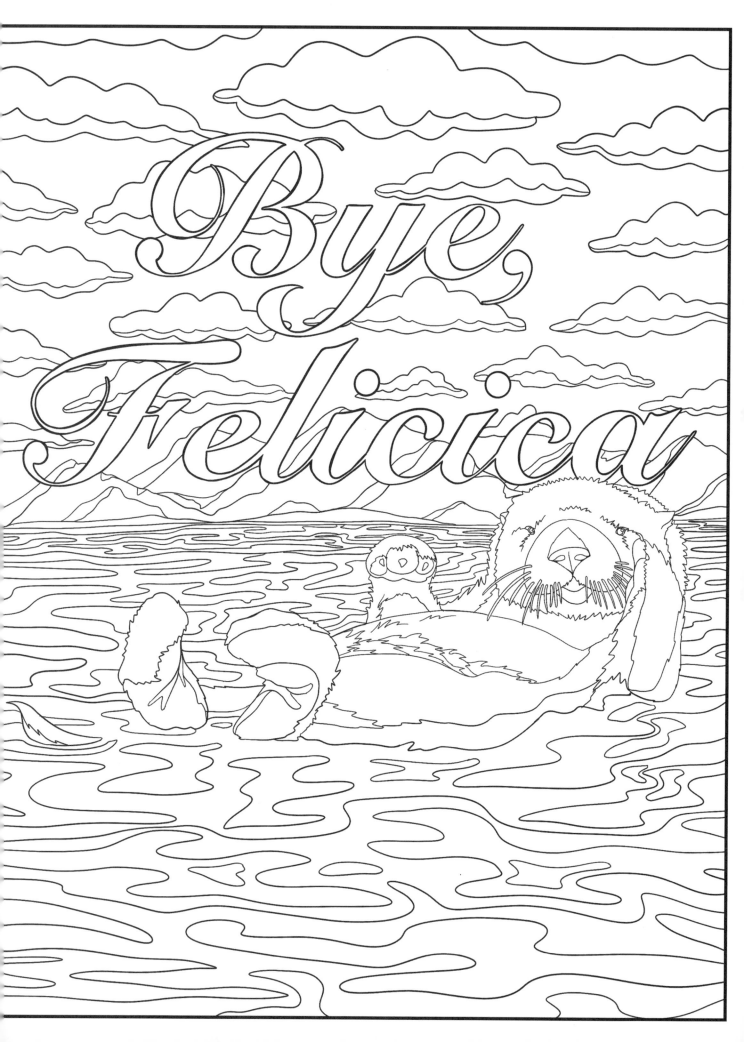

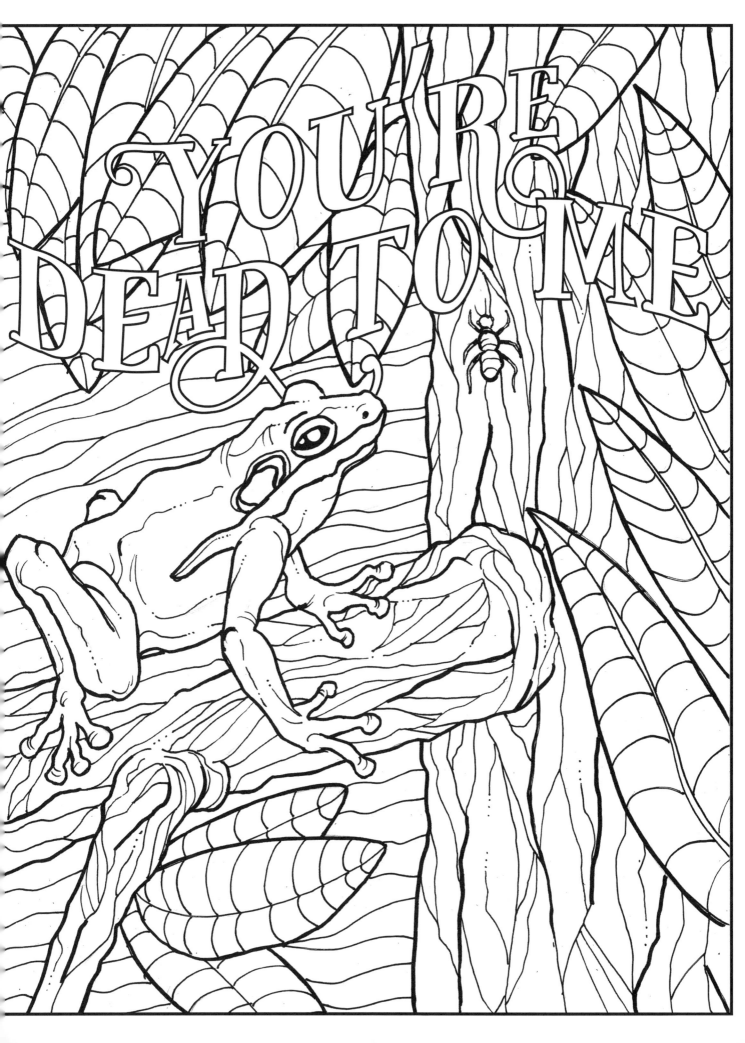

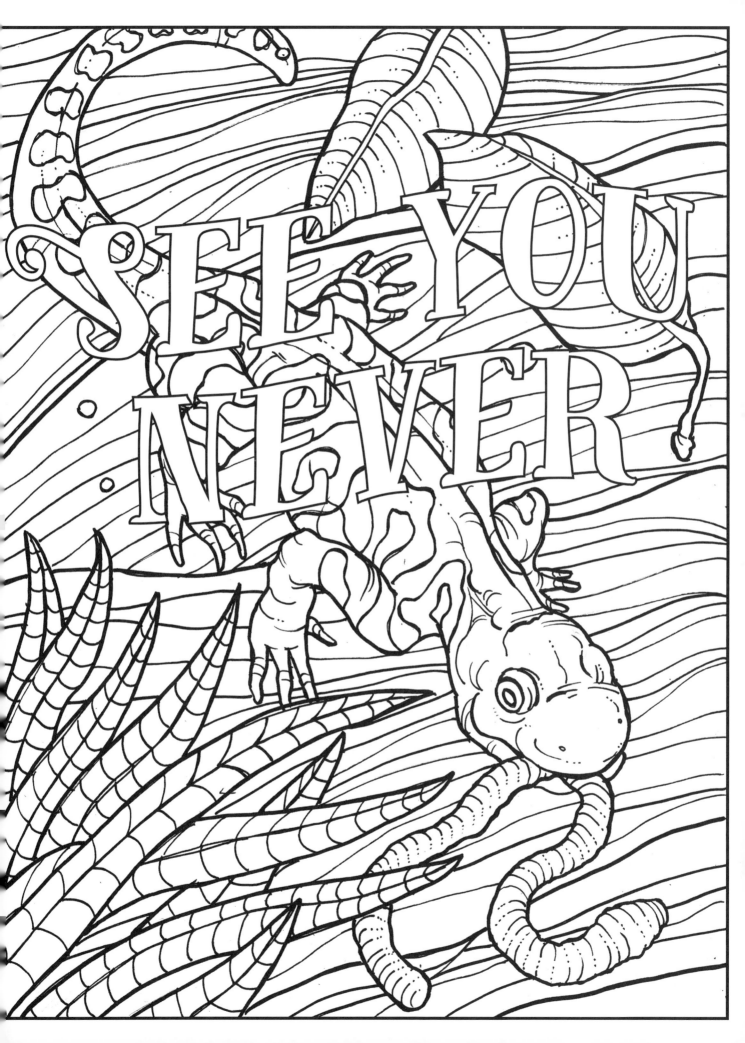

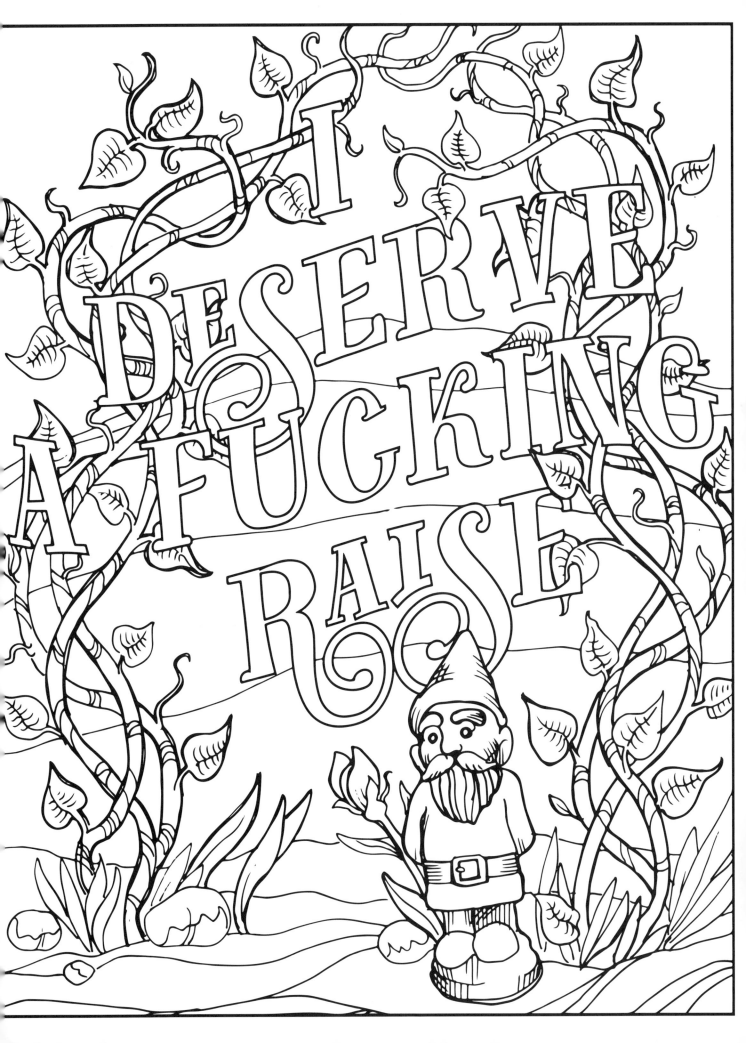

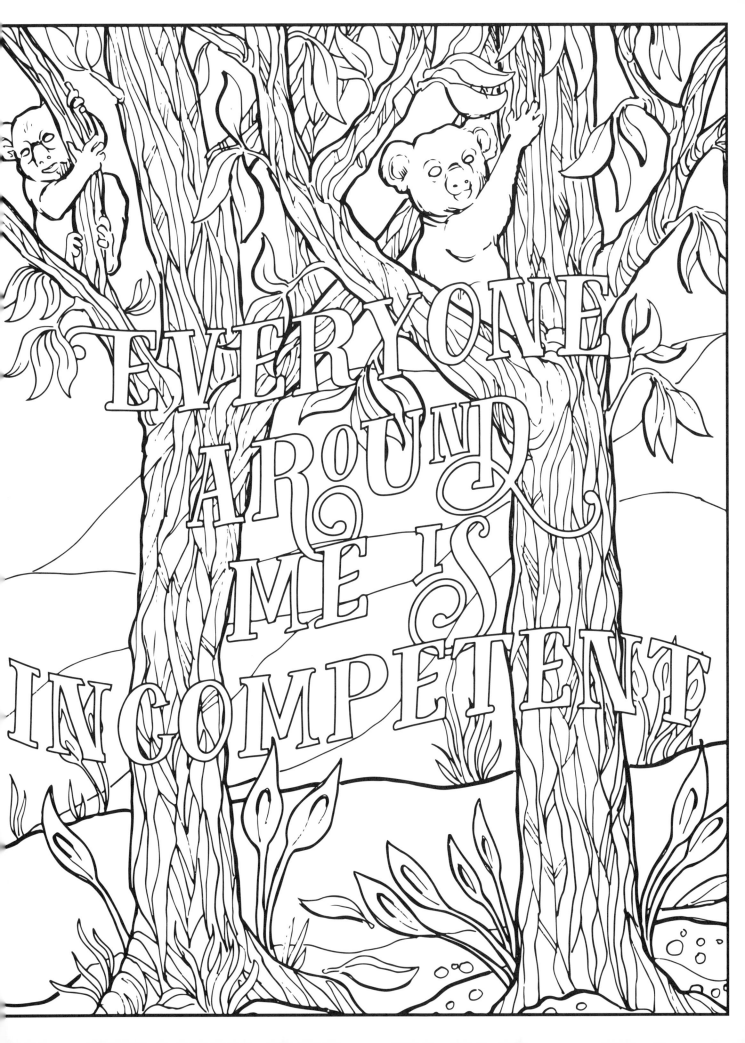

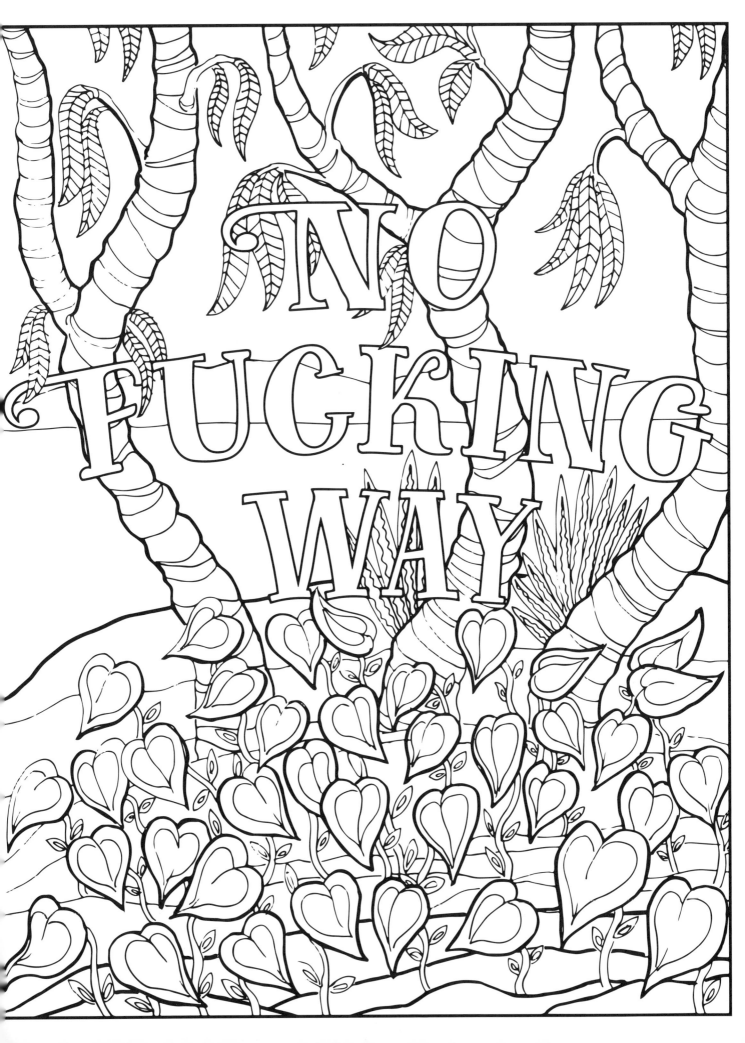

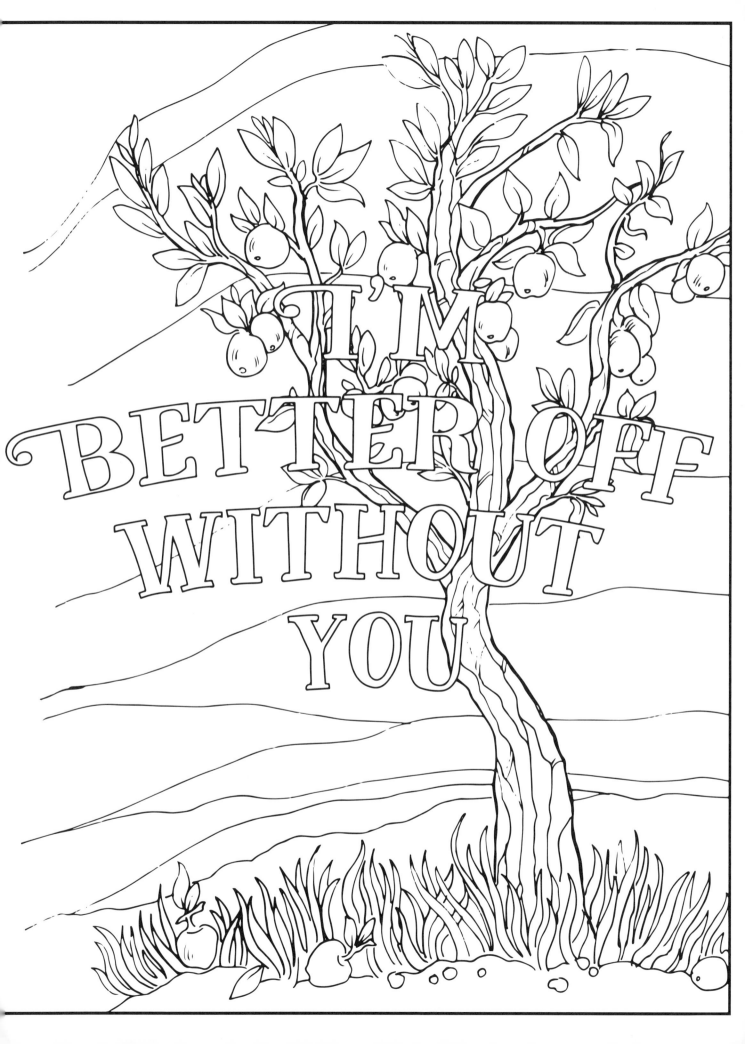

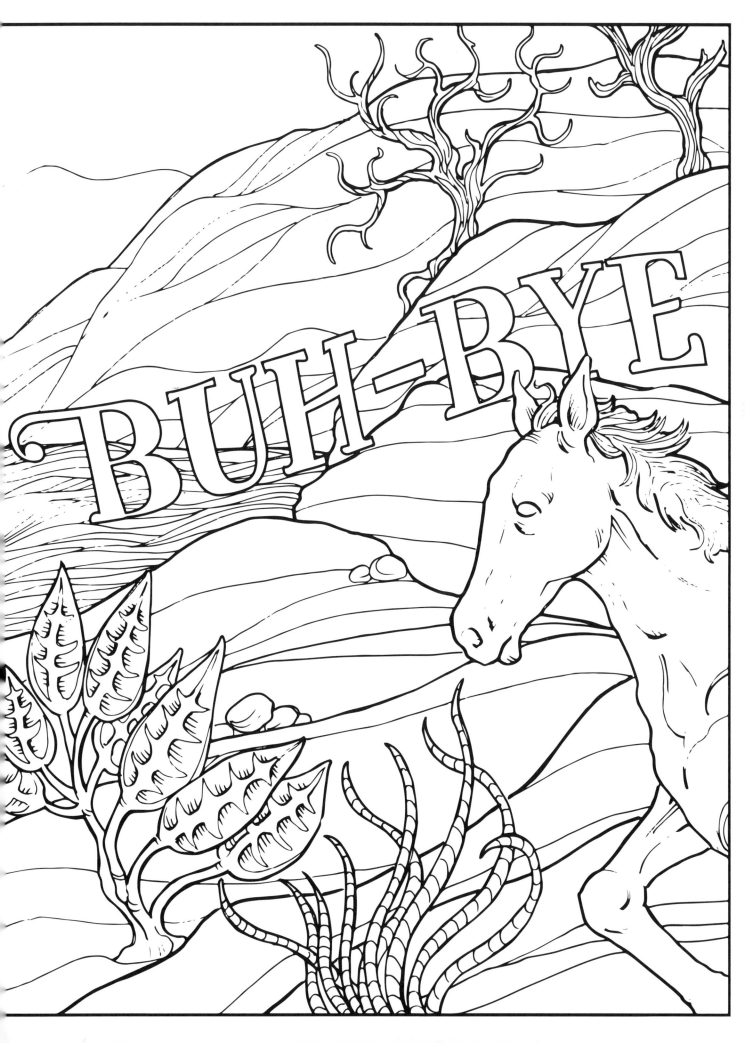

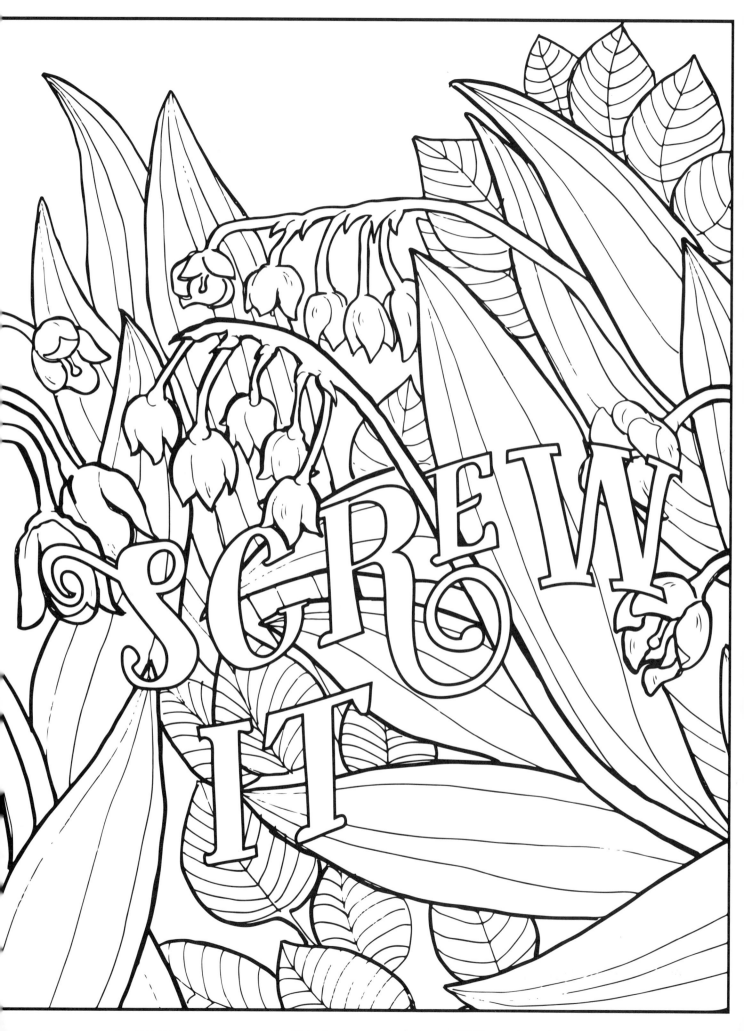

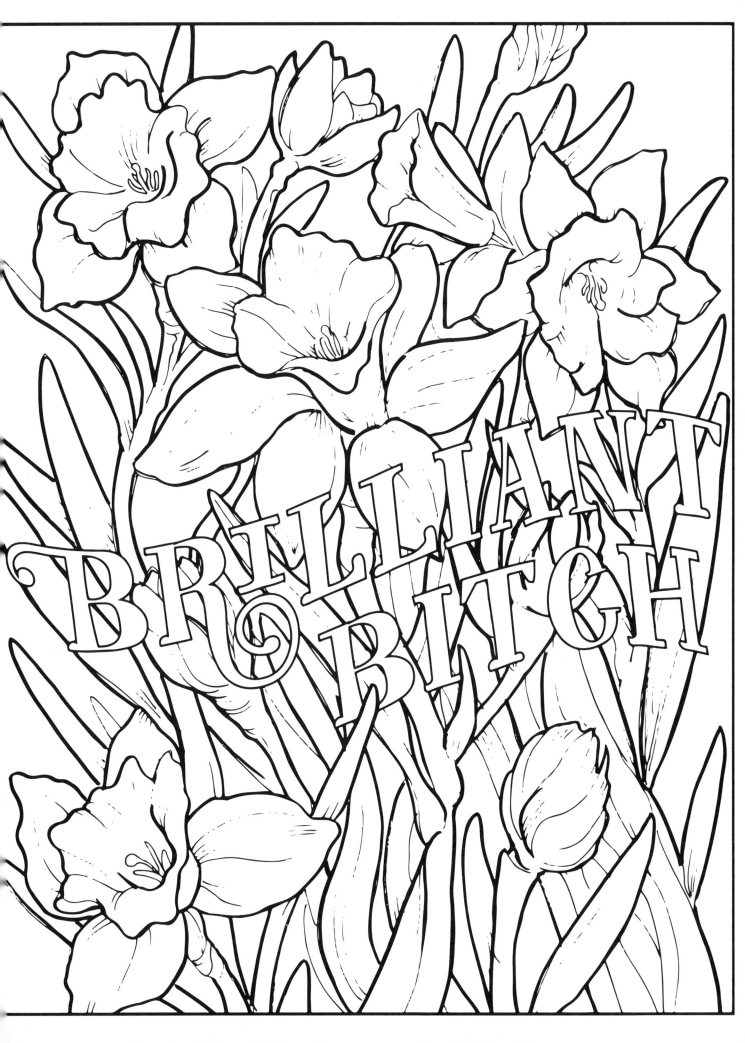

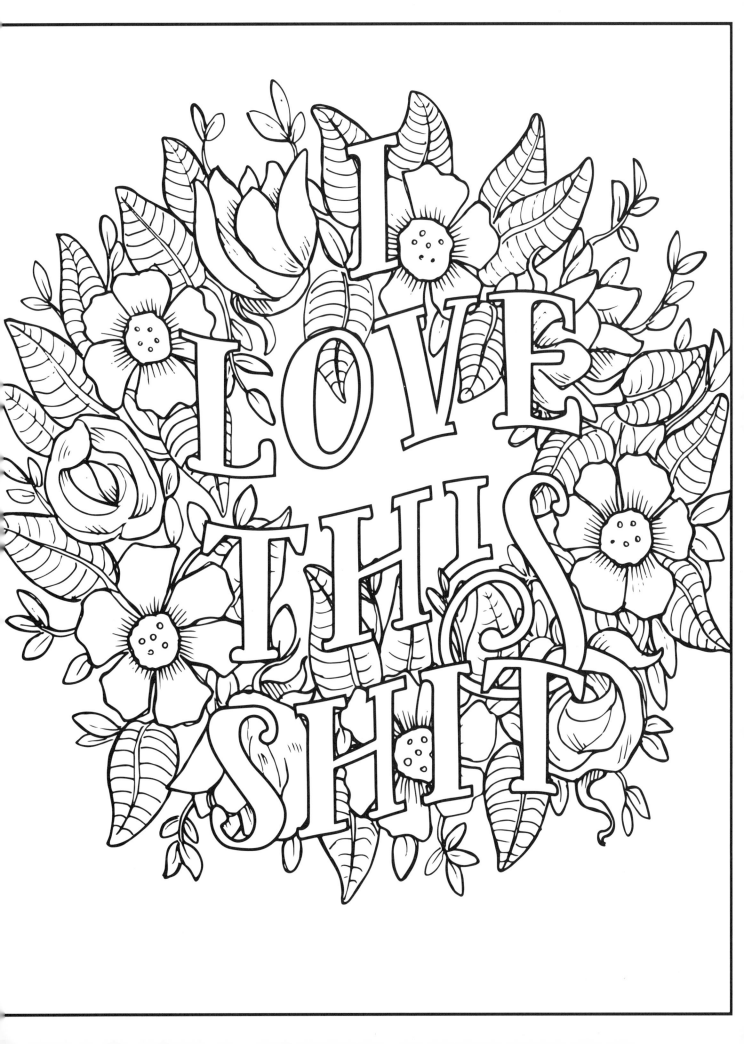

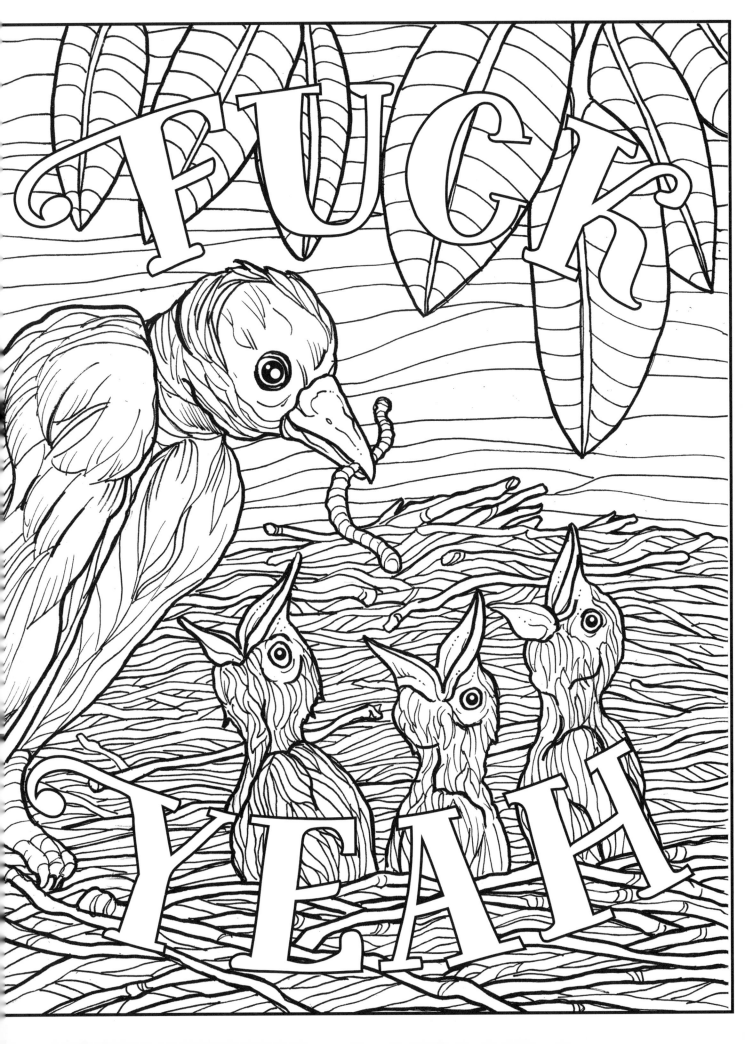

#FUCKOFFIMCOLORING #FUCKOFFIMCOLORING
#FUCKOFFIMCOLORING #FUCKOFFIMCOLORING
#FUCKOFFIMCOLORING #FUCKOFFIMCOLORING
#FUCKOFFIMCOLORING #FUCKOFFIMCOLORING
#FUCKOFFIMCOLORING #FUCKOFFIMCOLORING
#FUCKOFFIMCOLORING #FUCKOFFIMCOLORING
#FUCKOFFIMCOLORING #FUCKOFFIMCOLORING
#FUCKOFFIMCOLORING #FUCKOFFIMCOLORING
#FUCKOFFIMCOLORING #FUCKOFFIMCOLORING
#FUCKOFFIMCOLORING #FUCKOFFIMCOLORING
#FUCKOFFIMCOLORING #FUCKOFFIMCOLORING
#FUCKOFFIMCOLORING #FUCKOFFIMCOLORING
#FUCKOFFIMCOLORING #FUCKOFFIMCOLORING
#FUCKOFFIMCOLORING #FUCKOFFIMCOLORING
#FUCKOFFIMCOLORING #FUCKOFFIMCOLORING
#FUCKOFFIMCOLORING #FUCKOFFIMCOLORING
#FUCKOFFIMCOLORING #FUCKOFFIMCOLORING
#FUCKOFFIMCOLORING #FUCKOFFIMCOLORING
#FUCKOFFIMCOLORING #FUCKOFFIMCOLORING

SHARE YOUR BITCHIN' MASTERPIECES

Don't keep your colorful creations
to yourself—take a pic and share it
on social media with the hashtag
#fuckoffimcoloring and tag us
@cidermillpress!

For more stress-relieving coloring, check out:
Fuck Off, I'm Coloring
Fuck Off, I'm Still Coloring
Fuck Off, I Can't Stop Coloring
Fuck Off, Coronavirus, I'm Coloring
Bite Me, I'm Coloring
Available now!

INDEX

ABOUT
CIDER MILL PRESS
BOOK PUBLISHERS

Good ideas ripen with time. From seed to harvest,
Cider Mill Press brings fine reading, information, and
entertainment together between the covers of its creatively
crafted books. Our Cider Mill bears fruit twice a year,
publishing a new crop of titles each spring and fall.

DEYST.

"Where Good Books Are Ready for Press"

Visit us online at
cidermillpress.com
or write to us at
501 Nelson Place
Nashville, Tennessee 37214